Paint the Sea and Shoreline
in **Watercolors**
Using Special Effects

e. john robinson

international
artist

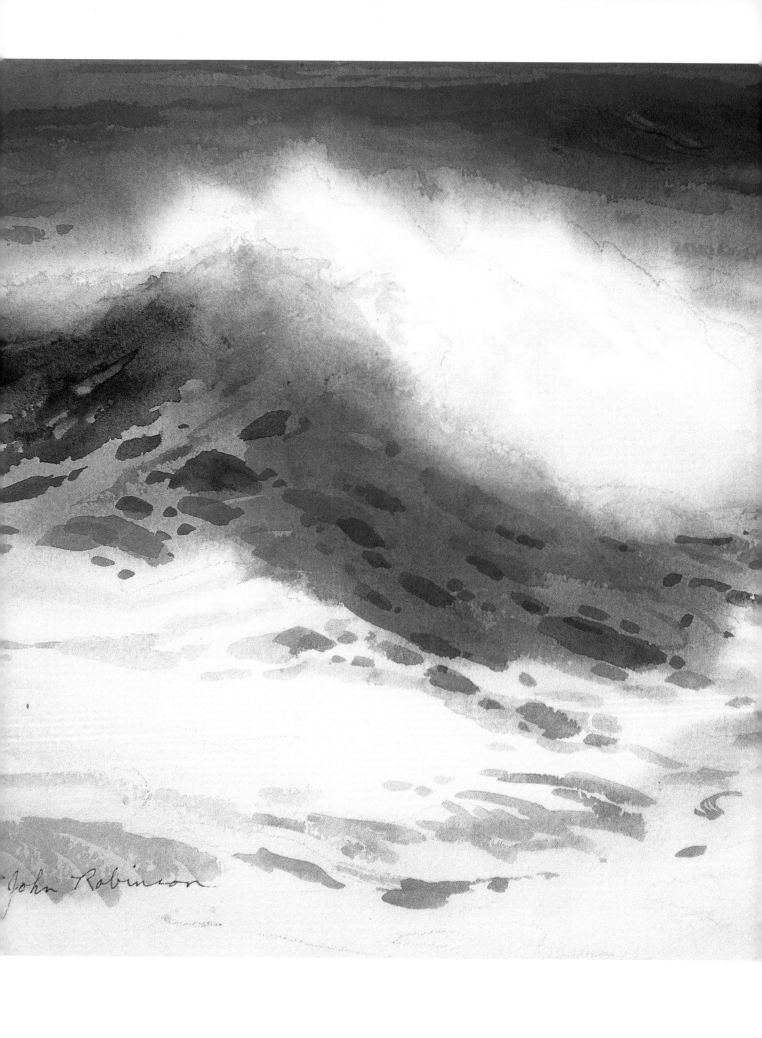

John Robinson

Paint the Sea and Shoreline
in **Watercolors**
Using Special Effects

by e. john robinson

international
artist

"Wave Study", 12 x 16" (31 x 51cm)

International Artist Publishing, Inc
2775 Old Highway 40
P.O. Box 1450
Verdi, Nevada 89439
Website: www.internationalartist.com

Edited by Terri Dodd
Designed by Vincent Miller
Photography and illustrations by E. John Robinson
Typeset by Cara Miller and Ilse Holloway

 Library of Congress Cataloging-in-Publication Data

Robinson, E. John, 1932–
 Paint the sea and shoreline in watercolor using special
 effects / by E. John Robinson.
 p. cm.
 ISBN 1-929834-32-2
 1. Marine painting— Technique.
 2. Watercolor painting— Technique. I. Title.

 ND2270.R63 2001
 751.42'2437—dc21

 2001024297

Printed in Hong Kong
First printed in hardcover 2001
First printed in paperback 2004

Distributed to the trade and art markets
in North America by:

North Light Books,
an imprint of F&W Publications, Inc
4700 East Galbraith Road
Cincinnati, OH 45236
(800) 289-0963

dedication

*To Vincent Miller, with his
extraordinary vision and ability
to bring great ideas to fruition.*

acknowledgments

I owe a debt of gratitude to many students from America,
England, Canada and Australia, who have encouraged
me to share my knowledge of the sea in watercolor form.
I must thank them because I have truly enjoyed creating
this book and may not have done so if they had not asked.
I must also mention the encouragement from Vincent Miller
in Australia, John Hope-Hawkins in England and the people
of F&W Publications in America. Most importantly, however,
I must thank the one who stands by my side, who believes in
me and inspires me — my wife June.

"Winter Waves", 15 x 20" (38 x 51cm)

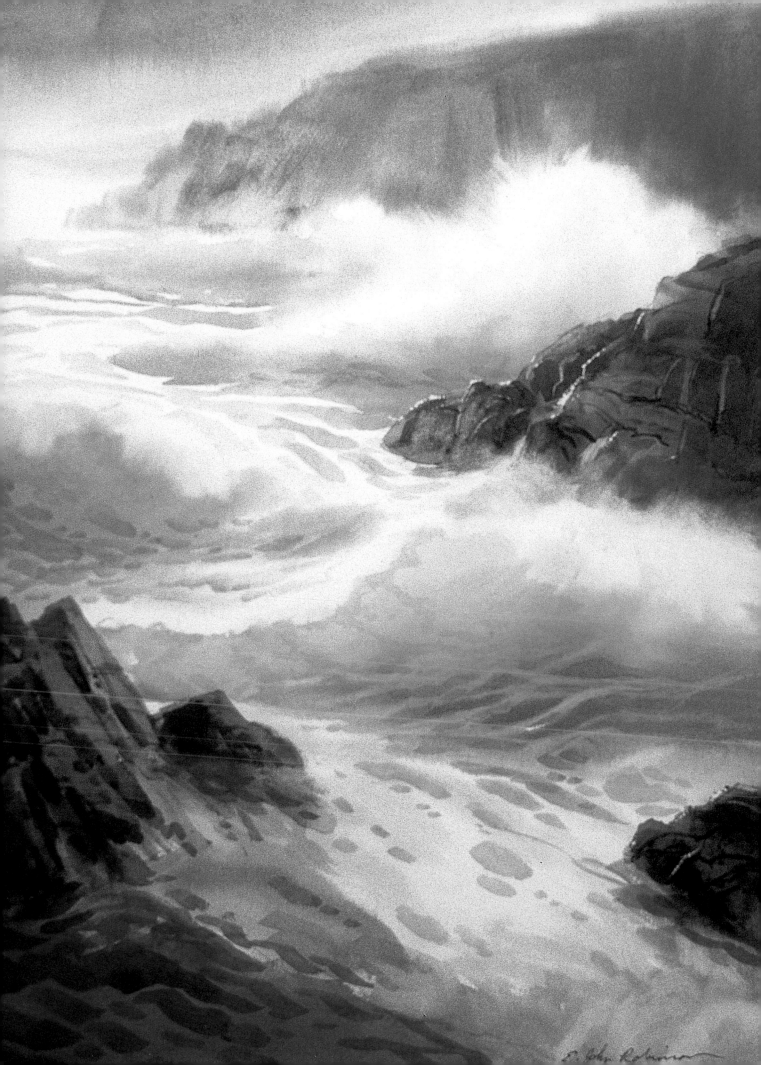

contents

introduction

I was eleven-years-old when I was given my first set of real watercolor materials — paint in tubes, a good brush and some genuine watercolor paper. At first I was very timid because my earlier attempts, with hard paints in tins and wrinkly paper, were frustrating and disappointing. The new materials changed all that, and I was hooked on watercolors for the rest of my life. It is true that I eventually made my career as an oil painter of the sea but I never stopped painting with watercolors. In fact, I prefer to travel with watercolors rather than with my cumbersome oil equipment and its associated difficulties of slow drying paints that, by some strange law of the universe, are attracted to clothing and auto upholstery.

Watercolor and seascape painting seem to be a natural marriage of sorts. The fluidity of watercolor perfectly suits the movement and softness necessary to represent the sea. As well, watercolors are transparent — and what could be better for producing the effects of looking through a translucent wave or into the clear depths of the surf?

This book is meant to teach and to be a guide in your quest to paint the sea and shore. You will have triumphs and disappointments but the more you study and the more you practice, the better your efforts will be. Don't hesitate to follow the step-by-step lesson and even copy the paintings for practice. We all must start by copying and then proceed with earned confidence to be our own master.

I hope that what I show you will help alleviate frustration so that you can paint with ease and assurance, while at the same time getting to know your subject.

In **SECTION ONE** of the book I show which materials, equipment, and supplies are needed, along with a good overview of watercolor techniques. I also explain my techniques for painting on site and show how these can help with later studio paintings.

SECTION TWO is about the elements that make a seascape painting. I explain and demonstrate the importance of color, atmosphere, sunlight, composition, and how water is a reflecting agent. Each of these chapters goes into enough depth that by the time you have read them and completed the exercises, you will have a very good grounding in the actual painting techniques. I strongly believe that success comes first from understanding the subject and then from continuous practice.

SECTION THREE shows how to paint seascapes and shorelines. Once you know what is needed to build a good composition comprising all the necessary elements, you can then learn the forms of the subjects. I show effective ways to paint skies, waves and breakers, the different types of sea foam, rocks, beaches and their tide pools and water outlets, and I devote a full chapter to painting harbors and shorelines. There are step-by-step lessons and exercises on each element that you can practice to build your experience and your painting skill.

Finally, in **SECTION FOUR** there is a gallery of my serious paintings. These works are the result of my years of painting and were created using the knowledge I am privileged to share with you now.

Watercolor is a noble medium and those who learn to use it well may freely express their perceptions of our beautiful world so that others may see it too.

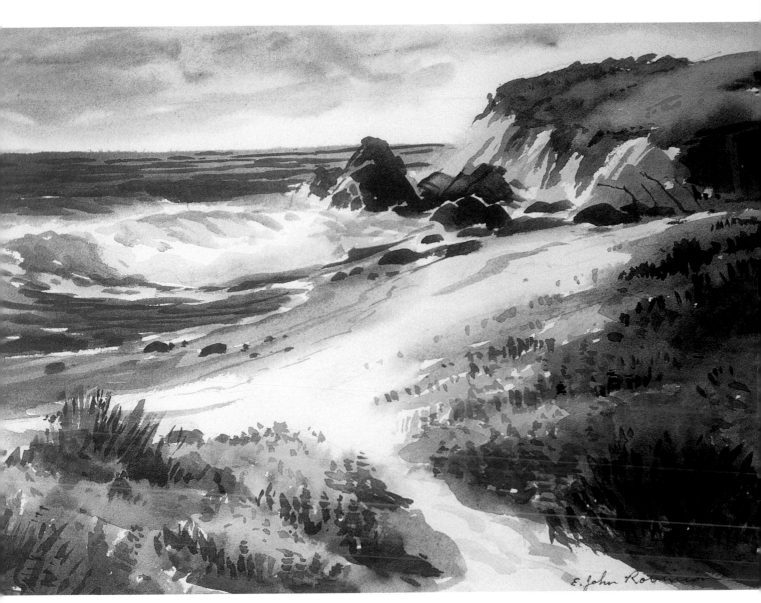

"Poppies and Lupines", 9 x 11½" (23 x 29cm)

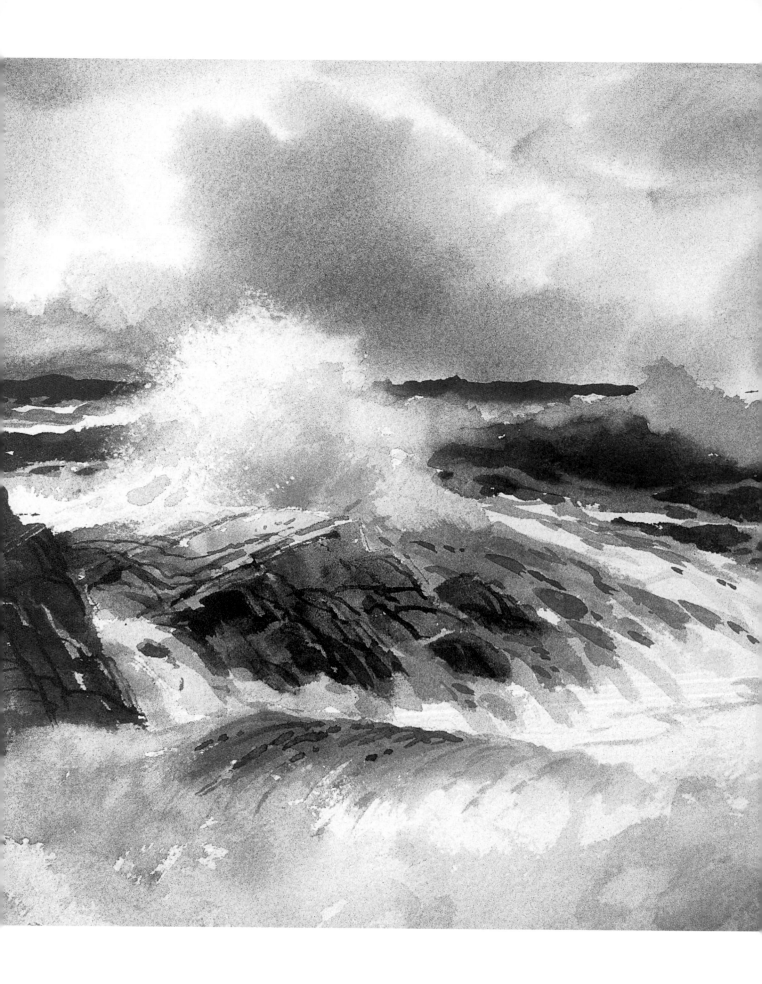

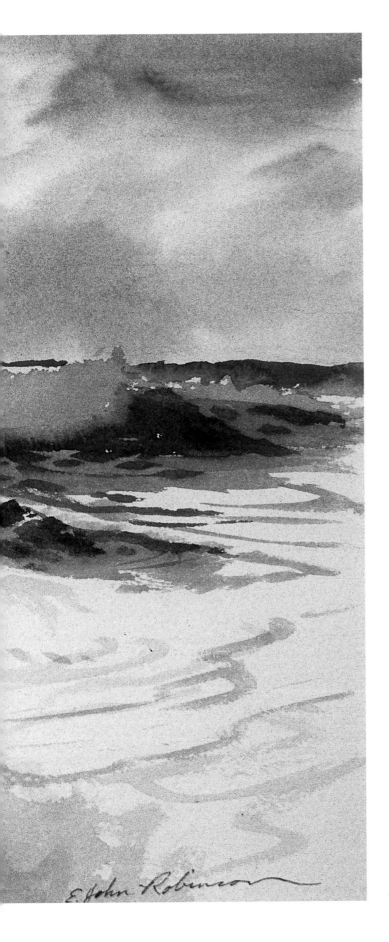

section 1

beginnings

"Cloud Shadows", 12 x 16" (31 x 41cm)

materials and techniques

Fancy equipment does not a painter make. Here, I list the only items I consider to be essential. Next, I describe the three main watercolor methods and all the special techniques you need to paint the sea and seashore.

I once attended a landscape watercolor class held by very fine artist and teacher Tony Van Hasselt. I had been painting seascapes for eons but I knew I could learn a great deal about landscape painting from him, and so made the trip to a beautiful harbor town in Maine. The night before the class a number of the students were chatting in a lounge after dinner and I couldn't help but hear the spirited conversation between two of them. They were discussing materials and equipment.

I was quite impressed with the knowledge of these two men about everything from easels to brushes and their opinion of the best colors for different subjects. I was beginning to feel like a rank amateur as they continued on into the evening. They knew where to buy the best of the best and each described the latest and greatest of everything that they had brought with them. I retired for the evening

wondering what they would think of my old, worn travel kit. I hadn't even brought a chair because I was reasonably agile enough to be able to sit on the ground and, even more important, get to my feet again.

The next morning Tony gave a good introduction and painted a stunning watercolor near the harbor. Then it was our turn and everyone set up their equipment. I went off to one side to park myself on the ground and lay out my watercolor kit, paper on board, and so on. Not far away the two artists I overheard from the night before set up. True to their stories, their equipment was the very best — they had everything imaginable, including chairs, and easels that gleamed in the sunlight!

After a while, when I thought I'd better not do any more damage to my painting, I arose, somewhat stiffly, and walked around a bit. My curiosity got the better of me and I ambled over to the two "professionals" to see what they were doing. I stopped and gaped. Apparently, book knowledge and fancy equipment does not a painter make! This is a good lesson for us all.

We all have to start somewhere but a lot of practice is more important than anything else.

In this chapter I will make suggestions for equipment and supplies, however, the only items I believe should be of the very best quality are good brushes and good paper that won't wrinkle when it is wet. Eventually you might add pigments to my suggested list, and when it comes to equipment this is a personal choice. Look for something comfortable and easy to work with. It doesn't have to be fancy, just practical.

studio easel

I made my own studio easel. I wanted an "L" shape with a hinged board and an area on my right for the palette, brushes and tools. I built it with drawers and a well that was able to accommodate a quart sized plastic water container.

Some artists stand up to paint and keep their board vertical all the time. My easel is at a height that is comfortable to either stand or sit, but I like the flexibility of a hinged board.

palette and brushes

There are many palettes on the market but I recommend one that is about 12 x16" with enough side bins (wells) for at least 20 colors and a large mixing area in the center. The bins should be deep enough to hold as much as a tube of paint that can be kept moist and ready to use. Don't let the pigments become hard and brittle. The palette should be white and made of plastic or porcelain or a material that is easily wiped clean. It should also have a lid to keep dust out and keep moisture in when not in use.

I have a whole array of brushes from a 2" wide flat to a tiny #000. I use the 2" wide mostly for wetting down the paper or making a large swath of color on wet paper. I rarely use the very tiny brushes. Mostly I use just a few in between. I do a great deal of work with flat brushes, mostly 1" and ½" , and I use the chisel end of the handles

for scraping wet paint.

Round brushes are valuable mostly for finer detail work. One good #12 sable that can hold a fine point is invaluable because it can do the work of all the rest. However, I sometimes use #'s 4,6,and 8. I have an old #10 round that no longer makes a fine point and I use it for areas where a hard edge is not wanted.

A note of caution: never leave your brushes in the water jar. They will become deformed and may never straighten out. I have drilled holes in the table portion of my studio easel that hold a good array and I have gotten in the habit of putting them back each time I use them. Naturally they are cleaned first and stand with the hairs in place and pointing up.

tools of the trade

- **Paper:** I use different brands of paper from 140 gsm to 300 gsm. Anything lighter is apt to wrinkle and that is intolerable. The same goes for watercolor blocks. Whether the paper is hot pressed and very smooth, or cold pressed and rough is a matter of choice. I use both but prefer a rough texture most of the time because I like the way colors will puddle in the depressions on rough paper.

- **Sponges and tissues:** I keep a large imitation sponge by my water jug because I like to dab out excess water after cleaning a brush. I use smaller, real sponges for wetting the paper and lifting out paint and I keep one old sponge for cleaning my palette. I also use tissues for lifting areas.

- **Hair dryer:** Sometimes I allow paint to dry normally. It gives me a chance to step back and see my progress from a distance. Other times I just want to get on with it, and I use a hair dryer.

- **Water:** As I mentioned before, the well in my easel table holds a quart of water in a jug. I recommend a large container because the water lasts longer before it becomes muddy. I generally change water for each new painting. It is annoying to wet down your paper and find it is tinted blue.

- **Other tools:** I always keep masking tape handy, both for holding my paper to the board and for masking out areas in the painting.

 I keep a pocket knife, or at least a knife with a sharp point, for scratching lines and making sparkle dots.

 I have a white crayon that I sometimes use for lines before I apply paint. It resists the paint and shows up very well, especially on smoother paper.

 I also have a small sheet of sandpaper as you will soon discover.

 Lights are very important. I have three 150 watt floodlights on an overhead track. Some artists like full spectrum lights or even fluorescent lights. Just make sure there aren't any cast shadows on your work.

 I also keep a small sketchbook and pencils for those quick thumbnail sketches.

techniques

As you may be aware, there is a transparent watercolor technique and an opaque watercolor technique. Opaque pigments generally contain white, or are mixed with a water soluble white pigment, and they can be used for many subtle color effects. White paint may be laid over other colors where needed. However, throughout this book I use a transparent watercolor technique which uses no white paint and instead relies on the white of the paper. An advantage of using transparent colors means you can glaze one color over another for a luminous effect.

The amount of water used in painting is also a technique. There is the **dry-brush** technique, where you apply color with very little water on to dry paper. This allows you to achieve different textures according to the surface of the paper.

There is a **semi-wet** technique, which uses a lot of water with the pigment on dry paper. This mostly covers up the paper texture but may give crisp lines and a more solid application of color.

Finally, there is the **wet-into-wet** technique. This is where pigment with plenty of water is applied to wet paper. This technique produces flowing colors and soft edges. It is ideal for laying down broad background colors, drippy skies, and areas where you may want to lift out the color with a sponge or tissue.

My personal technique can be called wet-into-wet, but I use all three in the process.

I generally start a painting by laying in background colors or an under-paint on wet paper. My next application is usually wet brushwork over the dry underpaint and, finally, I apply details using the dry-brush technique among others. One could say I work from the under layer through to the top layer, and from wet to dry. Think of it as making a cake: You must build a form before you can apply the icing. In other words don't start with details, lay something down first.

broad brushstroke
I use my large 2" flat for either large strokes of color or for wetting the paper. It is not good for dry-brushing but does well with wet paper or plenty of water and pigment.

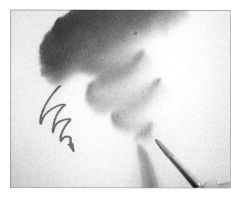

wet-into-wet
Here I used a #12 round sable and a lot of water with the pigment. I then made the brush squiggle in a zig-zag motion on the wet paper. The result is a flowing, soft-edged wash of color. This is the method I use for wet skies or laying down underpaint anywhere I need it.

semi-wet
This is the application of wet brushwork on dry paper. Notice how you can make a clean-edged stroke or get some texture from the paper. Holding the brush straight up as you move it across rough paper will fill in the texture and leave a flat swath of color. Laying the brush flatter will enable the pigment to scatter across the top of the texture.

dry-brush
Dry-brush means the brush has very little water in it and it also means the paper is dry. The way the color scatters across the textured paper is useful in many ways. Not only can it give a pebbly texture to rocks and sand, but it can give a sparkle effect to background water by leaving mostly white paper behind.

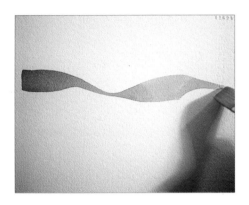

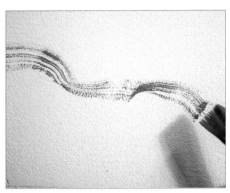

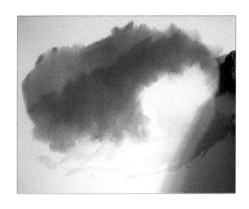

twist stroke
The flat brush is ideal for making strokes of varying thickness. Whether wet-into-wet or semi-wet, it gives a lot of variety. It is especially good for laying in background swells in a seascape, or even the twisted branches of driftwood.

splitting hairs
Use a flat brush with pigment and only a little water, and then use a knife to separate the hairs for a nifty texturing line. Applying pigment with split hairs is ideal for showing the lines and cracks in driftwood or textured lines in sand. Using the twist stroke adds to the variety of stroke effects that can be achieved.

softening edges
Once the under-paint has been applied to wet paper, you can lift off pigment with a sponge or tissue so there will not be a hard edge. This is especially important where foam or clouds will be. I often lay in the background color darker than the area I surround. Then I lift off any hard edges.

Wet-into-wet paint has a tendency to keep flowing on a slanted board and the unpainted area can quickly be covered if you do not lift off before it dries.

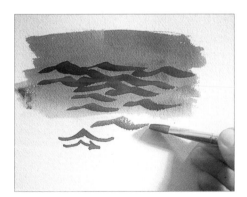

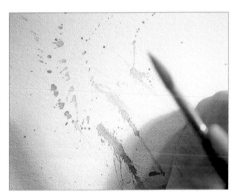

chops
Using a flat brush in a position that would make a thin line, you can create a chop by twisting the brush slightly vertically and then back again as you move it along. This is a stroke I use frequently for ripples and variations in the surf. If you used this for background swells it would be necessary to go back and fill in the bottom of the chop to a horizontal line. Only the upper edge of a swell can be choppy.

spatter
This may look like something you don't want but it has it uses. Some artists use spattering as a part of their technique just as some allow pigments to run in long drizzles as a part of theirs. Spattering is a good way to texture sand and rocks. Simply have enough water with the pigment that it will spray off the brush when you tap it or knock it against your other hand. I sometime have disasters because the spatter goes beyond where I want it.

here's one to avoid
A "bloom" is usually an ugly blotch in an otherwise clear area of color. It is caused by dropping water or trying to apply a spot of color when the underpaint is only partially dry. It is alright to add water and pigment when the underpaint is still very wet or when it is totally dry, but there is an in-between time that will not take kindly to interference.

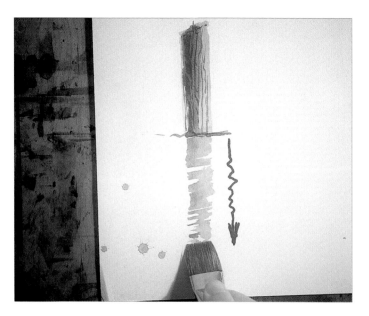

reflection stroke

Here is another use of the flat brush. If you look closely at this illustration you will see that the reflection has two shades to it.

With the brush wet, I dipped one side into the light color of the piling and dipped the other side into the shadow color of the piling. I then moved the brush back and forth as I worked it straight down over the dry paper.

masking out

I have never cared for masking fluids or rubber cement used to save white paper when underpainting. They always seemed to be messy, impossible to get just the right line, or hard to get off later. I use masking tape instead. I first draw the object, such as a piling or a seagull, then lay masking tape over it. The tape I use is white and I can see my drawing underneath. I then use a thin knife point and cut along the lines and peel off the excess tape. Next, I apply my color, let it dry, then peel off the tape and work in the clean, white area left behind.

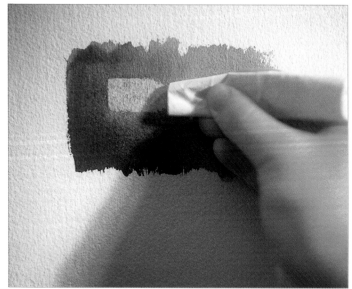

brush handle lines

The chisel end of your flat brush is a very handy tool. I use it to scrape a few lines through partially dry paint on top of dry paint or clear paper. If you scrape before the second layer has partly dried, the line fills up with the wet paint. If you wait too long, you can't scrape through the second layer so you must practice until you can tell when the second layer has dried just enough. I like this because the underpaint color shows up in the scraped out line. Caution: don't overdo this. It can attract too much attention.

lifting dry paint

You already know about softening edges by lifting wet color with a sponge or tissue. What I am referring to now is lifting dry paint. Sometimes we may want to lift a spot or cut in a lighter shape after the paint has dried. I use a clean, wet brush and carefully apply water to the area. Then I lift the wet pigment with a dry tissue. Sometimes I have to repeat the process several times. You almost never can get back to pure white paper. Nevertheless, it is a handy method for making corrections.

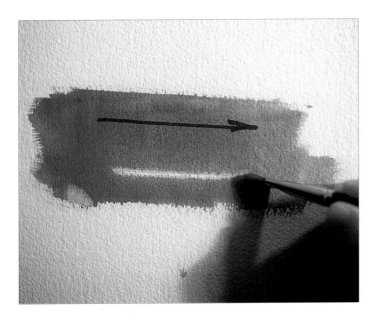

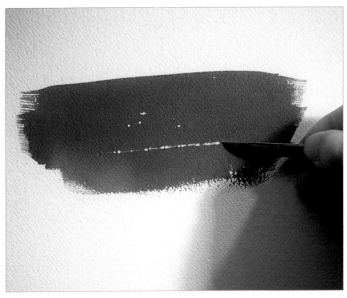

lifting lines with a brush

This is similar to the method used for lifting dry paint, but is meant for thin lines. If I wish to have a thin, white line, I use a flat brush edge-wise with water only. I make the stroke, then wipe the brush dry and go back over the same line. It lifts the wet paint. Again, it may take several steps. This is particularly useful for cutting in a reflected line over still water or for lifting out ripples on a wave.

scratching out

You may also use the point of a knife to scratch out a line but scratching can leave behind ragged edges that are better removed. However, it is a handy method of retrieving white as long as it isn't overdone.

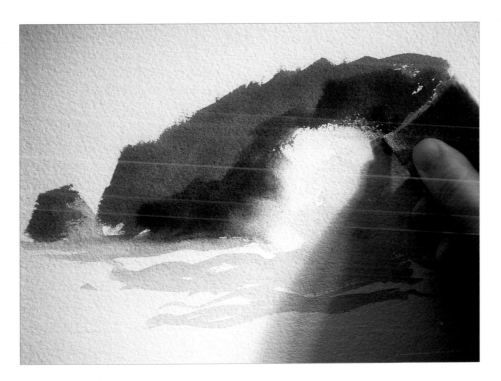

These are only some of many ways to play with watercolors. Some artists drop salt into wet paint for mini blooms; Some mix colored inks, and heaven knows what else, to achieve a special effect. It doesn't matter as long as it helps you get the results you want.

Practice the ones I have mentioned and then invent some of your own. The more you experiment, the more tools you will have when you need them. If you haven't already developed your own unique style, it will come with practice and determination. □

sandpaper edges

If you have edges of foam that seem too hard edged and trying to soften them with a wet sponge only muddies them, try using a little sandpaper. The paint and paper must be very dry and sandpaper works better on rough paper than smooth. I use a medium grit and gently move it back and forth over the area that needs attention.

chapter 2

painting on location

The secret of painting a subject that won't stand still is to focus on one thing at a time — then do some quick thumbnail sketches, make some value studies and take color notes. Working this way will make you feel warm all over. Here's how it's done.

Painting on location has been one of the joys of my life. It is like going fishing or collecting, or treasure hunting. There is the anticipation of fun and the high hopes of finding what you seek. For the artist, it is finding something new, something untried, perhaps it is a challenge, but it is definitely something exciting. After 40 years of painting the sea I can still find something different, some nuance of light or form that I had not picked up before and, of course, that special feeling of being there.

I must make one thing clear from the beginning: I do not go out to paint a masterpiece! I go out to gather useful information, to find something exciting, and to have fun.

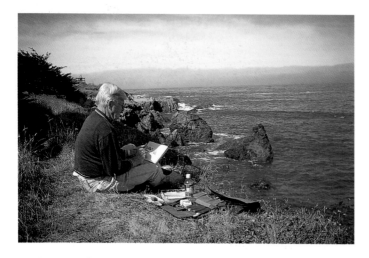

I always approach painting on location in the same way, no matter what. You'll see how I do it on these pages. Jumping in to paint before making a few preliminaries is a recipe for frustration and disaster. Be calm, make your sketches, visualize what you want as a result, then you can happily start painting.

I learned many years ago that the pressure of having to "paint a keeper" is a sure way to take the fun out of painting — it is tension that works contrary to creativity. Therefore I urge you to paint on location for the same reasons I do, and work on that "masterpiece" after the age of 90 or something. No, I'm a long way from 90 and still haven't painted that "masterpiece". In fact, the more I paint, the older I get, the more I care less about a masterpiece.

learning to paint the sea

Painting the sea on location is not easy because the subject keeps moving. When I first began seascapes in about 1960 I realized I didn't know enough about the sea to understand what was happening and I needed more information. I took photos and that helped some, but I always seemed to miss the right moment. There were no helpful "how-to" books then but I studied some oceanographic articles and learned the anatomy of the waves, (see chapter 9) and that helped even more. Finally I bought a movie camera (this was long before video cameras) and I took many reels. I was able to slow the projector and watch the action in slow motion, and this truly helped to improve my knowledge.

With the movie camera I learned the technique of looking for just one thing at a time. I would focus on a swell and follow it all the way through its rise to a breaker and then its collapse into the surf. Sometimes I would focus on just the roll-over, or the translucent corner, or the foam trails and patterns. Other times I would focus on water striking the rocks, the foam burst, the cascading and trickling over the sides of rocks, or the patterns left on the beach. Bit by bit I grew to understand enough so I could look at the action, take a mental picture, and sit down to paint it. All I needed was to look back frequently for details.

narrowing down the view is the first step

I'm sure you must be familiar with a viewfinder. Most artists simply put their hands together to form a window then turn from one angle to the next. Many use a small window cut out of some cardboard or other material that they can hold up.

Viewfinders are enormously helpful with a moving subject such as the sea because they frame out all but a small area and all of the extra confusion and action. Narrowing down the vast scene before you is the first step in composing on location. Look at the overall scene, then pick an area that has interesting action, then hold up your viewfinder to block out everything else. Study the area closely. It is still a moving subject but you can mentally choose just when the right moment is there. At that point, it is time to start your sketch. Make the sketch quickly and include that mental image of the right moment.

you CAN move things around

Sometimes you just cannot find the right scene even though there are plenty of subjects before you. A rock might look good but there's no action around it, or there's a beautiful wave and foam burst but the light is bad, and so on.

It is important to know that we can move things around. Who is to say that the rock was closer to the wave or the sunlight wasn't there at that moment in time? Who really cares? We must remember that we are not aim-and-shoot cameras taking snapshots or making postcards for tourists. We are there to capture the essence of that location. Of course we want the scene to look correct: the basic shape and colors of the water and the rocks are very important otherwise we might as well stay home. But we need not be literal. Here is just one example of how to move things around and still capture the scene.

composition results

In my color sketch I stayed reasonably close to how the big rock appeared as well as the background and the beach. This is important if you want to give it a known location title such as "Cape Arago Beach", but less important if the title is something like "Day at the Beach". The wave, however, was a different matter. I took a wave from elsewhere and moved it to where I wanted it. Who can say that very wave was never there in hundreds of millions of years? The point is: you are the director of the scene. You have the power to arrange and present the players in the best way you think fit.

drawing makes better painters

There is no way around it — you will need to be able to draw in order to be a better painter. You don't have to be a Rembrandt or a Leonardo da Vinci, but the ability to draw with skill will carry over in your painting. The pencil or the brush is an extension of your thoughts and your perception of the scene. The more you practice, the more skilled you will be. Therefore, making frequent drawings of waves, rocks, coastlines, or any subject you may wish to paint will make your work look much more skillful.

You can draw with any number of tools: pencils, either carbon or colored; chalks, crayons, conté colors, charcoal, or pen and inks. Whatever you choose, it should be a permanent member of your outdoor painting kit.

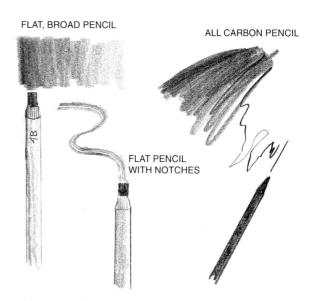

FLAT, BROAD PENCIL

ALL CARBON PENCIL

FLAT PENCIL WITH NOTCHES

sketching pencils

I am particularly fond of soft, carbon pencils, especially those that can lay down a broad swath as shown here. The flat, broad pencil can also lay down values from light to dark depending on how much pressure you use. Carbon pencils come in different degrees of softness: the softer the carbon, the darker the value, the harder the carbon the lighter the value. Notice that you can also nick some lines into the carbon and achieve a striated line. I use this technique for texturing rocks, for piling, old boards, or twisted tree limbs.

The all-carbon pencil not only gives a broad stroke but it can also give a better fine line than the broad pencil. The all-carbon has no wood so it may be finely sharpened or even shaped if you choose.

LEARN TO SEE VALUES

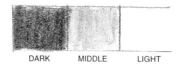

DARK MIDDLE LIGHT

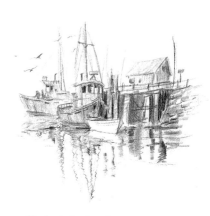

pencil sketch: harbor

This is a pencil sketch from a harbor in New England. It is a vignette, which means I have left out surrounding details and focused on a small area. Because the paper is white, all I did was to lay in a few dark values and the rest in middle values. If I were to make this into a painting, I would have to punch up the dark values a bit more, but the sketch does serve as a good reminder of the location.

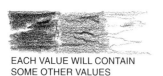

EACH VALUE WILL CONTAIN SOME OTHER VALUES

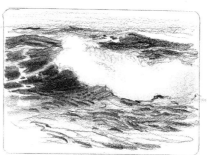

drawing with values

Another good reason to draw a lot is because it teaches you to see values as well as color. We tend to see only colors but in order to make better compositions it is extremely important to see values as well. All colors have values and when we compose a painting we need to first be aware of the values. Try to see in black and white or, better yet, look for dark, light, and in-between values. I collected a lot of black and white photos just for that reason. Here's how one of those photos became a simple value composition. Notice that each value may have other values within it but it still "reads" as dark, or light, or middle values.

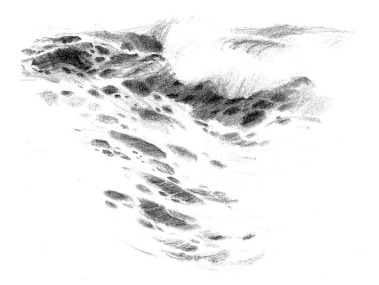

pencil sketch: wave

This sketch was done from a photograph I took years ago. I have again made it a vignette, leaving out superfluous details and capturing only the essence of the wave. The photo was in color so I had to see beyond that and copy the dark and middle values. It doesn't take much practice once you begin to look. In fact, if you laid in only shadows, dark against white paper, you would be thinking in terms of values instead of color.

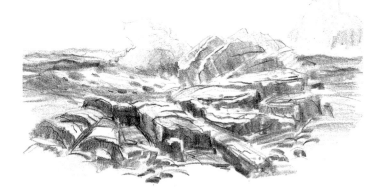

pencil sketch: rocks

Here is a good example of seeing values only. I sketched these rocks on location in the state of Maine. I first drew a very light outline of the shapes of these rocks and then went after shadows only. Shadows are strong in the foreground and fade into the atmosphere, so it was only a question of applying the right amount of pressure. If I were to transfer these rocks to a painting I could use any colors I wished, (within reason of course). As long as my colors retained the same values as the sketch there would be no doubt that they were rocks fading into the atmosphere. If I did not keep these values, I can guarantee it would be a confusing or monotonous composition at best. Values are more important than colors when composing a painting.

color sketching

I love the feeling of sitting on a rock, a bluff, or a sandy beach and sketching with watercolors. I used to brave all sorts of weather but I think I earned my bravery badge and no longer need to freeze, be rained on, or have sand blown into my palette. I remember painting in England under sodden skies and cold temperatures. I had to sit on a piece of plastic and every so often run to the car, turn on the engine and hold my watercolor to the heater vents to dry the paint before running back to lay in another area. I now choose more balmy days, wherever or whenever they may be.

I own several outdoor painting kits, including one I take backpacking in the mountains that is no larger than a paperback book. I like to keep extra weight to a bare minimum in those conditions.

I approach outdoor painting in two ways: I either take along a quick sketch kit for journals or information gathering, or a complete kit for either sketching or more serious painting. Quick sketches may be done on a block or watercolor notebook of various sizes up to 9 x 12". More serious painting, from 12 x 16" up to a 22 x 30" full sheet on a board, requires a more complete kit. For that, I like to use a full palette, a larger water tray, a better assortment of brushes and even a chair at times. I may also use an easel for my paper on a board.

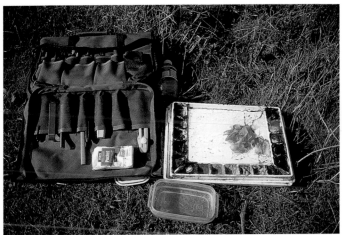

outdoor full kit

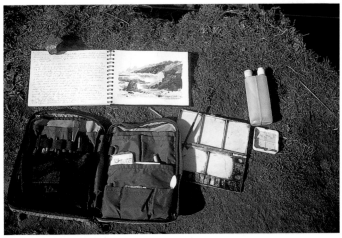

quick sketch kit

ON LOCATION DEMONSTRATION

QUICK LINEAR
THUMBNAIL SKETCH

QUICK VALUE SKETCH

COLOR SELECTION

preliminary work

I chose a site, studied it and decided to put together a set of rocks and a major wave. I first made a linear outline, then a value sketch to make sure I had a good arrangement, and then I decided the colors would be cadmium yellow medium, cerulean blue, ultramarine blue, viridian, a touch of cadmium red, and burnt sienna. Though the pencil sketch here is quite detailed, it is not necessary to do one before painting.

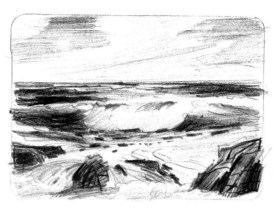

DETAILED PENCIL SKETCH

color sketching — quick or leisurely

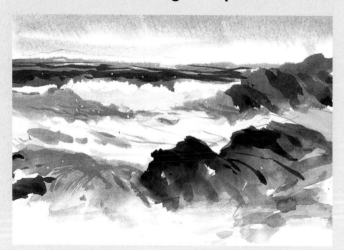

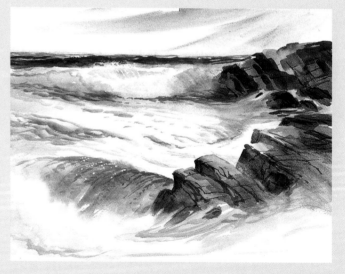

quick color sketch

This is a 10-minute sketch I did off the Oregon coast. I painted it on a smooth textured 8 x 10" block. It only took 10 minutes because I made a thumbnail sketch of lines and values and figured out ahead of time what colors I would use. It is a simple scene but it captures a moment and a certain spirit that no camera could ever catch. You will notice that the lines are loose and bold and that the only colors are cerulean, ultramarine, viridian, and burnt sienna. There are also few details and texturing but this is all I needed to jog my memories later.

leisurely color sketch

This is the same scene but I gave myself 20 minutes. This is also on a watercolor block but this time a textured 9 x 12". The colors are the same but the extra 10 minutes allowed me to be more creative, especially with the colors of the rocks. It also gave me time to texture the rocks with lines and forms. Truthfully, I'm inclined to like the quick sketch a bit more than the leisurely one because it is looser and freer. It captured the moment without as much information but seems more powerful for that very reason. Everyone has to decide just how much detail they want in their paintings and stick to it. I personally like quick sketches to be loose and bold but my more finished paintings to have more detail and better compositions. Even then, my paintings are a long, long, way from the photographic realism that some artists prefer. While I greatly admire their abilities, I personally don't have the patience to paint in that manner.

step one

I used my quick sketch kit and worked on a 9 x 12" watercolor block of light texture. I first transferred the outline to the block, not trying to be exact, but not too different from what I had planned. (If you have trouble transferring a tiny sketch to a larger page you might try making grid lines on each and then filling in the appropriate blocks.) Once the drawing was complete I wet the paper and quickly washed in cadmium yellow medium for the clouds and the surf area beneath the wave. I used only a #10 round sable. I should add that the block was tilted to allow the colors to run slightly.

step two

After the paper had dried, I re-wet it and applied cerulean for the sky around the clouds. I flattened the block so the blue wouldn't run into the yellow. I also washed in some cerulean to the shadow area of the foreground and added some cadmium red and more cadmium yellow to the clouds. This darkened the clouds in places and added warmth. Notice that most of the cloud edges are soft from being applied on wet paper. Hard edges at that distance would not look real.

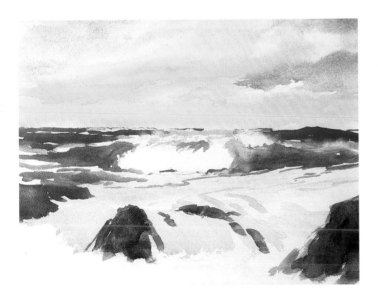

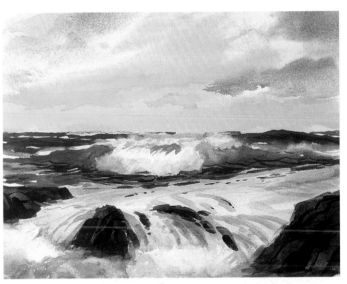

step three

Once the sky and some of the foreground shadows were in I could proceed with the rest of the painting. I painted the background sea with ultramarine blue and some cerulean to reflect the sky. Just behind the wave, I used viridian over the under-paint of yellow to suggest the feeling of light showing through. The main wave is viridian with less water at the top and ultramarine to darken it at the bottom. For the rocks, I mixed viridian and cadmium red, then charged it with burnt sienna. This was only an under-paint and I was still using the same brush. The details would come next.

step four

For the final details, and still using the #10 brush, I shadowed the wave foam with cerulean and a touch of cadmium red. I also darkened the surf under the wave with ultramarine and cadmium red. I used some of the same with a smaller brush, (#6 round) and applied it and some viridian to the water overflowing from the rocks.

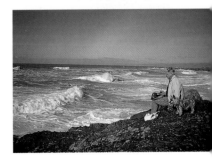

The final step was to add form and texture. I overlaid some darker versions of the underpaint with a ½" flat, then drew in some crack lines with the point of my #10 round. Because this was intended to be just a quick 10 or 15-minute sketch, I stopped before I added too much.

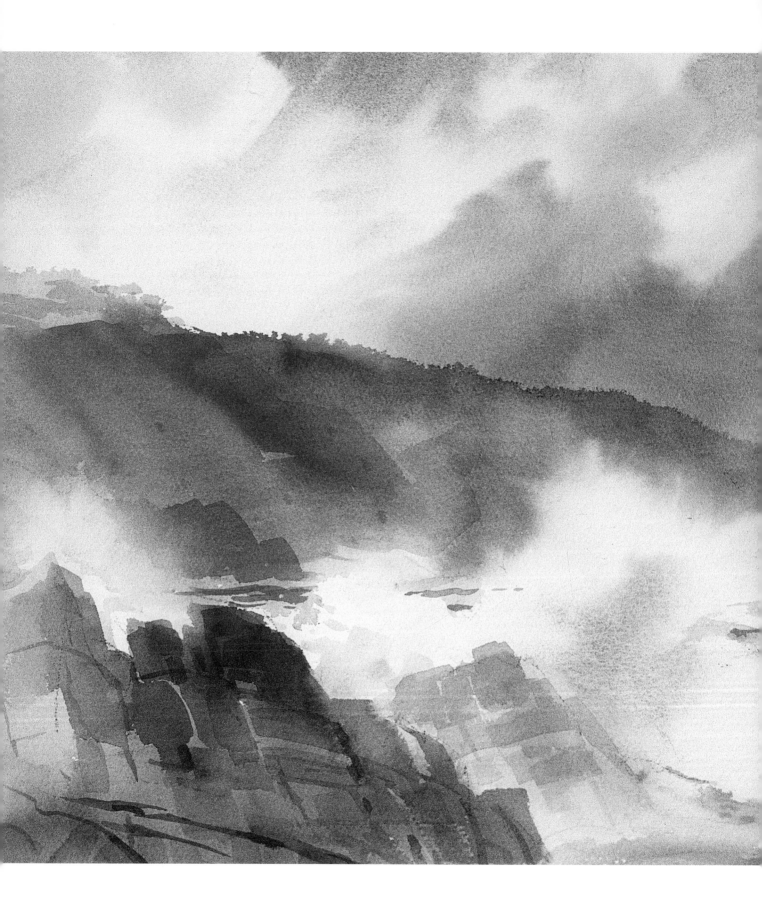

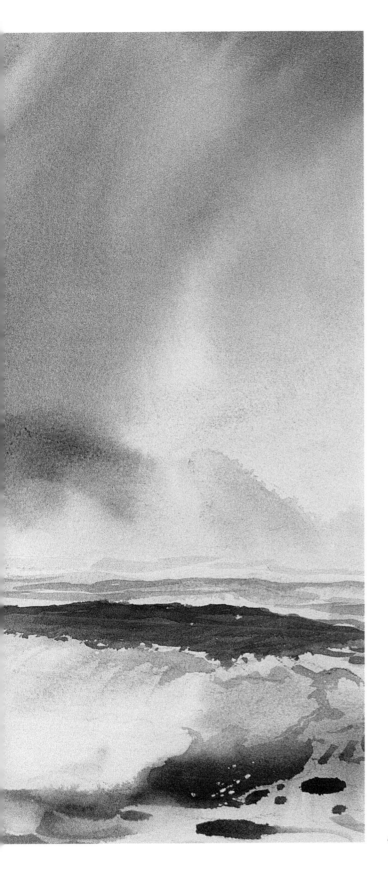

section 2

the elements

"Storm Light", 28 x 30" (71 x 76cm)

chapter 3

the importance of color

Color is very personal and eventually you will create your own palette, but heed this — colors straight from the tube are not the right ones. You must mix your own to create the subtle nuances of the sea. Then, learn to create color harmony by carefully using one dominant, one sub-dominant and a complementary color. I'll show you how in this colorful chapter.

For the most part, colors are very personal choices. We all have our favorite colors and color combinations and that is how it should be. When I compose a sea painting I always regard values as the number one priority, and then I slant the colors of the scene to my personal tastes. That does not mean I ignore the colors I see in front of me and just use anything I wish, it means I temper the colors to how I prefer to look at them. For example, the surf may have a lot of green which is similar to, but not exactly like, viridian. In that case, to make things easier, I may just use the viridian, because it is close enough, or I may want to show a warmer cast to the scene and add a touch of red to the viridian. The point is, I start with what is before me and alter it if I want to. I am not trying to improve on nature — I am trying to interpret the scene through my own personality, my likes and dislikes, and my slant on the world. If artists did not do this, all paintings would look the same, no matter who painted them.

When we paint in color, we are somewhat limited to what the manufacturers put in those little tubes. I once met a person who went to great lengths to collect hundreds of colors by different makers because one was correct for the

trunk of a walnut tree and another correct for the foliage, and so on. Believe me when I tell you that painting on site was a real chore for that person. Not only did they have to lug a lot of weight, they had to fumble around through it all searching for the exact colors for the scene. Apparently, they not only thought in terms of literal copying, but had never heard of mixing two or more colors to achieve a third one.

The colors of the sea

On the face of it there are not a lot of colors in the sea. It is mostly blue and green and the rocks are mostly brown, but there are endless nuances to all those colors, and all of them are influenced by sunlight and atmosphere. What that means for us is that we start with a few basic colors and then add to them. However, the one common factor that runs through all colors used for water is their transparency. Water is transparent and fortunately some colors are as well. Trying to paint a translucent wave with permanent green will not give the translucent results achieved by using viridian or phthalo.

Eventually, you will decide your own palette according to your preferences, but take a look at mine just the same.

palette

My palette is made up mostly of transparent colors with the exception of raw sienna and cadmium yellow deep. Even so these, and the rest of the palette, can be made more transparent by using more water and less pigment. Some opaque colors I do not use are: cobalt blue, permanent green, terre verte green, raw umber and burnt umber.

You will notice one really odd color on my palette called "opera". Well, folks, what can I say? It is a bit on the opaque side, is unlike anything in nature, and would look good on a clown. However, I find it a nifty color for enhancing other colors and, if used sparingly, it can warm the cockles of your heart. If you do not care for opera or cannot find it, either alizarin or cadmium red deep can be used in the same way. You will also see black included — another borderline color. I use it sparingly for subtle changes but never allow it to end up looking like black in a painting. In fact, this is how we should treat most colors on the palette. They are not there to be the absolute, end-all choices — they are there to be intermixed and have some influence each other.

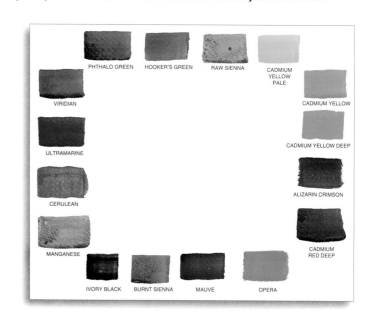

PHTHALO GREEN HOOKER'S GREEN RAW SIENNA CADMIUM YELLOW PALE

VIRIDIAN CADMIUM YELLOW

ULTRAMARINE CADMIUM YELLOW DEEP

CERULEAN ALIZARIN CRIMSON

MANGANESE CADMIUM RED DEEP

IVORY BLACK BURNT SIENNA MAUVE OPERA

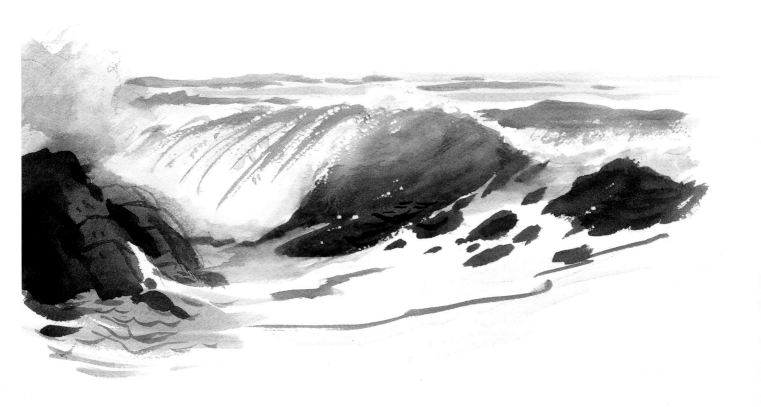

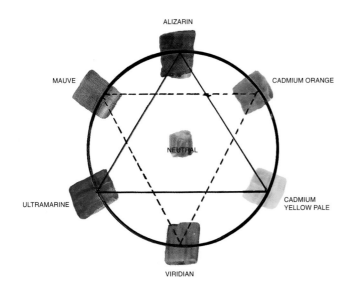

ALIZARIN

MAUVE

CADMIUM ORANGE

NEUTRAL

ULTRAMARINE

CADMIUM
YELLOW PALE

VIRIDIAN

primary and secondary colors
I'm sure most of you are familiar with the primary and
secondary colors but I must show them because I will
soon show how to use them in a different manner.
Primary colors — red, yellow, and blue — cannot be
mixed. Secondary colors — purple, orange, and green
— are called secondary colors because they can be
mixed from the primary colors. As you can see, mauve,
(purple) is the result of mixing red and blue, orange is
mixed from red and yellow, and green is mixed from
blue and yellow. Mixing any color with its complement,
the color directly opposite it across the color wheel,
will produce a neutral color.

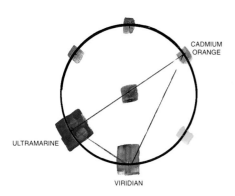

triads

A triad is any three colors on the color wheel. Most books refer to triads as every other one such as, red-yellow-blue, (primary), or purple-green-yellow, (secondary). I like to alter that by choosing two primaries, such as orange and blue, and one secondary, such as green. That way I can make one of them the dominant, most used color in the painting; another sub-dominant, used somewhat less; and a complement, used least but giving great strength to the triad. The sketch here shows blue as dominant, green as sub-dominant, and orange as the complement to blue. The result would be a blue painting with green to harmonize with the blue, and a shot of orange to highlight the others.

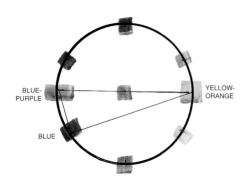

yellow-orange/blue-purple triad

This form of triad can be made up anywhere on the color wheel and it will always be in harmony. Let's look at another possibility: In the sketch here, the dominant color is yellow-orange, not a true primary color. Its complement becomes blue-purple, also not a true primary, but the third color of the triad is the primary color, blue. The blue harmonizes with the blue-purple because they are adjacent to each other. The yellow and orange mix are a combination of the complements to the blue-purple.

example: dominant blue triad

This is what I mean by a dominant blue triad. Overall, this is a blue painting. The next most used color is green, and the least used is orange. The orange, (burnt sienna) is subtle, but complements the blue. This is a very simple composition, both in subject and color, but the lesson is this: for good color harmony, have one dominant color, a sub-dominant color that is adjacent, or next to, the dominant color on the wheel, and a complement, which is opposite the dominant color on the wheel.

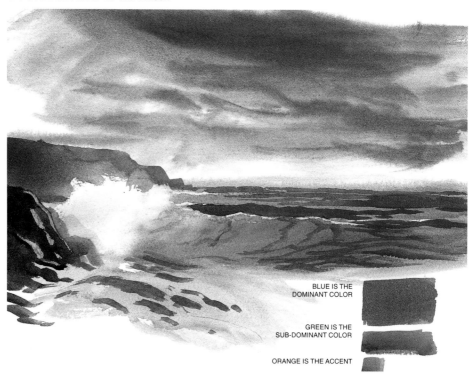

BLUE IS THE DOMINANT COLOR

GREEN IS THE SUB-DOMINANT COLOR

ORANGE IS THE ACCENT

example: dominant yellow-orange triad

The dominant color is yellow-orange because in this composition it is used more than other colors. The next used color is a pale blue-purple. In this case it is used as shadows and when mixed with the yellow-orange, produces a green. The least used is the primary color of blue which was used for the base color of the rock. The blue is not the complement of the yellow-orange but, because of its pureness, it demands attention and therefore must be used least — it has become the accent. The lesson here is that any three colors may be used in dominant, sub-dominant, and accent roles, but better color harmony can be achieved by having only one primary color against two secondary colors, or one secondary color against two primary colors. The "odd man out"— the single color against the other colors — makes the best accent color and is used least.

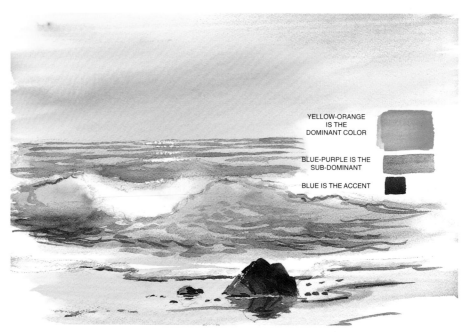

YELLOW-ORANGE IS THE DOMINANT COLOR

BLUE-PURPLE IS THE SUB-DOMINANT

BLUE IS THE ACCENT

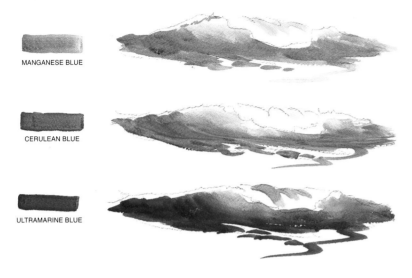

MANGANESE BLUE

CERULEAN BLUE

ULTRAMARINE BLUE

three blues for water

Of all the many blue colors available I chose three for my palette: manganese, cerulean, and ultramarine. Manganese is hard to find so when my last tube is gone I will use a similar one that is suitable. Cerulean is not quite as transparent but is still a good color for water. Ultramarine is very transparent and good for clear water but needs other colors with it to appear like water. I have never seen surf that intense. Of course, there are other transparent blue colors: prussian and phthalo for example. They are perfectly good colors for water but tend to be very strong and need to be mixed with something else.

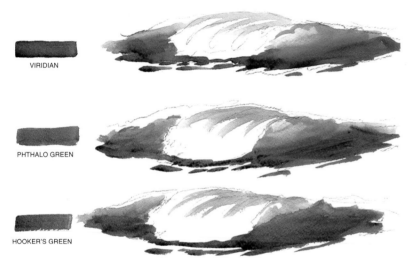

VIRIDIAN

PHTHALO GREEN

HOOKER'S GREEN

three greens for water

My three greens are viridian, a favorite of mine that suits my area of the world; phthalo and hooker's green. Understand that water changes color according to location and the colors of the ocean floor, the atmosphere, and the underwater rocks.

Phthalo green (Phthalocyanine) is very intense and I rarely use it straight. It needs either a lot of water to soften it or be mixed with other colors.

Hookers green has a lot of yellow in it and can be suitable in some areas. In any case, none of the blue or green colors I have on my palette should be used straight. They need others to make them look like real water.

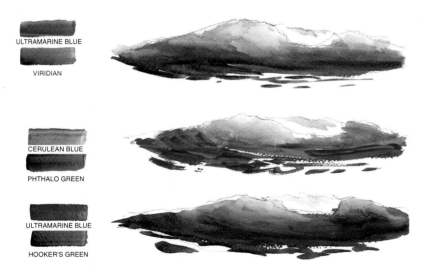

ULTRAMARINE BLUE

VIRIDIAN

CERULEAN BLUE

PHTHALO GREEN

ULTRAMARINE BLUE

HOOKER'S GREEN

combined colors for water

Any of the three blue colors can be mixed with any of the three green ones. This sketch shows the result of mixing ultramarine with viridian, cerulean with phthalo and ultramarine with hooker's green. These and any other combination you could make from mixing come much closer to the look of water than using the colors straight from the tube. Even these combinations may be enhanced by the addition of other colors as long as they don't overwhelm them.

charging colors

When you have a still wet area of color and drop in another color, it will blend and spread a bit. This is called "charging" and it is a great way to enhance colors. It takes away the sameness of flat washes and adds a touch of variety and interest. In this example I have shown the effects of dropping cerulean into cadmium red. This is far more interesting than if I had used all red. Just don't over charge colors to the point where the original is lost.

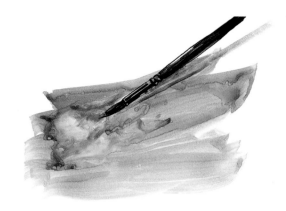

colors for charging

Here are only four examples of hundreds of possibilities. Each of the washes has been charged with two other colors and has been much enhanced by doing so. Of course, charging colors should relate to the subject you are painting. A green wave, for example, may look better with a touch of blue, or even a small amount of sienna or red, but too much of either would destroy the effect of the true color of the wave. Charge your colors carefully and you will improve them, but be moderate.

Looking at the ultramarine example, you may see why I like opera as a charging color. It looks great with nearly all the other colors as well.

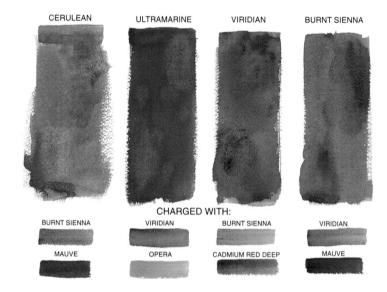

CERULEAN ULTRAMARINE VIRIDIAN BURNT SIENNA

CHARGED WITH:

BURNT SIENNA VIRIDIAN BURNT SIENNA VIRIDIAN

MAUVE OPERA CADMIUM RED DEEP MAUVE

overlaid lines

Lines and textures can ruin a painting because they do not harmonize with the base color. A sandy beach of light tan overlaid or charged with either very dark lines or some color such as bright blue that just doesn't relate is inharmonious. The same would be true of brown lines over a green wave. It is a jarring note that distracts the eye and takes away from the overall harmony of the composition. The best way to avoid that distraction is to keep the lines and texturing a slightly darker version of the base color: (sienna over sienna); or an adjacent color on the color wheel: green over blue, orange over yellow, and so on.

The same also may apply with charging colors, except you can get away with much more on rocks and beaches than you can with water.

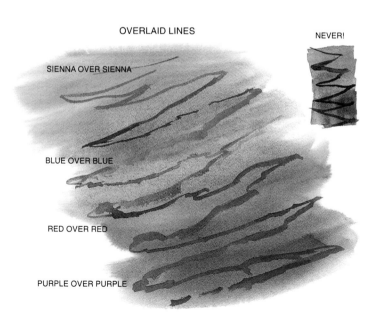

OVERLAID LINES

NEVER!

SIENNA OVER SIENNA

BLUE OVER BLUE

RED OVER RED

PURPLE OVER PURPLE

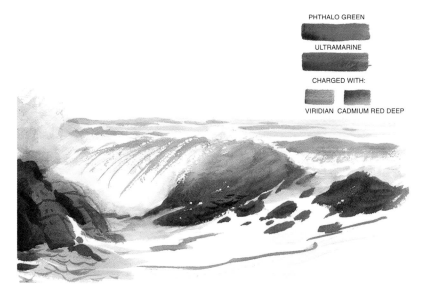

PHTHALO GREEN

ULTRAMARINE

CHARGED WITH:

VIRIDIAN CADMIUM RED DEEP

charging water

Adding charged colors to water must be done very sparingly. This is an example of about as far as you would want to go using red over blue-green. While it does add a touch of warmth to the coldness of the water, it also reflects the same color from the nearby rock. In fact, nearby rocks give a good reason to charge their colors into the water because the echo of that color relates the two subjects. You could also charge the rock with some of the green or blue of the wave, increasing the harmony.

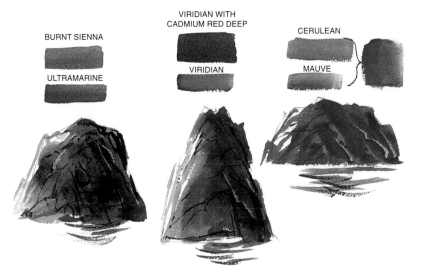

BURNT SIENNA

ULTRAMARINE

VIRIDIAN WITH
CADMIUM RED DEEP

VIRIDIAN

CERULEAN

MAUVE

charging rocks

Here are three different ways to charge the colors of rocks. In the first example, the base of the rock is burnt sienna and ultramarine was dropped in while the sienna was still wet. The process gave a shadow effect as well as breaking up what would be a flat color.

In the middle example the base color of the rock is a mixture of viridian and cadmium red deep. While it was still wet, more viridian, a base color, was dropped in.

In the third example cerulean and mauve were mixed for the base color and then charged with a darker version of both base colors.

There are endless possibilities for adding variety to the color of rocks. Doing so avoids the often seen flat, lifeless, brown, (or worse yet) umber or Payne's grey colors some people like to use.

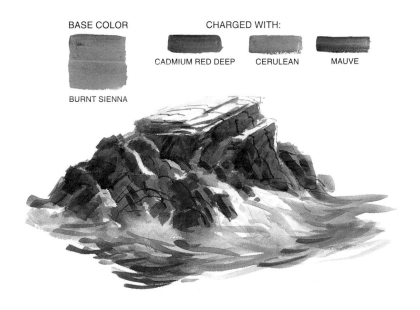

BASE COLOR

CHARGED WITH:

CADMIUM RED DEEP CERULEAN MAUVE

BURNT SIENNA

charged rock

I have given a base color of burnt sienna to this rock and while it was still wet, I charged it with cadmium red deep, cerulean, and mauve. You will notice that the darker colors were used to darken the shadow side of the rock and that I did not charge any dark colors into the light top — I merely added a watered-down sienna to give some base color. The rock is colorful but still "reads" as a brown rock. Notice also that the overlaid lines are just darker versions of the color beneath them

As a last word on the subject, may I repeat that color is very personal and you must create your own palette according to your tastes and the subjects you wish to paint. Just know that colors straight out of the tube are rarely the correct ones and that you can mix better ones. You can also add variety by charging and being subtle with overlaid lines and textures.

Experiment on scraps of paper with as many colors as you like. In a short time you will know which are the best, which ones complement or harmonize with each other and which ones can be charged to enhance the effect.

chapter 4

the importance of atmosphere

Nature is ever-changing, so sameness in painting is not something we can tolerate for very long. The one self-made rule I follow is to have at least some sunlight breaking through, even in foggy or stormy conditions. As I have said many times, a touch of sunlight is like a caress of love.

I cannot think of anything else that influences a painting more than atmosphere. One might think the sun is the most influential, and in some ways it is, but atmosphere even changes how the sun reaches us. The strata around the earth that is our atmosphere is made up mostly of particles of moisture along with some dust and, unfortunately, some pollutants. If there were no atmosphere, we would have no sunlight and it would be as black as outer space. Atmosphere breaks up the rays of sunlight into the spectrum we know as color and so in effect, they work together to present the world as we see it.

When we look at a view, we look through varying amounts of moisture in the air, (humidity). Humidity can be nearly non-existent, as in an arid desert, or it may be pea-soup fog so thick you cannot see beyond a few feet.

How much sunlight breaks through depends upon the thickness of the atmosphere. Humans tend to be more comfortable in warm, sunny atmospheres, places where light is abundant and the view is clear. However, if that was all we had, we would soon grow restless and wish for some clouds in the sky, and even rain. In other words, we truly enjoy variety, or change.

I enjoy all the seasons and try to bring a variety of atmospheres to my paintings. I would not want to paint everything under the same conditions anyway because I would be too limited in my expression and creativity. I certainly enjoy painting the sea in a clear, bright, atmosphere from time to time but I also enjoy everything else.

The one self-made rule I follow is to have at least some sunlight breaking through, even in foggy or stormy conditions. As I have said many times, a touch of sunlight is like a caress of love, and it is something I choose to be a part of all my paintings. Nature is ever-changing and sameness is not something we can tolerate for very long.

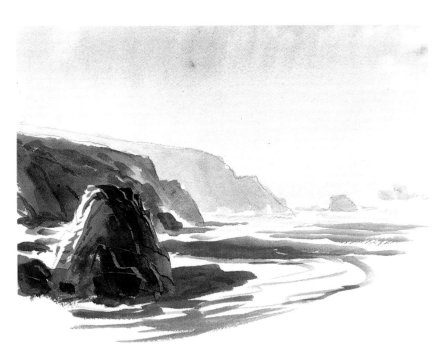

cool atmosphere
This is an example of a cool atmosphere with warm nearby objects. The sunlight is from behind the viewer and the atmosphere limits the visibility to a few hundred yards. Notice how the color of the rocks, the sea, and the headlands all fade into the distance.
I used cerulean blue for the sky-atmosphere and mixed it with the rock colors to give them aerial perspective. Eventually, the rocks became just cerulean but slightly darker than the background.

BLACK

FLAT

mixing grays
Thicker atmosphere carries color and color temperature and spreads it throughout the scene. Often the atmosphere appears to be gray, but what kind of gray? There are warm grays and cool grays and you must make a choice as to what you want in your particular composition. Here are three different ways to mix gray. The first one, above, is black and enough water to achieve whatever value you wish. It is flat; that is, it carries neither warm or cool temperature. It is also rather dull.

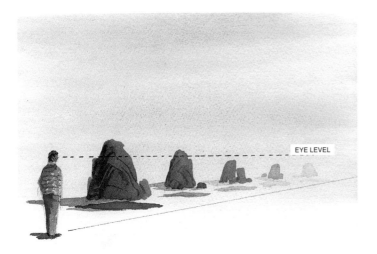

aerial perspective

Most lessons on perspective deal with the way objects appear to diminish as they become further away, and there are certain rules to follow regarding this.

Aerial perspective is about how objects diminish in visibility as they recede. In other words, their clarity is impeded by atmosphere.

Here you'll see a person looking at a series of rocks, from nearby to some distance away. Notice that the atmosphere is a pale blue and is somewhat thick. The nearest rock has a defined form with sharp edges, the color is apparent, and lines and textures are visible. All the rocks are the same color as the nearest one but as you can see, the farther away they get, the more they diminish, not only in size, but in visibility. The color gradually becomes the same as the atmosphere, and lines and textures disappear — even the cast shadows fade away.

The lesson is this: any nearby color will diminish because it takes up more and more of the color of the atmosphere. In other words, don't just add white to fade out colors. Instead, fade them with whatever is the color of the atmosphere.

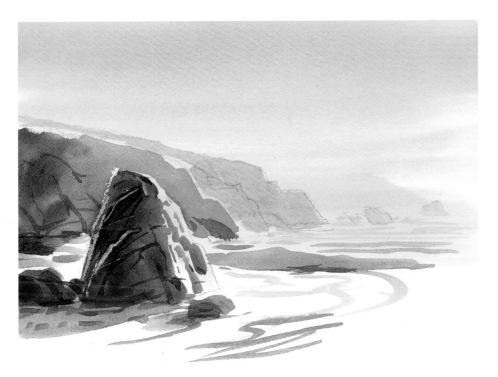

warm atmosphere

This is the same scene as shown in the cool atmosphere painting opposite, but the sun is near the horizon. The atmosphere is a warm, yellow-orange. Again, the nearby objects show their true colors and details, but the side facing the sun is influenced by the atmospheric condition. The headlands and the waves recede by having more and more of the atmospheric color than their true color.

These are just two of many ways to show warm and cool atmospheres. For example: the warm atmosphere could have been painted with the sun behind the viewer, and the cool atmosphere could have been painted with the sun at the horizon. It all depends on the conditions. Also, any number of colors could have been used, with any number of conditions, for the same results. The possibilities are endless.

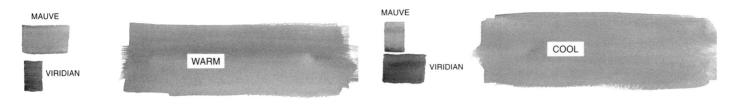

To mix either warm or cool grays you must use both warm and cool colors. In this example I have used viridian and mauve. Mixing more mauve than viridian produces a warm gray.

A cool gray is produced with more viridian than mauve. Again, the value is determined by the amount of water in the mixture. There are other ways to mix grays: complementary colors on the color wheel produce a neutral that can be either flat, warm, or cool; also, mixing other reds with other greens will work as well. The main thing is to avoid a muddy gray.

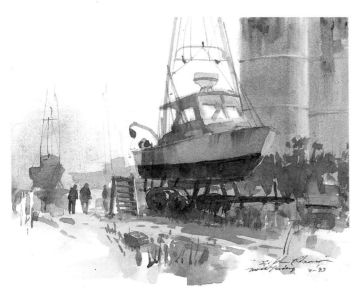

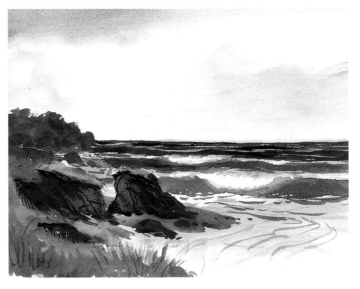

white atmosphere

Sometimes the sky is so full of moisture that the sun blends with it to make a canopy that just doesn't seem to have any color at all. It also doesn't appear to be either warm or cool. I call this a "white atmosphere". I have noticed this condition many times in the British Isles as well as along coastlines.

What I do is to leave the sky unpainted, or mostly white paper with a touch of blue sky here or there. I am then free to mix warm or cool colors for the subjects. I treat a white atmosphere as a fog or haze and therefore must choose how far to allow objects to be visible. A distant horizon line would not show up so don't have a white atmosphere with clear visibility very far out.

clear day

Before I go any further with atmospheric conditions I want to show a clear day for comparison. A clear day doesn't mean there aren't clouds in the sky or some atmospheric condition. It does mean that you can see the horizon line and the sea will probably be a dark blue that far out. It also means headlands and rocks don't fade away as quickly and detail will still be visible for quite a distance — depending on our eyesight, of course.

A clear atmosphere is more likely to be apparent during mid-day than either morning or evening. Mid-day sunlight also carries less color because of this. Morning and evening usually have more atmosphere and therefore break up the sun's rays to warmer colors.

rain

Rain is a part of our world and just as important as any other condition in our paintings. I use it much like the fog bank opposite. It may obscure or soften a hard horizon line and it may act like a stage curtain to keep the focus elsewhere.

Rain is achieved by first wetting the paper, then tilting the board so that all the strokes flow downward. You may slant them or not but they can flow even past the horizon line. When they are dry, you can go back and show faint swells, headlands, or any object along a coastline, but be sure to keep light values. The rain appears as an atmosphere which obscures or diminishes details and values.

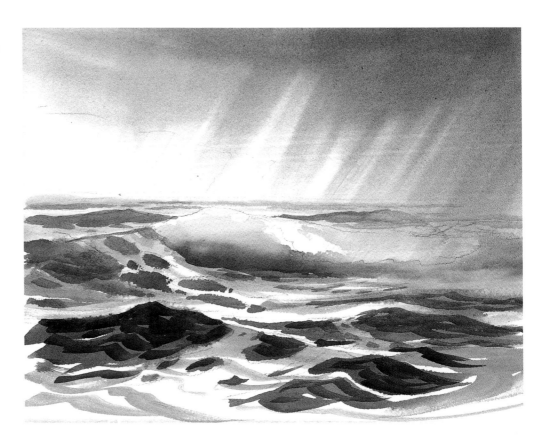

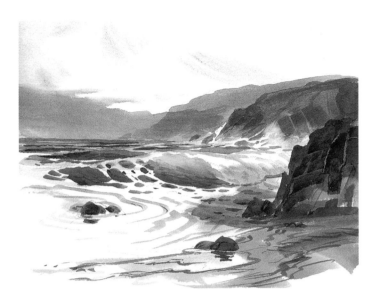

fog bank

A fog bank is a cloud at the horizon line that will probably move its way toward land. The atmosphere may be perfectly clear otherwise, and this fog bank can occur at any time of day. I particularly like to use a fog bank for two good reasons: first, it softens the otherwise hard line between the sea and the sky at the horizon line; and second, it acts like a stage curtain that protects the main action from distractions behind it. Fog banks can have a leading edge of whatever slant or shape you wish and can add either a warm or cool area to your composition.

incoming fog

As the fog moves in, the background becomes less visible and the sky can no longer be seen. You are now looking through a cloud. However, the foreground objects will still have their basic colors and details. If the sun is behind you, it will still influence the foreground objects before they too, become obscured by the fog.

I particularly enjoy this kind of atmosphere, especially if I am painting a coastline and not featuring the sea. Fog brings a mood of mystery with it. What is it we cannot see? What lies behind that rock or down the coast? Artists should be cautious about showing every detail from one side to the other and from here to miles out to sea. Leaving a little to the viewer's imagination is a very wise thing to do.

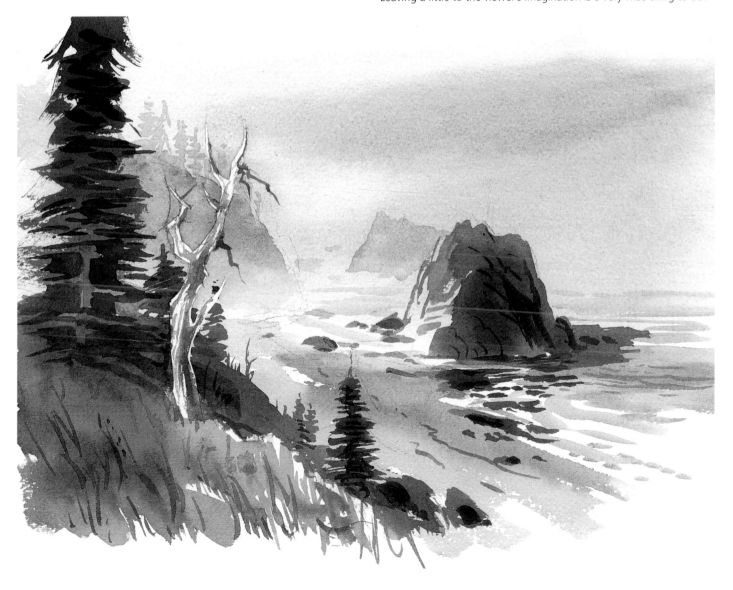

pea soup

When fog envelops everything, and visibility is limited to a few feet or few yards, it is like trying to look through pea soup. Frankly, I never paint a true pea soup. As I mentioned before, I choose to have at least a touch of sunlight in all of my paintings.

Here, I painted as if the sun were behind my back and allowed a bit to strike the rock and the foam burst. The foreground rocks are in shadow and nearly everything else fades very quickly. You will notice that the fog is warm — a mixture of mauve with only a touch of viridian. I prefer that to a cold, foggy atmosphere, but that is my choice again. Also notice how that touch of sunlight allows that one rock to show its true colors.

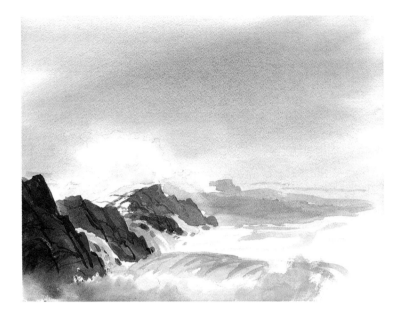

fog bowl

A fog bowl is a seldom seen phenomena. It requires the sun to be near the horizon and the atmosphere to be just right. It wouldn't happen with an atmosphere that was either too thin or too thick. Nevertheless, it is a way to diffuse the brightness of the sun and yet spotlight exactly what you wish to show as a focal point. All else fades away except for foreground objects and you may choose what to have and how much you want them to play their part in the scene. A fog bowl may either be warm or cool in temperature.

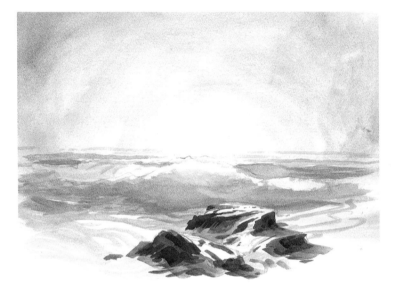

casting shadows

Clouds are part of the atmosphere and they can serve us well. I like to spotlight a focal point in some of my paintings and that means diminishing other objects around it. To do this on a clear day, I simply cast one or more cloud shadows wherever I want them.

In this sketch you can see that the foreground rock and wave are in sunlight but the background wave and the near headland are in shadow. This was my choice. I can always justify a shadow of this sort because there are clouds in the sky. Who is to say that cloud wasn't there? If I had left out the shadow, the background wave could well detract from the action I had chosen as a focal point

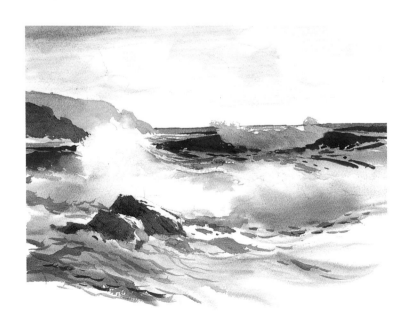

I must conclude with just a few thoughts: You have seen the importance of atmosphere as a way to give variety to your paintings. You have also seen that there are limitless conditions that can be applied and any of them will improve your technique. I cannot emphasize enough the importance of variety but it must be tempered with your own special likes and dislikes. If every one of your paintings is different you will not establish your individual technique or style. On the other hand, if you did not have variety there will be too much sameness, not enough change, and you and your viewers may grow bored.

Therefore, painting comes down to making choices. You may have noticed how many times I have said, "I choose to . . ." that is the approach. Again, we are not cameras and we are not making copies for postcards. We are artists. We must decide what we like in the way of colors, values, atmosphere, and even subjects, then choose our favorite ways to present them. We first perceive, then we express. We are expressing ourselves as much as the scene before us.

fog with sun glow

This is not quite the same as a fog glow because the visibility may be much better and you can see further out. I know there are good people, who live far inland, that cannot believe the sky and the sea can ever look like this but, perhaps, they have never seen it. Sometimes, a yellow-orange sun near the horizon will glow in a certain thickness of moisture and spread across the background. It becomes a condition where the sun and the atmosphere blend into one. The result is a yellow glow that influences everything, all the way to the foreground.

I paint this by wetting the paper and washing all of it with the yellow color I have chosen. I then lift out the area of the sun with a tissue or a sponge. I use a darker version of the wash for distant objects and add local color in the foreground. Even then, the light side of the rocks, for example, retains the color of the glow.

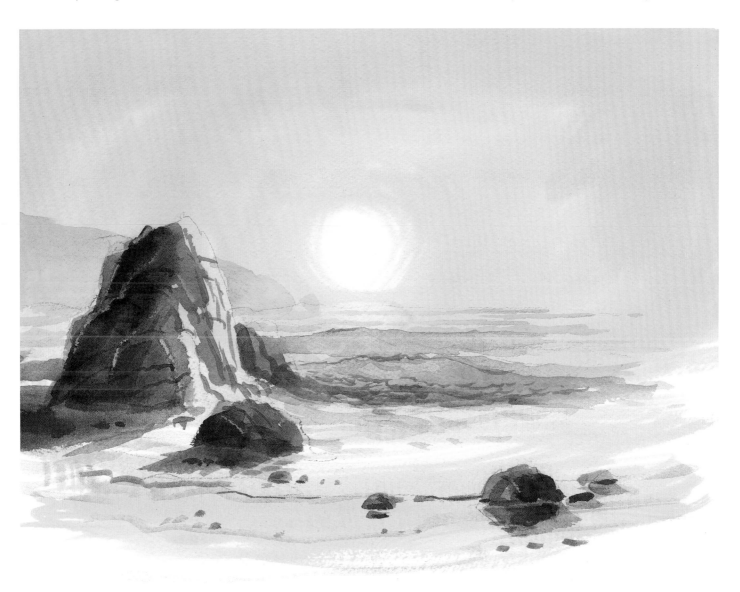

chapter 5

the importance of sunlight

The Impressionists discovered some exciting truths about the color of light and shadow at different times of the day. The secret is to avoid neutral or brownish colors for shadows and be careful not to overplay either the sunlight or shadow colors.

Without sunlight there would be no world as we know it. Very little can exist without it, for sunlight carries the energy required to sustain all living things. Even a day of overcast skies seems to lack something vital for our well being. But the energy carried by the sun is more than just light and warmth; it also effects how we feel and how we see the world around us. I see many paintings in which there is little sunlight and the result is that most of them lack warmth and vitality. Of course there are cloudy days and of course there are subjects that show well without much sunlight. It is just that I, as an artist and an individual with likes and dislikes, prefer the touch of the sun in my painting. To me, a touch of sunlight, even in a stormy or cloudy seascape, gives balance — it is like a caress of love in a less than bright day.

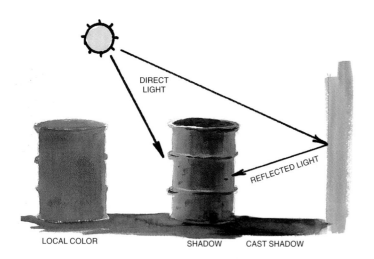

LOCAL COLOR SHADOW CAST SHADOW

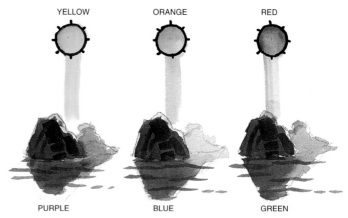

YELLOW ORANGE RED

PURPLE BLUE GREEN

the influence of sunlight on color

Everything has a local, or true, color. That is, it is red, green, or some other natural color regardless of outside influences. If you look at the barrel in the above illustration you will see that it has a local color that we call "rust". Under an overcast sky the barrel would show very little else than its local color but, if the sun comes out, it changes dramatically. The sun carries color of its own and in this case it is a pale yellow. So the first thing to notice is that the rust becomes partly pale yellow on the side facing the sun. The next thing to observe is that the opposite side of the barrel is in shadow but there is some reflected light that has bounced off of an object close by. The shadow is a light purple that mixes with the rust color.

You may also notice that the grass has changed. It too, has yellow mixed in on the sunny side and purple on the shadow side. Looking closer you will see an exchange of color between the grass and the barrel. A bit of green reflects back onto the barrel and a bit of rust has reflected back into the grass. The important note here is that even though the local color of rust on the barrel changed with the play of sunlight and shadow it still looks like a rusted barrel. In other words, the local color still dominates — it has not changed to another local color.

sunlight and shadow colors

The theory that sunlight carries color and influences all that it touches was not really put to use until the time of the French Impressionists. They theorized that the break up of light rays in the atmosphere and its effects were the true subject of their paintings. In other words, they were painting light no matter what it fell upon. Before that time outdoor scenes were mostly contrived in the studio and little attention was paid to variations in sunlight. Shadows were interpreted as brown.

The Impressionists studied light outdoors and found that shadows are very much related to the color of the sun. As shown above they believed that yellow light from the sun produces a purple shadow which is its complement on the color wheel. They then realized that an orange light would produce its complement of blue for shadows and that a reddish light would actually create a greenish shadow.

The lesson is very important: never use brown colors for shadows. Instead, determine the color of the sun and make the shadows the opposite color on the wheel. It is also important to note that both sunlight and shadows are transparent. You should be able to see forms, lines, and textures in shadows as well as where sunlight touches on something.

In the last chapter we explored the ways atmosphere can affect scenes and how making choices can bring vitality to a painting. The same applies to the use of sunlight.

Sunlight carries color and that in turn affects other colors, including those in the atmosphere. I know of an artist who only paints on overcast days because that is when colors are the truest. Though that is correct, it is also very limiting. Colors, may well be at their truest on overcast days, but they lack the vitality and beautiful variations that sunlight can give them. Sunlight also means shadows — and that represents a whole new spectrum of possibilities! The many variations of atmosphere, sunlight, shadows, and reflected light, are all there to enhance our paintings. Without them, our lives and our paintings would be very dull indeed.

warm sunlight

If you are on a west coast looking out to sea, the morning light, or light behind you can be quite warm. It can range from a deep yellow, to orange, and even to a reddish light. The sketch above shows just that sort of setting with a pale orange light. The pale orange shows up mostly on white objects such as clouds and white foam. The shadows are mostly blue but including some purple with them shows the influence of the yellow part of the orange light. Either blue or purple would be acceptable, but can you imagine how ugly a brown shadow would be?

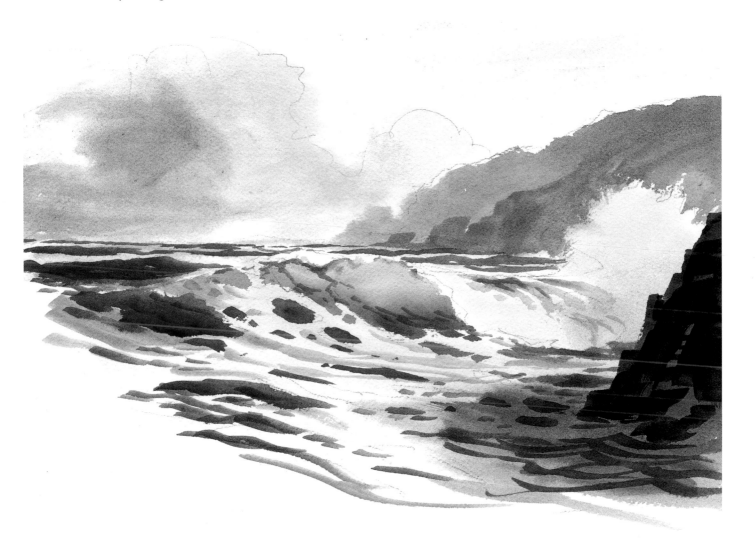

high noon light

The color of the sun is at its weakest at high noon. It may be brighter in some cases but there is less color than at other times. High noon light is down-lighting. Few shadows appear and they exist according to the atmosphere: heavy atmosphere results in weak shadows while a thin atmosphere produces quite dark shadows.

No matter what the atmosphere may be, the sun has little color however, it is better to assume it has a touch of yellow. In that way any shadow at noon would show some purple. Even though you may think the sunlight is nearly white, using its opposite would create black shadows and that is just not the way of nature.

I repeat — never use either brown or black for shadows.

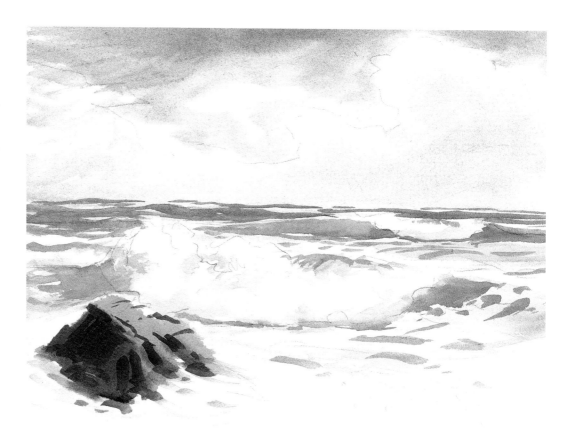

low horizon sunlight

When the sun is either rising or setting, depending upon which coast you are observing, the light can be very warm, even reddish. As mentioned before, reddish light creates greenish shadows. That may sound strange but in theory is correct. There aren't many shadows in the sketch opposite, but green is used both for the shadow side of the near wave and some shadow on the rocks. The sky in this illustration also suggests a touch of orange so it is not a pure red light. Therefore, it is perfectly acceptable to have a blue shadow.

Here is the point: the color theories of the Impressionists are quite right and we should avoid neutral or brownish colors for shadows, but we must also be careful not to overplay either the sunlight or shadow colors. Avoid the "all blue" shadows that many artists seem to use. Instead, you might start with blue and either make it warmer for a cool, yellow light, or cooler for a warmer light.

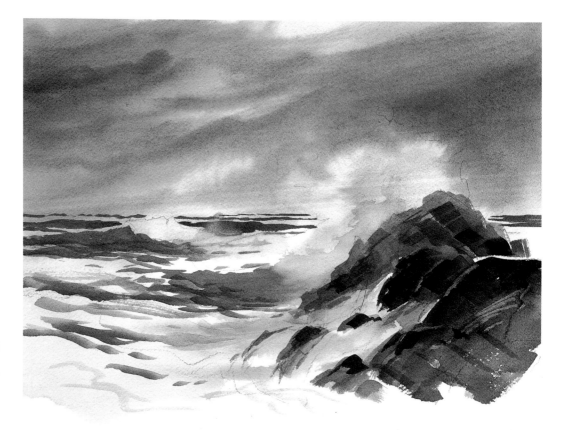

practice steps

I believe this would be a good time to show how to paint an overall yellowish sun and atmosphere effect. In this instance this applies to any combination where the color of the sun spreads through a moisture-filled atmosphere.

step one

This method can be used for any subject. First, draw in a scene, either the sea, or a harbor, or shoreline. Tilt the board so the paper is on a slant, then wet the paper with a sponge or large brush. Now you may choose a color for the sunlight. I have chose cadmium yellow medium and quickly applied it to the wet paper with a 1" wide brush. I used horizontal strokes and let the color run, but you may notice the upper area of the sky has more color than the rest. That is the source of the sunlight and I want it to be stronger.

step two

This step defines all the objects merely by applying a darker wash of the same color you started with. In my case, after the first wash had dried, I reached for the cadmium yellow medium again but this time I used less water so it was naturally darker. Then it is just a matter of painting that value of color over all the shadow areas. The effect is light and shadow but using the same color.

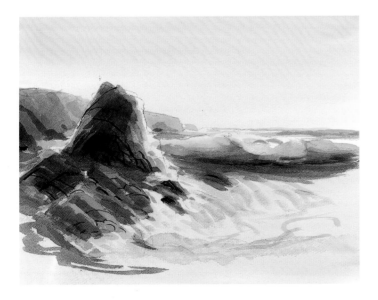

step three

When the second wash is dry, start adding color and details with smaller brushes. Use a purple wash for the shadow side of the waves and rocks because it is the complement of the yellow. Also add a touch of green for foreground water to show that the yellow sunlight didn't spread that far.

This is a very quick procedure but is applicable to any number of scenes, color schemes, and atmospheres. Think in terms of washes, or glazes if you prefer. Start with the color of the light. Let it influence all the objects including the shadows. Finally add more color and details in the foreground.

bright light

We have seen how sunlight may carry different colors according to the time of day and the atmosphere. Now let's look at the position of the sun and at the same time look at bright light. Sometimes the sunlight appears white, especially at high noon or in a heavy atmosphere. It is alright to simply allow all sunlit objects to just be the white of the paper. That doesn't mean the shadows will be black though. It is still better to use a variation of blue and purple which will suggest to the eye that there is color in the sunlight.

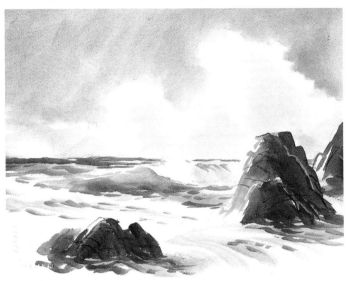

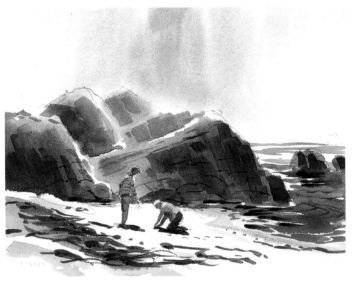

side lighting

Here is an example of bright light from the side. It touches one side of the clouds, the waves, and the rocks. Notice I have left those areas to be the white of the paper. The shadows on the other side of the objects are not black or brown. Instead, I used blues and purples; strongly in the foreground, and washed out in the background. The warm colors of the rocks and the warm shadows suggest a subtle warmth to the sunlight even though it is just white paper.

down lighting

When the sun is directly overhead and very bright, shadows will not be cast from objects but the vertical sides may appear shaded. Once again, I left the white of the paper to show where the sunlight touched the rocks, the sand, and a bit on the figures. The sides of the rocks are shadowed with blues and purples down to the sand. This contrast makes the sand appear very bright. So do the very dark purple shadows under the figures.

front lighting

Front lighting is probably the least interesting, as well as the most difficult to use, unless it is a warm, colored light. When bright, white light floods the scene from behind, everything appears flat and washed out. Also, shadows are lost unless there are objects from behind casting them into the picture area. Here I show how interest can still be achieved under bright, front lighting. There is interest in the wave because of contrast and the foam patterns. The foreground rocks have a warm color to contrast with the cool water, and there is a warm, cast shadow from rocks behind the viewer.

back lighting

Back lighting can be very dramatic. For one thing, it creates the most translucent waves, and it may also give a silver lining around clouds and highlight the tops of objects under the sun. Shadows may not be as strong as with down lighting or side lighting but, nevertheless, the shadows will be more visible than in front lighting. I have used bright light again for this example to show its effects. Usually, I would rather combine back lighting with warmer sunlight and shadows.

spot lighting

Spot lighting has always been a favorite of mine. I wish I had invented it but, alas, Rembrandt was the originator and master as well. Nevertheless, it is there for us to use and I use it quite a lot. Spot lighting happens when there are clouds in the sky and the sun streams through a hole of sorts and strikes a small area while most everything else is in shadow. This is one of the greatest tools because you may choose where you want the light to strike and it is always justifiable as long as the sky shows some clouds. This example shows that the effects can be quite dramatic. Here again, I used bright light but the warm shadows suggest a slightly warm sunlight even though the white area is just white paper.

casting shadows

I mentioned before the need to sometimes cast shadows from objects behind the viewer. This is especially true with front lighting. Here, the large bluff on the left casts a shadow across the breaking wave. If it was not there, the wave would be totally exposed to bright light and would be too flat. Because the shadows are blue and the bluff is a warm earth tone, there is a suggestion of a yellowish sunlight. The lesson here is: put shadows to work for you. They suggest a color for the unseen sunlight, they break up flatly lit areas, they can point to a center of interest, and they introduce a darker value wherever you need one.

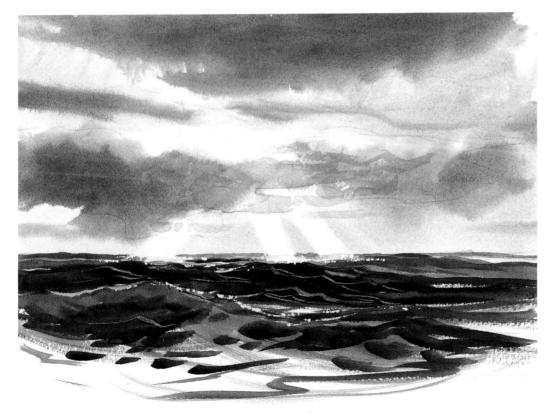

sun rays

The sun's rays are beams of light that stream through the clouds and spotlight the background sea. As long as you can keep them subtle then they are a nice addition to a painting

Let us not get too carried away with this phenomenon however. It is beautiful to look at, and may add a nice touch to a painting, but it can also be distracting. Nature provides us with too many beautiful things to be put into one painting. We must choose carefully and remember not to distract the attention from the intended focal point.

composition for balance and harmony

In a play, a "scene stealer" is someone or something that distracts from the focus of attention. In a painting it is anything that takes the attention away from the center of interest. Make sure no lesser member of the cast steals the scene.

A painting is more than just a recording of a scene. It is also a way to convey a message or a mood. In order to do this in the best possible way requires a well thought out and well arranged composition. There are unlimited ways to arrange the elements in a painting but only a few will be the best way to express what you want the viewer to receive.

I like to think of these arrangements as if I were directing a stage play. A drama is made up of a star with supporting actors and various props. Sometimes the action is done with more than one, but they work together in one area or center of interest. If there are two or more separate stars, or areas of action, the scene is confusing and lacks harmony. In a drama, a "scene stealer" is someone or something that distracts from the focus of attention. In a painting it is anything that takes the attention away from the center of interest. If we compose our paintings with this in mind, we can avoid cluttered, hard-to-read compositions and will be able to convey our message or a mood to the viewer.

Stage plays are made up of people and various props. Paintings may feature any number of subjects and there is nothing wrong with the sea as a backdrop, but this book is about FEATURING the sea. A seascape is made up of air, water, and earth and they are influenced by the sun and atmosphere. Somewhere in the composition something must attract the eye, and it must be supported by other features. I have painted over 4000 seascapes in my long career and most have had either a wave, a corner of a wave, or a wave-rock combination as the center of interest. One might think that meant few possibilities but the opposite is true.

Seascapes are first made up of the elements: sky, water, and earth which are influenced by sunlight and atmosphere Second: the forms of each of the elements — types of skies, waves, rocks, and foam. Putting them all together means limitless possibilities for compositions.

Of all the paintings I have done, I can truthfully say that each one was different from the others. Many looked similar but each had its own unique touches. I might add that I have had to destroy a good many for various reasons but not because they were a copy of another.

Anything you paint will carry a mood even if you are not aware of it. I truly believe that if an artist is in a bad mood, his painting will unconsciously reflect it, probably with somber colors or subject. Conversely, an artist in a happy frame of mind may unconsciously convey that mood, more than likely using warm colors and a happier subject. We humans may have many moods that can be reflected in paintings and you can consciously reflect them in your work if you wish. You already learned in chapter 5 that color may carry a mood, and now you will become aware of how line and value may do the same. With this in mind you can compose for mood as well as good balance and design in your painting. If you choose, you can paint seascapes that are either happy, sad, angry, lonely, somber, menacing — or one of many other moods.

outline

Most people believe drawing means outlining all of the objects. In other words, drawing all the outer edges of each object. While this is a valuable tool and useful for sketching-in the basic structures, there is much more to drawing than just the outline. Outlines do not show lines within an object, what I refer to as interior lines, nor do they indicate any movement — what I call the "spirit line".

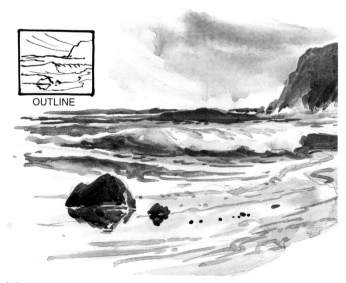

OUTLINE

spirit lines

A spirit line is not a physical line but rather an implied one, a line that is drawn to make the eye follow in chosen directions. In classical paintings, implied lines were considered extremely important. Certain objects or arrangements which became symbols can have a profound influence on the subconscious of the viewer. For example: a religious scene may arrange a group of figures in such a way that they form the shape of a gothic arch, like those in church windows; or it might show a figure gazing at something heavenward encouraging the viewer to look up to see what it was. Classical symbolism is rarely used today but we can use the principal ideas to enhance our paintings.

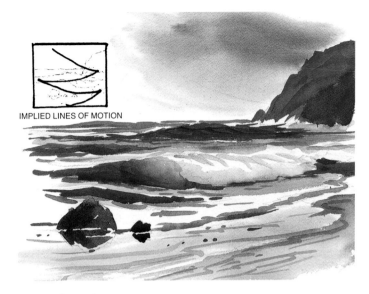

IMPLIED LINES OF MOTION

lines of motion

If you look beyond the realism this scene has gentle lines of movement. Notice that the slope of the brushstrokes in the sky slant toward the bluff on the right. From there the eye follows back along the waves, then down to the foreground rock and back up the edge of the scud foam. At this point the beach is prominent and the eye is led back to the left. Of course the eye could be led around the painting from the foreground backward as well. In either case there is a feeling of some motion in a rather static composition.

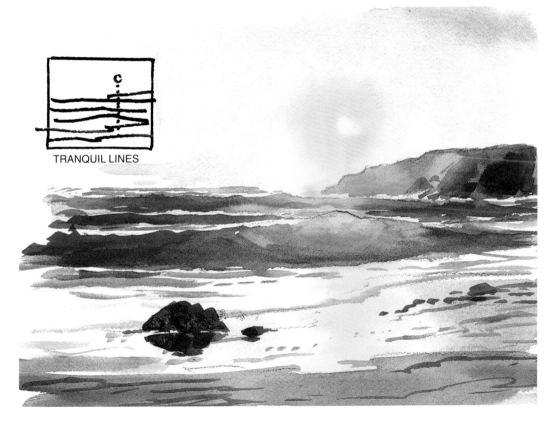

TRANQUIL LINES

tranquil lines

Sometimes you may want a composition that is really static or has very little motion to create a restful scene. You achieve this by keeping all the implied lines in a horizontal position. A horizontal line is symbolic of lying down, being at ease, and suggests the feeling of repose.

You may notice here that all the horizontal lines are offset by the implied vertical line of the sun's reflections. Always have some minor way of opposing the major theme for good balance. Nature never repeats itself without an opposite.

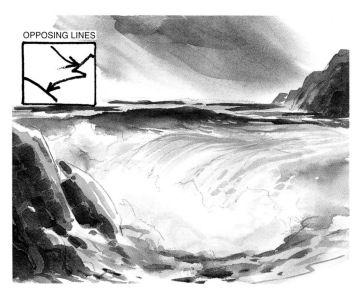

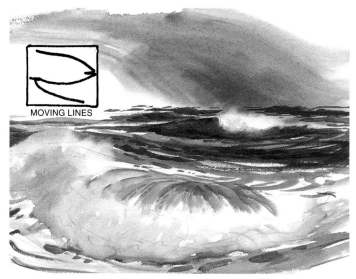

opposing lines

The opposite of tranquil repose is conflict. Here, the lines crash against each other as if they were fighting. The implied lines of the sky bump into the opposing lines of the bluffs and then the eye is led rather quickly along the crashing wave which is about to slam into the rock. The lines of the rock are in exact opposition to the lines of the wave. You may think such a mood is anything but harmonious but harmony doesn't necessarily mean everything at peace. Harmony in nature means the natural order of things whether it is a stormy conflict or a quiet paradise.

moving lines

This example is much like the top picture on page 45, but here there is a touch of opposition with the moving lines. The sky forms an arc as it flows to the sea, then the implied line of the sea forms an opposite curve as well as an opposite direction. The curve of the wave is the same as the curve in the background sea, therefore the sea shows motion separate from that in the sky. The mood here suggests that a storm may be approaching and the sky is transferring strong energy that may stir up the water. The lesson is: whenever you have one element, such as the sky, in opposition to all the other elements, the sea and the land, you have created a conflict between one and the others. This treatment could be transferred to any of the elements in a painting.

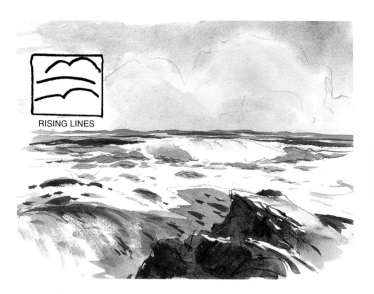

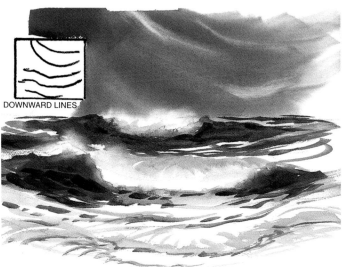

rising lines

Notice the implied lines here. The position of the foreground rocks, their shadows, and the water on the left describe an upward arc. Behind that, the incoming wave describes a more gentle, but rising arc, and finally, the rising clouds form an even stronger arc. Upward arcs such as these suggest a rising or uplifting mood. It is an ideal symbol for a morning scene. The day has just begun and watching the sea as the sun rises to light it suggests a new beginning and new expectations. It is a happy theme and warm colors and light values can only enhance it.

downward lines

The opposite of rising lines and the uplifting feeling are downward lines. These lines suggest a downturn, moodiness and, possibly, sadness. There may be times when you may want such a theme but be aware of their meaning. If you look back at some of your work and notice downward lines it may show that you were sad or depressed and included them without even realizing it. The message here is: be aware of the power of suggestion with any implied lines!

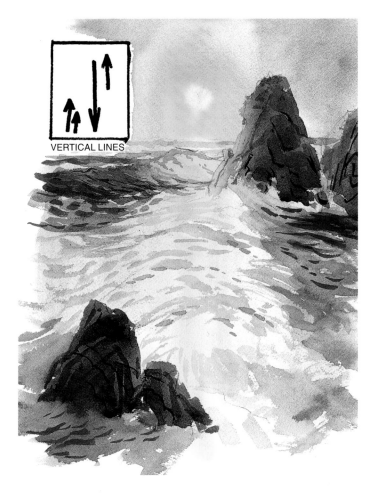

VERTICAL LINES

"Harmony doesn't necessarily mean everything at peace. It means the natural order of things, whether it is a stormy conflict or a quiet paradise."

vertical lines

Sometimes you may want to paint in a vertical format. When you do, the composition is better if it includes more implied vertical lines than horizontal ones. I have seen vertical format paintings with continuous horizontal lines and they are repetitive and look like a horizontal scene that has been squeezed into a vertical one. Whereas, in this example, the rocks are all more vertical than horizontal, the surf is an upward arc and the reflection of the sun implies a vertical line. The background sea and single wave give balance to the theme by running in the opposite direction.

diminishing lines

When you look straight out to sea, perspective dictates that the waves appear smaller and smaller as they recede. Atmospheric perspective, or aerial perspective, causes things to fade in color and value as well, but there is little perspective to a wave when it's seen face on and close up. It's only when you turn to look up or down the coastline that diminishing perspective plays a role. Notice here that the vanishing point is out of the picture frame and the eye level is the same as the horizon line. The nearer waves are slanted along the diminishing lines but the background waves gradually straighten up to a level line at the horizon. Therefore, make sure a slanted wave in the foreground does not have a diminishing line that is different to all the others. Of course there are times when a wave may seem very tilted but be aware that it may cause a perspective problem.

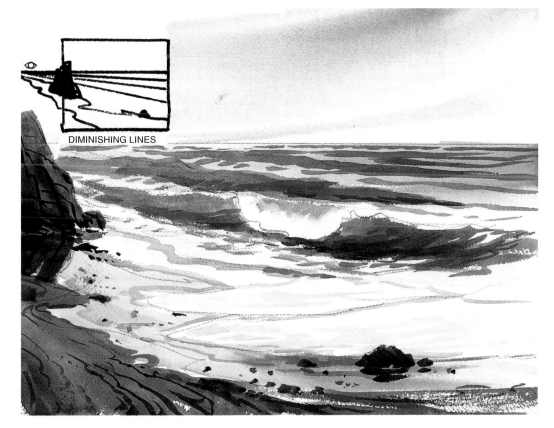

DIMINISHING LINES

values

I am sure you know that values refer to the lightness or darkness of colors. Most of the art books I have read refer to a value scale of 1 to 10, with white being the first, and black the last one. All the others are graded in between. I have no argument with this but have always taught that it is much easier to compose with values if you work with only three: light, middle, and dark. The other values will fall into place when you begin painting. If I had to work up a composition being careful to use all 10 values, I would never get to the painting at all. As you will see, using three values with three areas of space on the paper, will give six good combinations for balance and harmony.

Keep in mind that values also carry mood. Dark values, especially in the sky, can be depressing or they may simply carry a message of a coming storm. Light values tend to carry a lighter mood and can convey happiness, peace, and space. Combine the values, make one dominant with the others as sub-dominant for the mood you wish to convey.

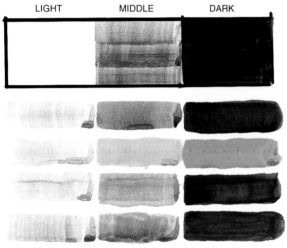

ALL COLORS HAVE VALUES — SOME ARE NOT FULLY DARK

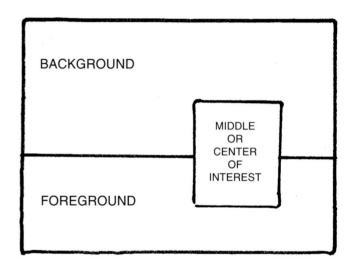

three values

As I mentioned earlier, colors carry values. Here are a few colors broken down into three values. You will notice that only the yellow does not have a dark enough value to represent the darkest patch. Obviously, yellow would not be the darkest value in most paintings anyway. The main thing is that all colors have values and can be used to match the light, middle and dark colors you have chosen for your composition. I might add that I, and most other artists, consider values to be more important than colors when it comes to composition. True, everything is important, but if the values are not right, the colors will not say what you want them to say.

space divisions

To make the arrangement of objects easier, think of only three major areas on the page: a background, a foreground, and a middle ground, or a center of interest. All the other areas will fall into place later.

It should be noted that either the background or the foreground can be the dominant feature but the center of interest must take up less than 50 per cent of the area and would be more effective if smaller than that.

dominant and sub-dominant divisions

Notice how the rock stands out because of contrast and therefore serves as both the center of interest and the middle ground.

In the upper left version, the background takes up more space than the foreground and is therefore dominant.

The middle example reverses the space and makes the foreground dominant in area, with the background sub-dominant.

The lower right example shows the two areas as being too equal and therefore less interesting. It would have been even worse if the rock was moved to center stage!

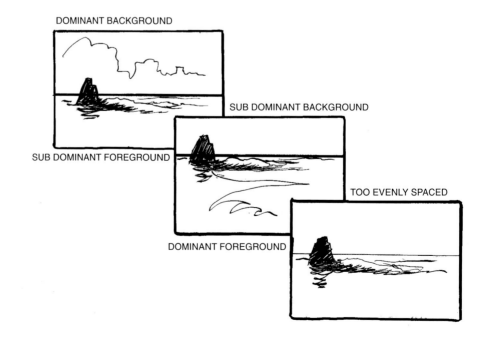

**MIDDLE VALUE BACKGROUND
LIGHT VALUE FOREGROUND**

**DARK VALUE BACKGROUND
LIGHT VALUE FOREGROUND**

**MIDDLE VALUE BACKGROUND
DARK VALUE FOREGROUND**

DARK FOCAL POINT

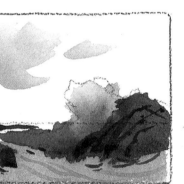

MIDDLE VALUE FOCAL POINT

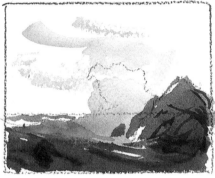

LIGHT FOCAL POINT

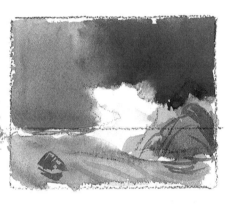

**LIGHT VALUE BACKGROUND
MIDDLE VALUE FOREGROUND**

**LIGHT VALUE BACKGROUND
DARK VALUE FOREGROUND**

**DARK VALUE BACKGROUND
MIDDLE VALUE FOREGROUND**

six combinations

Here's what happens when you combine three values with three space divisions. In each case the wave against the rock is the center of interest and also represents the middle ground. When the focal point is of a dark value, the other two areas will be either a light value or a middle value. When the focal point is a middle value, the background and foreground may either be light or dark. When the focal point is light in value, the other two areas will be either middle or dark in value.

You will notice that the dark focal point has no trouble showing up against the light and middle values. The same is true with the light focal point against the middle and dark values. Only the middle value focal point struggles to be noticed. The rock becomes more visible than the water. The lesson is that placing the lightest light value against the darkest dark value creates contrast. Contrast always demands attention which is ideal for a center of interest. However, a middle value focal point can still demand the attention if it has more interest, either as a change of subject, more detail, or a color change. (Turn to the example on page 50)

"I consider values to be more important than colors when it comes to composition. True, everything is important, but if the values are not right, the colors will not say what you want them to say."

focal points

The center of interest, or the focal point, reads better if it is kept away from the center of the page or the outer edges of the composition.

A good way to find the right spot is to divide the paper into thirds, both horizontally and vertically. Wherever the lines cross will be the ideal place to put the center of interest.

You may then choose a right or left position, which makes one side dominant in size with the other side being sub-dominant.

You may also select an upper or lower quadrant for the focal point. This will determine that either the foreground or background will be dominant against the sub-dominant.

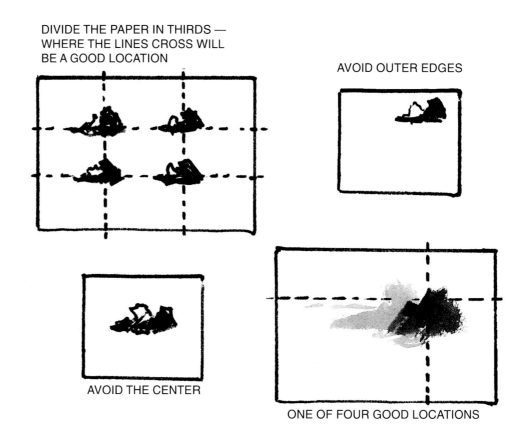

DIVIDE THE PAPER IN THIRDS — WHERE THE LINES CROSS WILL BE A GOOD LOCATION

AVOID OUTER EDGES

AVOID THE CENTER

ONE OF FOUR GOOD LOCATIONS

ways to focus attention

I have already mentioned this but here are some examples that guarantee a center of interest.

CONTRAST is the most obvious way, as long as it is the only place with the lightest light against the darkest dark. Of course there may be other dark and light values in the composition but none should be next to each other or they may become scene stealers. Changing to a strong use of another COLOR will also call attention to a focal point. That color may also be used elsewhere but not as strongly as here. This is a good approach when the center of interest doesn't have enough contrast to make it show up. Again, if there is not enough contrast, a good way to assure attention is to add more DETAIL to the center of interest than elsewhere. Remember, there should be more detail in the focal area anyway because that is the way we view things.

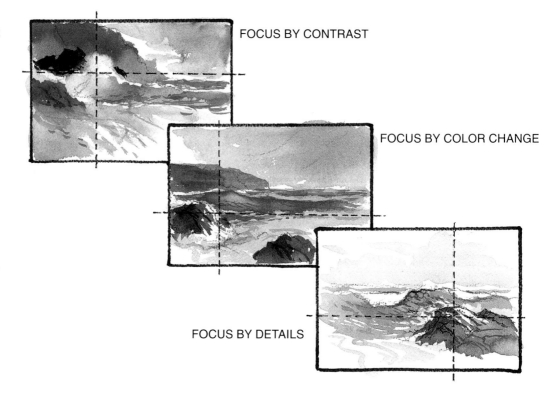

FOCUS BY CONTRAST

FOCUS BY COLOR CHANGE

FOCUS BY DETAILS

LEAD-IN WITH SHADOWS

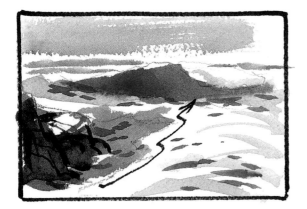

LEAD-IN WITH ROCKS

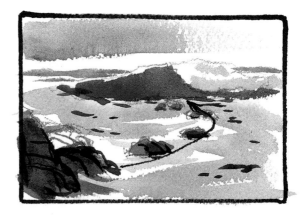

LEAD-IN WITH PATTERNS

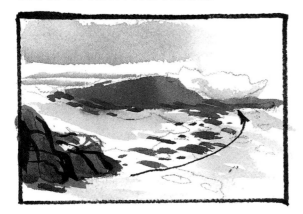

LEAD-IN WITH REFLECTIONS

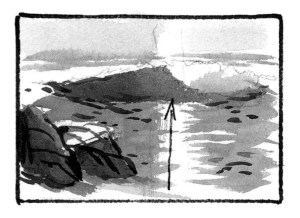

leading the eye

An old trick in composition is to lead the viewer's eye to the center of interest. Here are four ways to do this: Projecting shadows can be placed to draw a line of sorts that the eye will follow; a series of rocks or anything that is in keeping with the scene can lead the eye like stepping stones; foam patterns, either a trail or a linear path, will lead the eye and, finally, a path of sunlight can do the same.

These are just some methods of composing and there are many more, but if you only use a few of them your compositions will be much improved over the average painting. Just remember, your moods will be transferred to your paintings even when you are not aware of it, but if you wish to add a mood, you may do so with a careful choice of lines, values, and colors. Then you will have painted more than just a copy of a scene. When you create something that has a message, besides being nice to look at, you give the painting a life of its own. It will live on, quietly conveying your feelings to all who may look upon it. That is real artistry!

"When you create something that has a message, besides being nice to look at, you give the painting a life of its own. It will live on, quietly conveying your feelings to all who may look upon it. That is real artistry!"

water as a reflecting surface

All the reflection examples in this chapter will make your paintings more authentic. Reflections also help to bring harmony to your work because they repeat light and colors throughout the composition. Let's get started.

The most important truth for painting the sea is the knowledge that reflections are everything! Clear water by itself has no color and no light. Therefore when we look at it, we see it because of its reflections. The sea takes its colors from the sky, from rocks and bluffs and even from the ocean floor. Those colors would not be there without light so the color of the sea is dependent upon the sun or the moon. As pointed out in chapter five, colors change throughout the day and night and therefore will influence the reflections.

To understand this concept is to be aware of the harmony that happens due to these laws of nature. We are painting the elements of land, sea and sky and each has an influence on the other. If we forget this and fail to include even a simple reflection, we have taken something away from the harmony of our painting. Too often I have seen a painting of a bright sunset with none of the sunset colors reflected on the sea, or a brilliant white foam burst with no reflection on the clear water below. We must keep in mind that each of the elements has an influence and a changing effect on the others.

Reflections appear to behave in different ways but there is no great mystery and this chapter should clear up any problems you may have had. Just keep in mind, "Reflections are everything!"

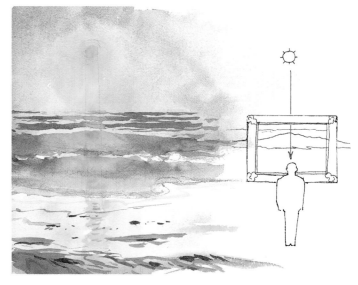

light path — straight view (above)
When we look straight out at the sun over the horizon, the path of light reflects in a straight line to the viewer. Think of it as if you are looking at it through a picture frame. You will notice that all the waves are parallel with the frame. Also notice that the sky colors reflect downward to the viewer as well. The waves allow the light and color through where they are thinnest but show their darker colors where thick. The trough area, the space between the waves, reflects the changing sky. The concept here is: reflections always come in a straight line from the reflecting object to the viewer's eyes.

light path — angled view (right)
The reason I made this illustration is to correct a common mistake I have seen in a number of paintings: an incorrect path of light. This happens where the path of light angles off to a corner because the view is from an angle. When you look at the sea from an angle, either up the beach or down the beach you must remember that the path of light is still a straight line to the viewer. The frame is not parallel to the waves but that doesn't mean the reflection follows the waves. It still comes to the viewer. A path of light that goes somewhere else leaves the viewer out of the picture. Notice how the colors also follow downward to the viewer.

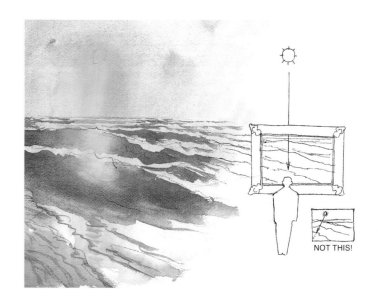

NOT THIS!

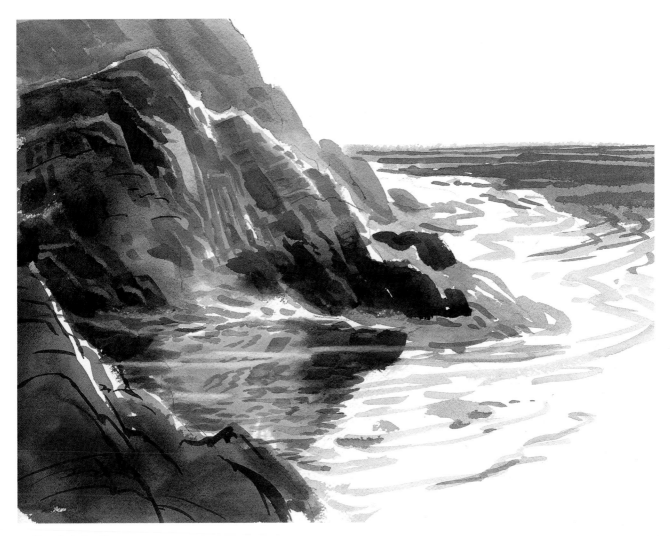

reflecting bluffs

Sometimes bluffs are very colorful and it is nice to include them along with their reflections. This is also true of some rocks. I sometimes get tired of painting the same blue-green seascapes and the inclusion of a nice, warm color is very gratifying. In this illustration there can be no doubt about the center of interest, however. It would be very hard to make a wave or a foam burst the "star" when the bluffs are this colorful. Frankly, they are a bit too colorful to be acceptable and a little moderation would have been better. Nevertheless, I wanted to make an important point: there are ways to bring warm colors to a cool painting and reflect them as well.

All of the examples in this chapter can be used in many different ways and any one of them will enhance the credibility of the scene. Reflections also help to bring harmony to your paintings by repeating light and colors throughout the composition.

mirror images

Looking at this example you might think that the leaning pole doesn't reflect to the viewer, but it does. You can draw a straight, vertical line from the top of the pole to the bottom of the reflection. The point here is: don't paint a vertical object and have its reflection go off on an angle.

There is another important rule here: In smooth water, where the reflection is mirror-like, the reflection is equal to the distance between the top and the base of the object. Always measure the length of the object then equal the length from the base to the end of the reflection.

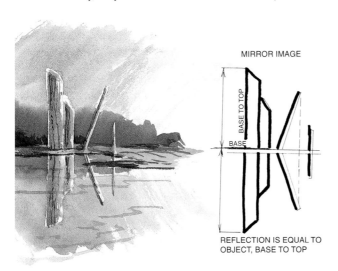

MIRROR IMAGE

BASE TO TOP

BASE

REFLECTION IS EQUAL TO
OBJECT, BASE TO TOP

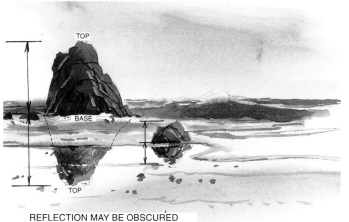

REFLECTION MAY BE OBSCURED
FROM BASE OF OBJECT DOWNWARD

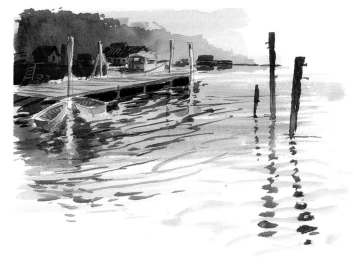

reflection obscured

This sketch shows there is an area of foam and water in front of the large rock. I reflected the rock from its base downward equal to the rock's height. If I had painted the full reflection starting from the bottom of the foam and water, I would have made another common mistake. The lesson is: always start from the base and reflect downward, no matter what may cover the reflected area. Notice there is only a small interruption in the reflection of the small rock but the reflection is equal to the object from the base downward.

extended reflections

All rules have their exceptions and here is one regarding mirror images: Sometimes reflections appear longer than the object. This happens when water is disturbed. Rippled water breaks up a reflection and each little hump of water becomes another mirror. This causes the reflection to be repeated over and over, However, the reflection still draws a straight line to the viewer. Repeated reflections may also appear to be larger than the object. Remember, moving water reflects differently than still water.

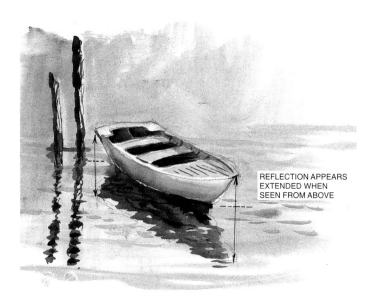

REFLECTION APPEARS
EXTENDED WHEN
SEEN FROM ABOVE

extended reflections from above

If you are standing above an object, the reflection will appear longer than the object. That is because your eye level has changed and you are seeing more of the object than you would at water level. Look at this boat — you can actually see some of the underside of the boat in the reflection even though it is obscured from your viewpoint. Notice also that the reflection is straight down and meets the outer limits of the object at those margins.

broken reflections

This illustration shows two more effects of rippled water.

1. A gull has just broken the surface and created mini waves that circle outward. Ripples created by the gull, or anything else that breaks the surface, interrupt the mirror image and allows the sky to be reflected where the bluff should be. The sky reflections show in the circular ripples.
2. The reflection of the bluff is broken up by ripples. The broken edge of the bluff's reflection is an interchange of values. Because of the ripples, there are a few sky reflections in the bluff area and a few bluff reflections in the sky area. Again, this is due to moving water but shows the reflected edge as scattered rather than a hard edge as it would be in a mirror image.

bounced light and color

Sunlight falls on all objects that face it, therefore one side will be lit and the rest will be in shadow. What is often left out is bounced light, which is also a reflected light. Bounced light is reflected back from an object and lights up another one nearby. It also bounces the color which may be a combination of the sunlight color and the color of the object.

Here, the light strikes both rocks. The rock on the right reflects the warm tones of the sun onto the center rock.Now the center rock has a light side, a reflected side, and a shadow in-between. Not only is this correct, it also gives a three-dimensional effect rather than just a two-sided one.

Keep in mind that this principle can be used elsewhere — wave color to rocks and rock color to waves, to name just two.

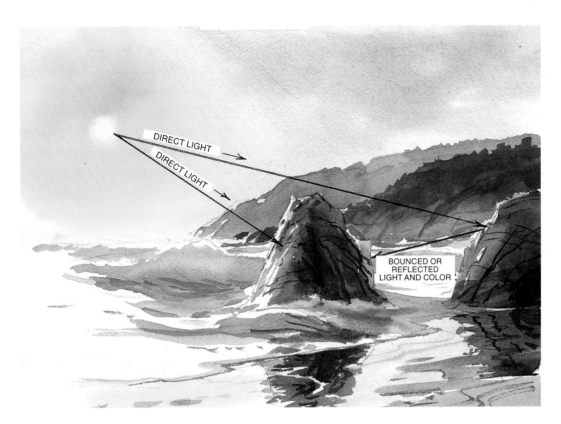

light bounce

This example also shows reflected light but in this case it is light bouncing from white foam to nearby objects.

Here we see the sunlight striking white foam and bouncing to the dark bluff. The bluff is visibly made lighter because of this reflection. It should be mentioned that the wetter the bluff the more it will be lightened by reflected light. Very wet rocks will also receive color as well. In other words, the blues and greens of the surf may be reflected.

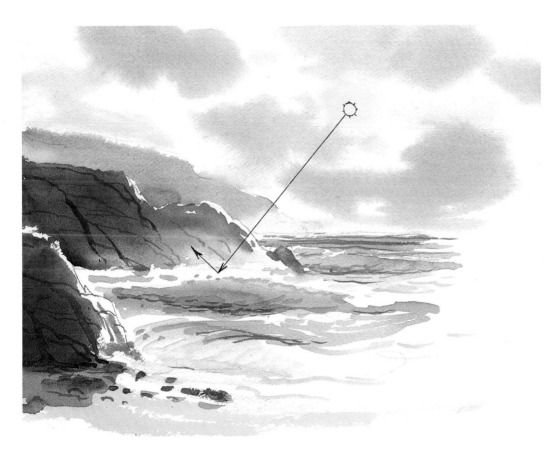

55

reflected wave foam

I mentioned this type of reflection at the beginning of this chapter. Here, the white foam of a breaker is reflected downward to the clear water below. This is again something many people leave out of their paintings, yet it is very important.

The reflection is hardly ever as brilliant as the actual foam but it lightens the water considerably. If the foam was in shadow, then the shadow color would be reflected. In this example the foam faces the sun so little shadow is visible.

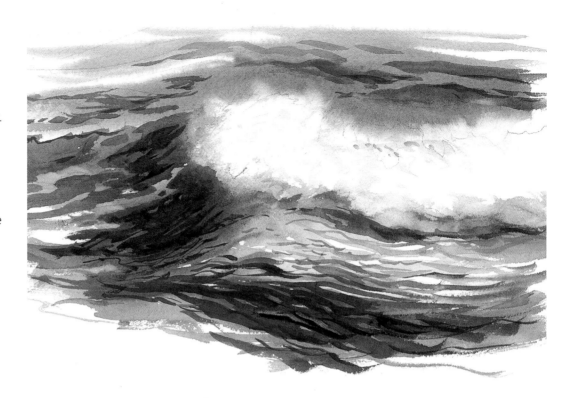

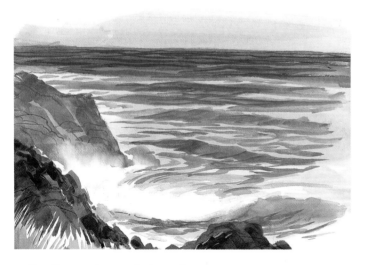

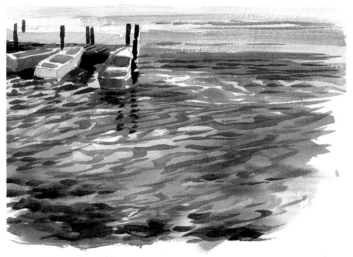

reflecting water and sky colors

If the water is already a color due to reflections from beneath the surface, then there will be a combination of both its color and the color of the sky. You can't see this unless you are standing on a bluff or well above the water. Here, you can see that the water is a green color but it is green mixed with the pale blue of the sky. The trough area is mostly sky color. I did this by first painting the sky color over everything except the wave foam and the foreground rocks. I then painted the green over the blue as a thin glaze and the result was a mixture of sky and water color. You will notice that the background sea is darker blue. That is because the deeper water adds darkness to the sky color and because there are no reflections of color from below the surface.

shallow water reflections

This is an example of very shallow water. In this case it is low tide in a bay, but it could be a shallow area of surf as well. The water must be clear. It may have some ripples but the ripples will most likely reflect the sky. What I do is paint the color of the water almost as if I were painting the floor with dark and light areas and with spots of color that might be seaweed or rocks. I then go over it with swirls and ripples the color of the sky overhead. As the water becomes deeper, there will be less underwater color and more sky reflections.

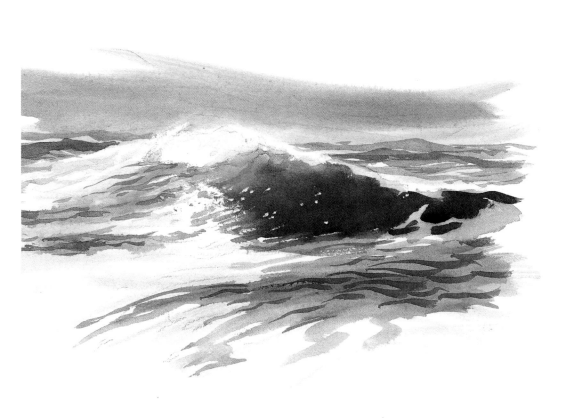

sparkle

I believe photographers call these glints of sunlight "spectral highlights". In any case, they are tiny reflections, the "sparkling diamonds" on the face of a clear-water wave. They appear because of a ripple on the surface that acts like a mirror, bouncing the light from the wave to our eyes. They add a nice touch to any painting but remember, they can only appear if the wave is facing the sun. Also, be sure to use only a few sparkles and keep them in tight little groups. You may dot them in with a mastic or a white crayon before painting the wave. Or you could wait as I do and nick them in with a knifepoint when the paint is dry.

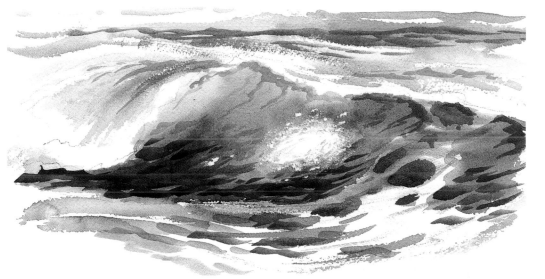

glare

Glare also requires a clear-water wave that faces the sun but, in this case, the whole sun is mirrored back to our eyes. We can only achieve about ten per cent of the brightness of the sun with paint, but we can give the illusion that it is so bright that it obscures the surface behind it. The area of glare touches the wave in a fleeting moment because the water is moving but at some point it reflects back to the viewer's eyes.

Notice in this illustration that the center is pure white with only a few light dots of wave color at the edges. This is enhanced somewhat by a bit of sparkle surrounding the area of glare. I sometimes do this to help make a center of interest more interesting.

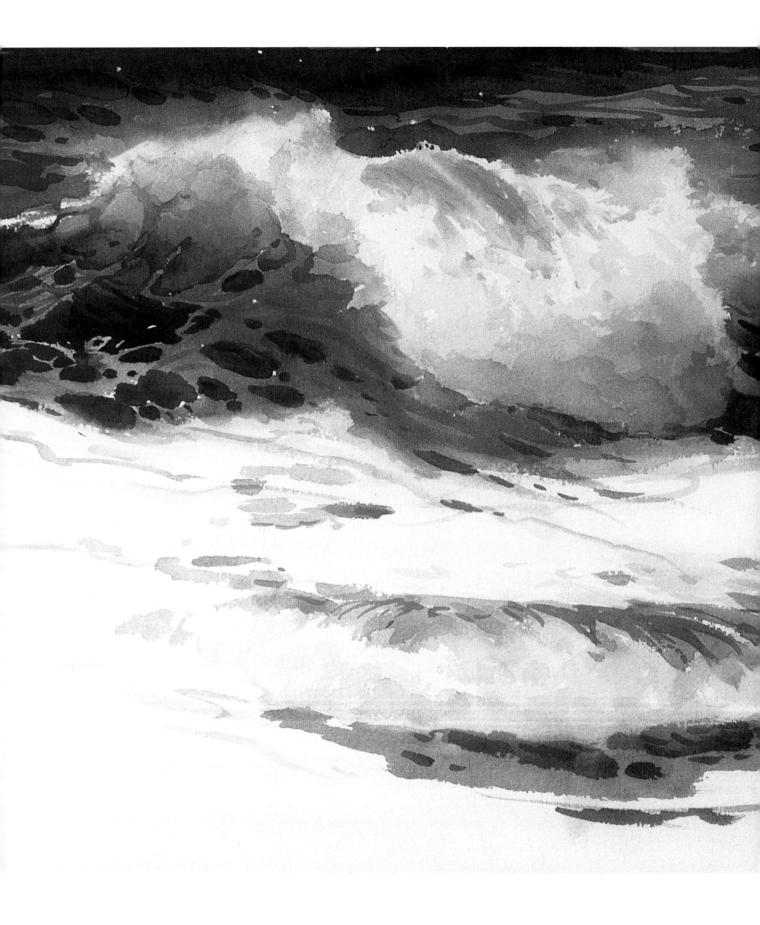

section 3

the forms

"The Big Green"

chapter 8

skies

All the whys and wherefores of painting skies, clouds, fog and how they can be combined with color and light to turn ordinary seascapes into stunning ones.

The sky is an integral part of a seascape because it has so much influence on everything else. It will set the mood: quietness, activity, stormy, calm or moving, to name a few. The sky also influences the sea and land through its atmosphere and color, as shown in chapters 3 and 4. Even if the painting doesn't show the sky, its influence will be felt. That is why I generally start a painting with the sky and/or its reflective qualities.

Don't guess when you are painting skies. Go out and study them. Study the clouds: their shapes, color, motion, and shadow lines. Feel the influence of their moods, see how the sky casts shadows on the sea, how the sun influences their color, and how there is a sense of freedom when we look to the sky. All the elements: the sky, the sea, and the earth, are in harmony and we have to be aware and able to carry that harmony through to our paintings.

The following illustrations are just a few possibilities. When you combine mood with sky color, atmosphere, and the position and color of the sun, again, there are infinite possibilities. There is no need to repeat the same sky over and over in your paintings. There are times when a painting just doesn't need the drama of an interesting sky and in that case a few strokes of color and motion will be enough. You must decide for yourself and then proceed.

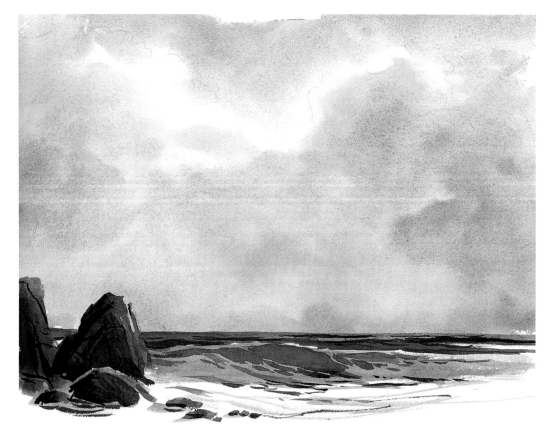

cloud glow
When clouds are not thick with moisture and have thin areas, sunlight from behind them may create a glow. This may also create warm colors which can show through. I suggest this effect by first painting the warm, background colors, then applying the cooler colors over them while the paint is still wet. It is a great opportunity to introduce colors that can be reflected on the sea and land. If you wish to make the water the center of interest, this type of treatment does not have to overwhelm the sea. In fact, it may enhance the water with beautiful colors and, I must say, that I believe both artists and the public grow tired of endless blue-green seascapes.

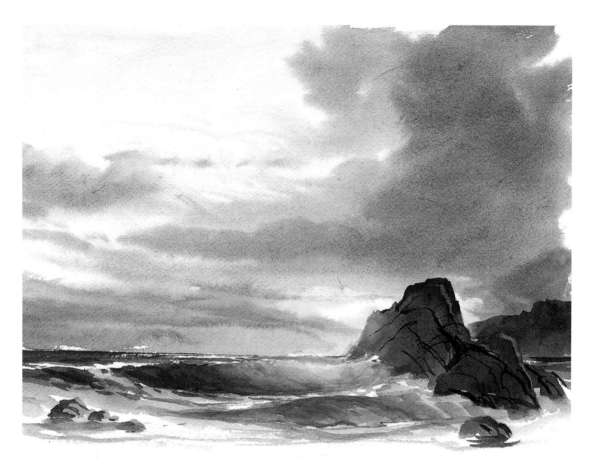

sundown

I realize that sundown on the Pacific coast is like sunrise on the east coast, so let us look at this sky for its beauty. Of course there are endless ways to show the sun at the horizon and no doubt every artist has found most of them. However, it has been my experience that sundowns are a bit gaudy with too much brilliance and too many bright colors. Of course this happens in nature but some things can be recreated nicely and others cannot. I feel those gaudy, red sunsets we've all seen are poor examples of nature and can become terribly commercial. I prefer quieter examples such as this. The beauty of the color is apparent and may influence the sea without being gaudy. Notice how the yellow stands out against the gray and violet background.

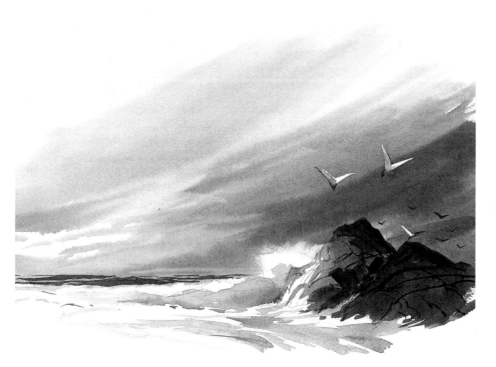

motion drama

The sea is horizontal unless we are focusing on close-up action in the surf. Sometimes we want the sky to repeat the horizontal theme for a restful mood. At other times we may want the sky to balance horizontal lines with motion. In this example the sky is slanted, light at the top and dark at the bottom where it levels out over the horizon line. The mood is "vastness" — a large, sweeping sky over a quiet sea. The gulls add to the theme of freedom and motion. Notice how the subtle warmth in the upper portion of the sky relates to the red and sienna colors on the rocks. This is echoing color for harmony.

silver lining

A silver lining occurs when the sunlight is behind dark clouds whose thin edges don't have enough water content to make them dark so the light shows through. When the contrast is strong enough, the clouds appear to have a halo around them. This example shows lighter clouds but they still have a white edging. I like clouds like this because they cast their shadows on the land and the sea. You can therefore choose what will be in sunlight and what will be in shadow. In this case I chose to cast shadows over the distant headland, part of the background sea and the nearer rocks.

Remember, you can always justify a cast shadow by clouds either in or out of the scene.

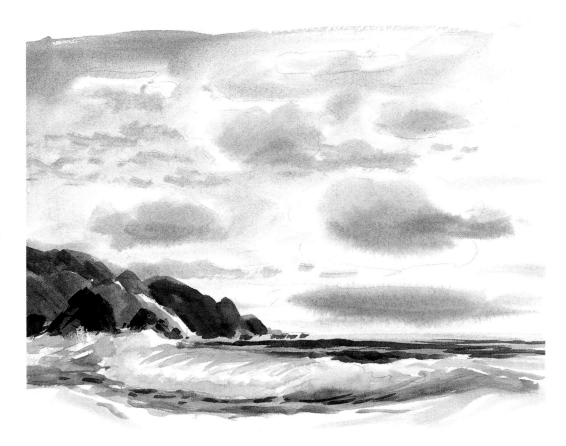

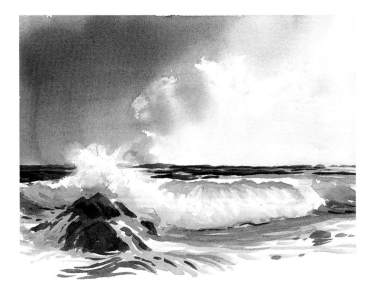

rain front

This could also be called a line storm but in either case, look out! Rain is coming and it isn't just a few sprinkles. Dark, storm skies such as this add a lot of drama to a painting. The dark background is ideal for contrasting with a white foamburst on something drenched in bright sunlight. When painting skies with so much dark and light together, be careful which dominates the sky area. In this illustration the darkness is less than the lightness, showing the storm encroaching on a bright scene. Having more dark than light suggests that the storm is overwhelming the scene and the result would be very moody. Either approach is alright.

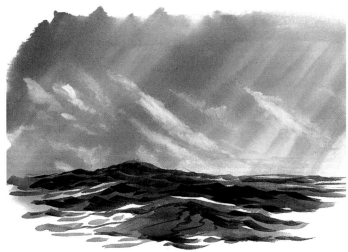

lifted clouds

Sometimes there are wispy, thin clouds in front of a darker background. It is a way of showing motion where none exists. I achieve that result by first painting the background colors, then lifting off color with a tissue. The paint must still be wet when you do this. Any number of formations may be created but more than likely you will not be able to bring the area back to pure, white paper.

It is just another trick that may be useful in certain cases.

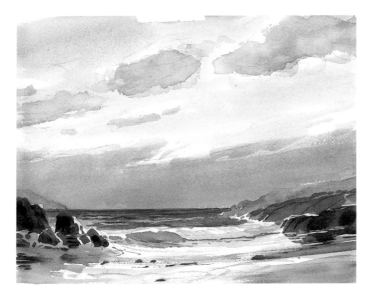

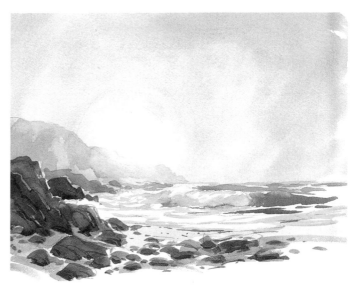

fog bank

Summertime often brings on fog, low clouds and areas of mist. When they are moving in from the horizon line and have a definite top edge, we call them fog banks. Often the leading edge releases floaters and wisps of smaller clouds that drift ahead, blown by the wind. The fog bank is usually a middle value and is very useful for giving a transition in values between a dark sea and a light sky. Notice that I have the sun out of the picture frame but behind the clouds. This makes a cast shadow from the cloud bank over the background sea. It also gives a silver lining to the floating clouds overhead.

fog

Total fog is another matter. As described in chapter 4, fog is the closest we can get to living in a cloud. It is the thickest atmosphere as well. Fog has some wonderful characteristics though: it may be used to soften harsh edges, set a mood of quiet and mystery or allow us to select a small area for attention. I never paint fog so thick that you cannot see more than a few feet. I like to show some sunlight filtering through and allow it to obscure the distance. Here, the sun is behind the fog and therefore creates a soft glow. I deliberately made the foreground rocks more colorful than they would have been. This gives a sharp color contrast as well as a value contrast to the light gray fog.

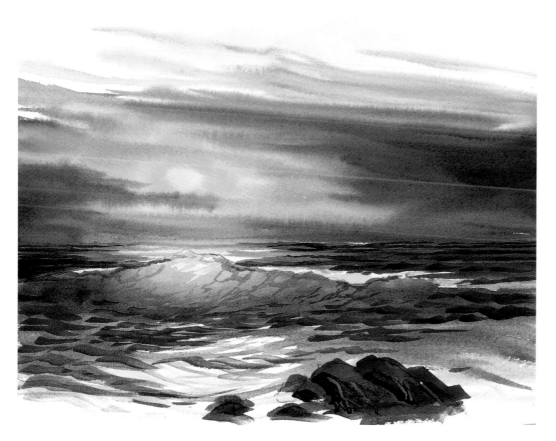

deep reds

Well, here it is: deep yellows and reds, a symphony of bright colors that look downright beautiful in nature. I'm less enthusiastic about them in paint, however, because they don't show the brightness of nature. Paint, in itself, can only repeat 10 per cent of sunlight so all we can do is try to make it look brighter. Some artists are far better at this than I am so I will leave it to them. Perhaps you can be one of them, but I must warn you that the public also becomes weary of too many of these as well.

cumulonimbus

I don't really want to get technical with labels but this particular cloud formation is a rain maker and frequently seen over the sea. I would rather call it a "mixed weather" formation because it has both blue skies and rain clouds.

There is no limit to the combinations of blue sky, white clouds and rainy ones that you can make up. Just make sure all the clouds are not the same size or shape.

In this illustration I have combined clouds in motion with horizontal, linear clouds near the horizon. This suggests wind from the sea generating clouds that may give showers very soon. Also notice the cast shadows on the sea and the headlands.

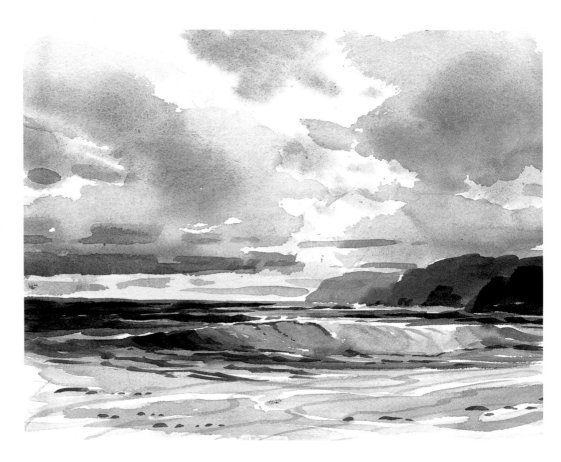

cumulus

I realize this is another technical term but I didn't want to call them "thunder heads". You don't often see thunder heads over the sea in the Pacific northwest, they are most often found inland where I live.

I consider cumulus clouds to be among the most beautiful cloud formations and do use them in seascapes from time to time. The thing is, they are so beautiful they are best painted as "skyscapes", otherwise there can be a conflict of interest between a beautiful sea and beautiful clouds. As you can see here, the sea plays a happy supporting role to the sky as the star attraction. The land plays a secondary role. There is nothing wrong with that because I didn't try to feature both equally.

stratocumulus

It occurs to me that a meteorologist might take issue with my interpretation so maybe we should call these formations "future rain clouds" or "downright stunning" clouds. In any case, this particular formation is backlit and aglow with sunlight except where the moisture is thickest. It is a dramatic sky with the sweep of the clouds, the warm colors, and the hint of rain at the horizon. There is also a lot of depth due to the darker, wispy, clouds on the left. Notice these are lined up in the opposite direction and cross in front of the background clouds. This trick is always helpful for creating depth. Once again, the sky overwhelms the sea and once again I say that is quite alright.

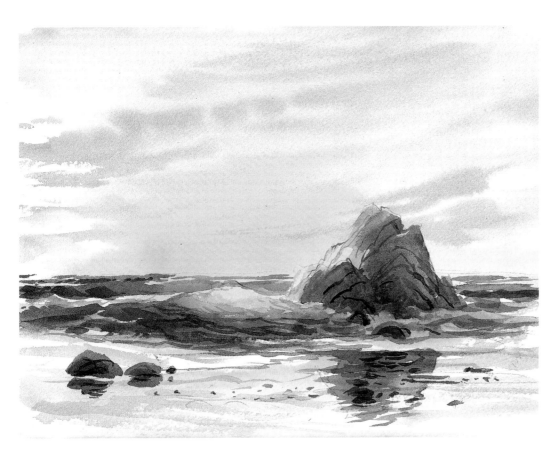

afterglow

The sun just below the horizon may still influence the sky which in turn, influences the sea. Afterglow is a favorite of mine because it is not garish but may have beautiful colors. This sky is a quiet one with light colors but the glow has turned the waves yellow where the light comes through. There are as many variations of this as you can think up and they are all good for special effects in your seascapes. This is another sky that will not detract from a center of interest in the sea as long as you don't make the colors too strong. In this example the center of interest is the entire glow: the lower part of the sky, the rocks and the central waves.

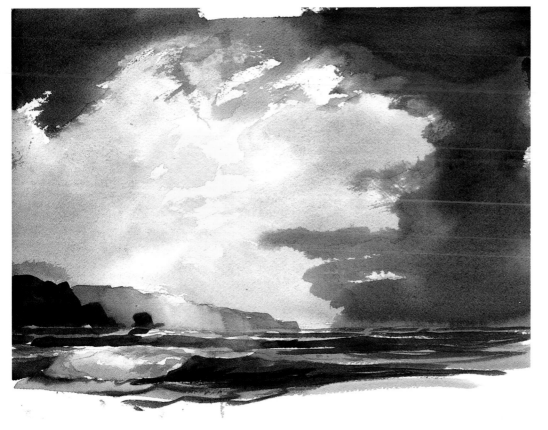

moonlight

Moonlight is a variation of cloud glow, (see page 60), but in this case the light is from a full moon. Like anything else, there are numerous ways to paint moonlight and this is just one example. Here, I have shown a dark sky with a bank of thin clouds with moonlight behind them. There is a bit of silver lining as well. Though I have featured the sky, a seascape with the water as a feature could still have this effect. Again, the sky need not be overwhelming if you choose to play up the sea, especially in the foreground.

As I said before there are limitless possibilities for skies and they all have influence on the sea and land. I cannot urge you enough to go out and study skies, just as you would study rocks and waves. Fill your memory banks with as many experiences as you can, then find your own way to express them.

DEMONSTRATION

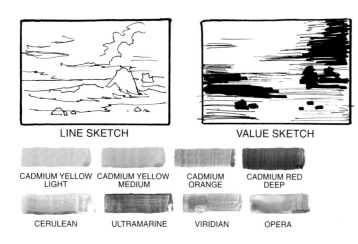

LINE SKETCH VALUE SKETCH

CADMIUM YELLOW LIGHT CADMIUM YELLOW MEDIUM CADMIUM ORANGE CADMIUM RED DEEP

CERULEAN ULTRAMARINE VIRIDIAN OPERA

This demonstration is a version of, "Sundown" on page 61. I have chosen it for its quiet colors and still, dramatic effect, and also to show you just how I would proceed in painting such a sky.

The line sketch is simple with most lines being horizontal. They are broken by the vertical rock and the upsweep of the upper, right side clouds. The value sketch confirms the same theme: most everything is horizontal with the rocks and clouds creating a balance with vertical shapes.

The colors are mostly yellows with reds. The cooler colors will give contrast but play a minor role.

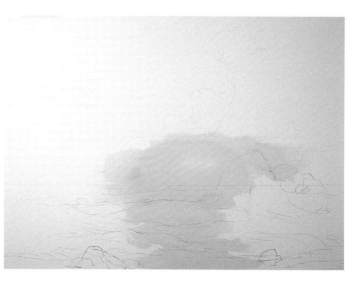

step 1: sun and glow
This first step is to suggest the sun and glow area only. I slanted my board a very little and then wet only the glow area. I used a #12 round with cadmium yellow light and drew a circle of sorts with white paper left behind. I then washed some of the yellow downward where it would influence the background sea. While the first paint was still wet, I drew a larger circle with cadmium yellow medium and let it flow into the first circle as well as downward. Last, I ringed the first circles with a bit of cadmium red deep, which also flowed into the wet paint. As it all flowed downward I lifted any hard edges with a tissue so the waves could be painted in with a gradual transition.

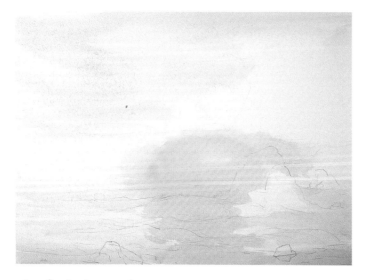

step 2: sky base colors
I mix most of my grays with a combination of red and green. In this case I mixed cadmium red deep equally with viridian. The gray can either be warmed or cooled with either color or left neutral. I also used some opera and cerulean for added variations. Next, I slanted the board some more and rewet the entire paper, except for the glow area. With a 1" flat I painted the warm and cool gray colors I had mixed up. I started at the top and worked downward with horizontal strokes right to the foreground. I was careful to paint up to the glow area, but not to cover it.

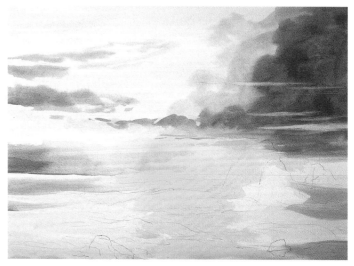

step 3: finishing the sky
There are actually three mini steps in this last application: First, with the paper dry, I stroked in the pale clouds with a slightly darker version of the under paint; Second, I painted in the cerulean clouds on the right and, finally, the dark clouds on the right. For those, I first rewet the area then used ultramarine blue to darken a mixture of cerulean and cadmium red deep. I also touched some of the darker colors into the lighter ones on the left and carried them downward. Notice how I faded the dark colors into the glow area by adding warmer colors. I used my flat brush edgewise to lift some linear clouds on the right. This broke up the large dark area and also retained the horizontal theme of the composition.

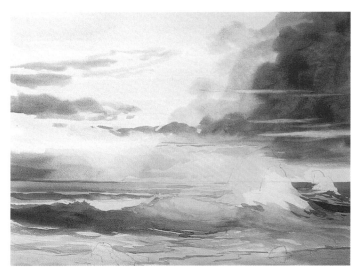

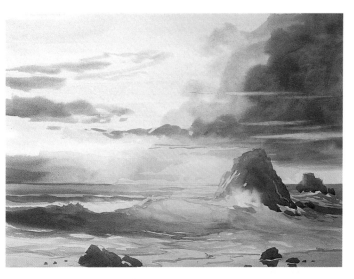

step 4: sea and surf underpaint

The glow on the background sea must be retained so I was careful not to cover it with new paint unless it was the same basic color. I started on the outer edges with ultramarine blue and cadmium red deep but as I worked toward the glow I used less blue, more red and then, finally, just yellow. I also used more water with the yellow so it would fade gradually into the underpaint.

step 5: rock underpaint

I started with watered down yellow on the sun side of the main rock. I then added cerulean, some red and then ultramarine for the shadow side. I did much the same for the other rocks. While the paint was still wet at the base of the large rock, I lifted out the edges of a small foamburst. This light against dark, along with the glow area, would create a strong center of interest.

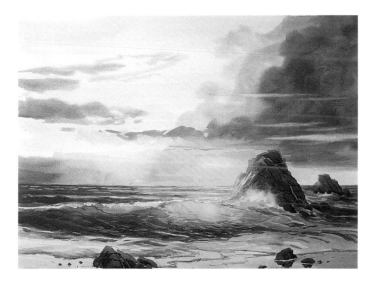

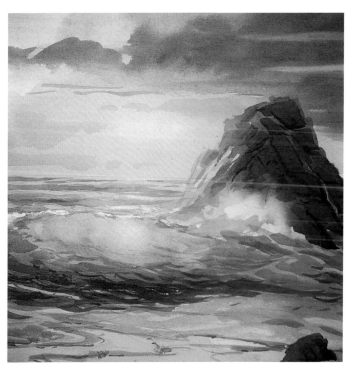

close-up

step 6: final details, "Twilight Glow",
watercolor board, 17 x 20" (43 x 51cm)

First, the background sea: I laid in some darker swells made lighter and warmer toward the glow. I created some crisp edges with a ½" flat, mostly on the nearer swells. For the wave, I added some chops with the same brush, using ultramarine, viridian and a touch of red. Next, I put down shadow lines on the wave and foam and a cast shadow on the blanket foam. Last, the rocks needed definition and details. With the flat brush I blocked in some slabs then underscored them with darker lines. I then added a few cracks on the foreground rocks and a few pebbles in the slick area.

waves and breakers

To paint the sea well it is important to understand what's going on out there.
That way, you won't make the mistake of giving waves shapes that are impossible.

I'm going to show you how to paint four major forms of waves: background swells,
rising waves, the breaker and the collapsed wave. In order to paint them correctly, it
is important to understand how they are formed and how they appear under different
circumstances. It may seem complicated, but this chapter will help you understand
exactly and, with a little practice, you will easily be able to master waves and breakers.

transfer of energy
Out at sea, energy is transferred from storms, crossing currents and
temperature changes to create swells. Think of it as a gigantic version
of dropping a pebble into a pond or mud puddle. The energy you
used to lift the pebble was transferred when you released it and that
energy was transferred to the water when it struck the surface. The
result was shockwaves, a series of concentric rings that moved out in
all directions and didn't stop until they reached land.

anatomy of swells
The moving rings in the puddle are much
like the swells out at sea. However, the
swells are not mounds of moving water.
Instead, they are forms of energy that ripple
the surface of the sea. In fact, you could
drop a piece of wood over the side of a ship
and watch it bob up and down as swell after
swell passed by. Eventually the floating
material would reach a shore because of
currents and wind, but not because the
surface water is moving with the energy.

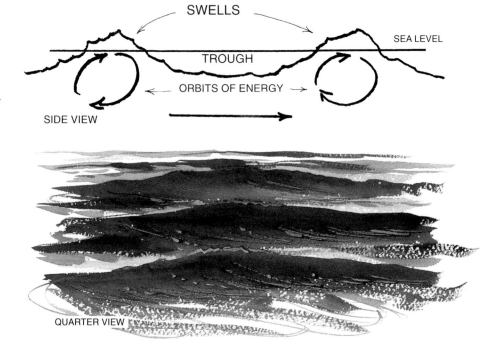

QUARTER VIEW

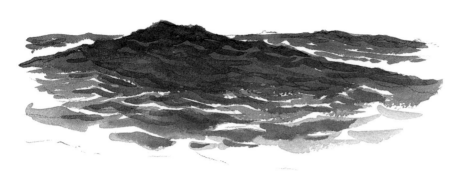

swells with ripples

Swells may vary in shape and size but they are generally much longer than they are high. They are thicker near the center and taper off on each end. Their surface may be covered with mini swells, or chops, and they may be streaked with foam. The upper edge will be scalloped from the ripples and sometimes frothy.

When painting ripples, make sure the scalloped lines touch each other as you can see here. If they do not touch ripple lines look unnatural, or like pieces of ropes scattered across the surface.

RIPPLE LINES CONNECT

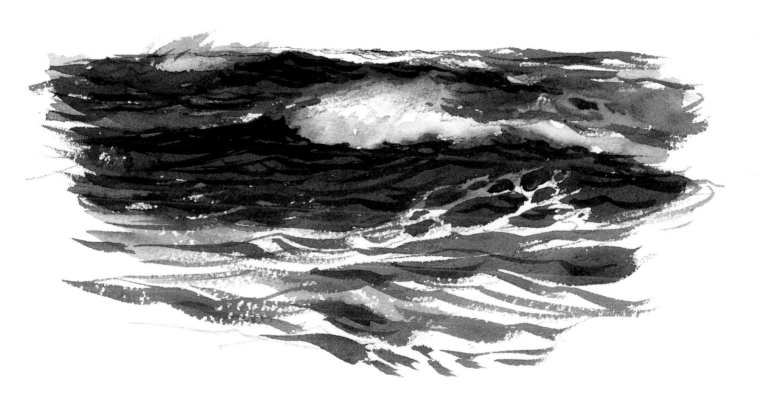

whitecaps

Sometimes swells become very agitated in storms and the thin, upper edges are whipped into boiling foam. The foam is blown off by the wind, scattered and is laid down where other swells pick it up. The upper foam is called a white cap and the surface foam streaks the swells with white lines. White caps can look a lot like breakers but they are not. The energy doesn't break as it does in shallow water. In fact, the swells will move out from under the white froth which settles down as a thin layer that will disperse in a short time.

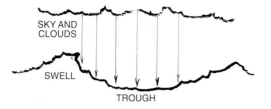

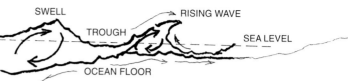

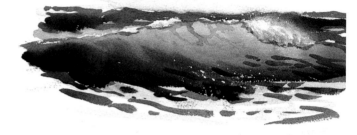

sky and cloud reflections

It should be noted that the upper portion of a swell is usually darker than at the base, which is known as the trough. This is because the trough is more or less horizontal and reflects the sky and clouds above. The upper part of the swell is more vertical and cannot reflect what is above and therefore appears darker. The only time a swell may appear lighter is when the water looks thin enough to allow light to pass through. Even then, the translucent area would never be as large as it would be on a true breaker. Notice also that the curve of the swell is gradual and therefore there must be a gradation in the values of dark to light.

Swells will travel for hundreds of miles until they reach a shore or shallow water. Larger swells travel faster than smaller ones and pass right over them. It is as if they were in a contest to see who can get there first. Standing on the shore, you can also tell how close is the storm that created the swells. The closer together the swells, the closer the storm. A longer time-lapse between the swells means the storm is much further away.

rising wave

A rising wave is a swell whose energy has reached shallow water. This is when the form of energy begins to change: It tries to maintain its shape and direction but, as it rises higher, it can no longer support the weight of the now moving water. The highest portion of the upper edge becomes thinner and begins to aerate. The leading edge begins to curl forward and the front of the wave begins to rise upward. Notice here that the upper edge is scalloped. This is caused by the ripples. There is also a beginning of translucent water where the upper areas are becoming thinner.

Now we come to the star of all the forms, the breaker. It is the largest, noisiest and most flamboyant of all and, of course, the most painted. I look at breakers as having personalities. They all have the same basic anatomy but each one is distinctly different, like we humans in a way. I have often been asked why I don't paint seagulls in my seascapes. My answer has always been the same: When I feature a wave as my center of interest, I look at it as a portrait, an object with individual characteristics. To add a seagull or any other living creature, would be like adding a butterfly on the nose of a portrait of a human. Rather distracting wouldn't you say? So, I keep the seagulls for panoramic scenes.

breaker anatomy

When the moving energy rises above the ocean floor it can no longer hold its shape and "breaks". The thin, leading edge curls forward as a roll mixes with air and falls to the trough below. At the same time the face of the wave rises upward and if you look at this sketch, you will see that the rising wave face meets with the curling front roll and together they form the orbiting circle of energy. This shows how the original circular movement creates this shape we call a breaker. Notice also that a tunnel is created between the wave face and the roll. Surfers refer to this as the "pipeline".

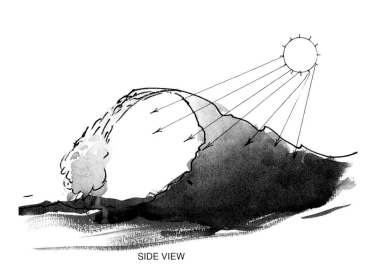

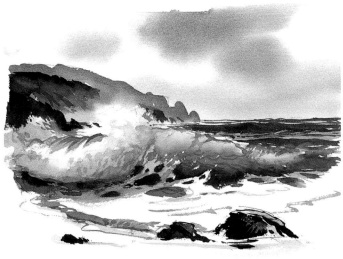

SIDE VIEW

light through the wave

Let's go back to the breaker and look at the translucent effect. This side view is an exaggeration of a wave, but you can see how its shape determines just how much light can pass through. Notice the gradual change from dark water at the base to thinner, translucent water at the top. The gradation is due to the changing thickness. This is why the transparent area of a wave should not be shown all the same from top to bottom. Even though I have seen many paintings done that way, it would mean the water would be a thin sheet which is impossible.

front view from the right

This could be called a quarter view. We are looking from an angle at a breaking wave. We see the gradual change from dark at the base to light at the top — the translucent effect. We can also see the top of the roll before it collapses. Notice how the top still shows the color of water before it aerates and becomes foam.

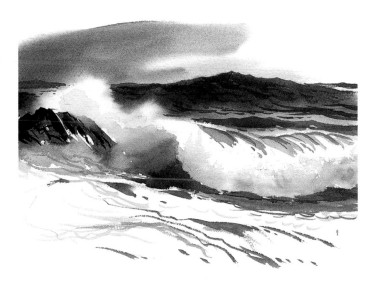

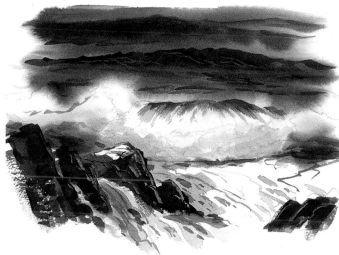

front view from the left

This quarter view is from the left and I have shown the wave nearly collapsed this time. Not much translucent water remains and the green water of the roll is lower and flatter looking. Very soon it will become a totally collapsed wave as shown over the page, and will be mostly foam.

I haven't shown a wave straight-on because they are less interesting. However, there is nothing wrong with painting them that way. You merely have to make sure they are not too symmetrical and have more interest on one side than the other.

take the wider, safer, over view

It is a good idea to stand back from the action because the surf and crashing waves can be downright dangerous. Too often, unwary people are swept away by a "sleeper" wave or knocked down and dashed against the rocks. You may observe waves at sea level if there is plenty of beach in between but if the waves are crashing against rocks and bluffs, stay well above them.

This example shows background swells and a breaker from a safer height. In fact, I enjoy painting waves from this vantage point — and I stay dry as well.

71

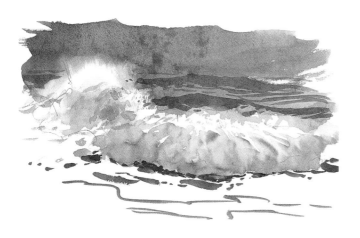

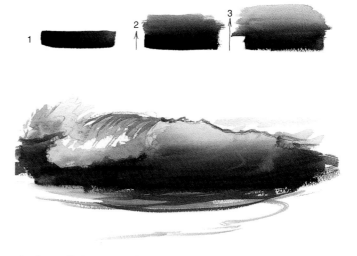

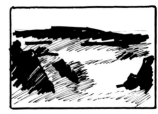

collapsed wave

You have seen how transferred energy created the shape of a swell, how the swell was pushed up to form a rising wave and then to a full breaker. The last stage is the collapsed wave. The weight of the water with only air below causes the whole wave to collapse in on itself. The trapped air explodes upward causing spray and mist and the froth churns forward, still pushed by the energy of the wave. At this point only a small corner or two will show any translucent water. We will study this and other types of foam in chapter 10.

dark-to-light wave face

It is best to keep your board flat for this approach. First, make a rough outline of a wave face and a roll with foam. Next, mix up a color. In the first step use ultramarine blue with little water and with a ½" flat, brushed across the base with horizontal strokes. In step two, rinse your brush in clean water and keep it wet. Then lay the brush over the top edge of the dark color and make more horizontal strokes. The blue fades into the clear water. Finally, in the last step, clean your brush again and work the last area up with water. The result is a gradual gradation from dark at the base to light at the top, the translucent effect.

DEMONSTRATION

For the following demonstration I worked out the line drawing and the values I wanted then decided which colors would be best although, nothing is written in stone so I could make changes if I wanted. I used a 300# paper, half sheet, or 15 x 22" (38 x 56cm). You will note that this is a larger version of the "overview" illustration on page 71.

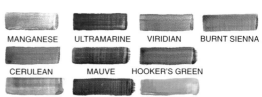

LINE SKETCH

VALUE SKETCH

MANGANESE ULTRAMARINE VIRIDIAN BURNT SIENNA

CERULEAN MAUVE HOOKER'S GREEN

OPERA CADMIUM RED DEEP CADMIUM ORANGE

I worked up a line sketch after taking a critical look at one of my outdoor sketches. The concept was to have rough seas from a storm with a large wave moving into a turbulent surf. The vantage point was from above so the rocks on the left conformed to a downhill pattern. They were placed as if to meet the oncoming wave.

The value sketch shows the dark, light and middle areas. As you can see, the rocks and the background swells are the dark values, the surf and sky the light values, and the middle values help to harmonize the others.

You may think I chose too many colors but most of the colors used came from the top row. The other colors were not meant to be primary colors for this painting. Instead, they were used for variety, or for charging other colors.

I tell you how I did it, so treat this demonstration as an exercise.

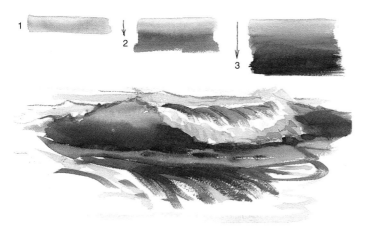

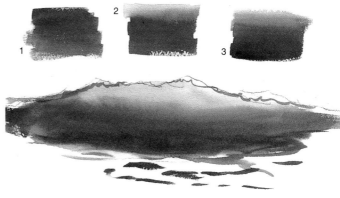

light-to-dark wave face

This method of painting a translucent wave is the opposite of the first one. In this case, using the same brush and any blue you would want to use, start at the top of the wave with just a little color with a lot of water. Step two, the brush must have more color and less water. As before, horizontal strokes are a must. Step three is mostly a good dark color for the base. Each time you brush in color it should overlap the last one so that they blend together. If there are obvious lines in the three stages you can go back and blend some more, as long as the paint is still wet.

wash out technique

This third method can be tricky, especially if the paint dries too quickly, but it can be used effectively. In step one, using a flat brush and a mixture of color that is about the middle value of the wave, paint in the entire clear water area. In step two, with only water in your brush, make horizontal strokes across the top. This will thin the mixture and it will flow downward. You may want to slant your board to guarantee this. In step three you may darken the base with any mixture you choose that relates to the first color. For example: if you use viridian for the first wash, you could darken the base with either ultramarine blue or any other that is naturally darker than the viridian. The paint must still be wet when you either lighten the top or darken the base, otherwise lines may show or it may become muddy.

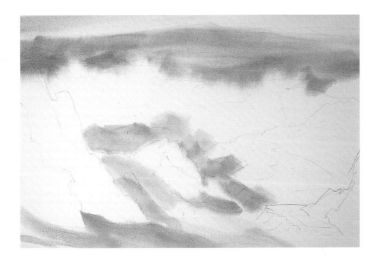

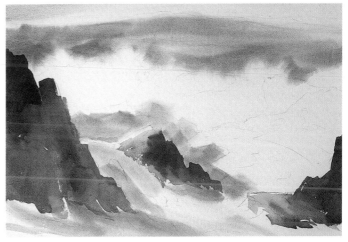

step 1: shadow underpainting

I like to establish major shadow areas first because to add them later could muddy the colors or change the appearance in a detrimental way. Shadows are usually lighter than rocks and waves so darker objects go over them without problems.

In this first step, after making a very loose drawing, I wet the paper with a sponge. Then, with a 1" flat I made one horizontal stroke of manganese blue for the sky. My board was slanted so the colors ran slightly. I then mixed ultramarine blue with a touch of cadmium red deep and stroked it across the area of the background and for the cast shadows in the surf. I added a bit of viridian to the same mix and painted in the area of cascading water off the main rocks. Notice that I sponged the upper edges of the wave foam where the background color was invading. This guarantees very soft edges, ideal for showing misty foam.

step 2: rock underpainting

The paper was now becoming dry so I rewet the rock areas. I wanted these rocks to be colorful, rather than the usual dull brown seen so often, so I mixed up hooker's green, mauve, and some burnt sienna. Then, while this was still wet, I dropped in a few strokes of opera, cadmium orange, and cerulean blue. This was just the underpaint and at least two more applications would be needed to finish these rocks.

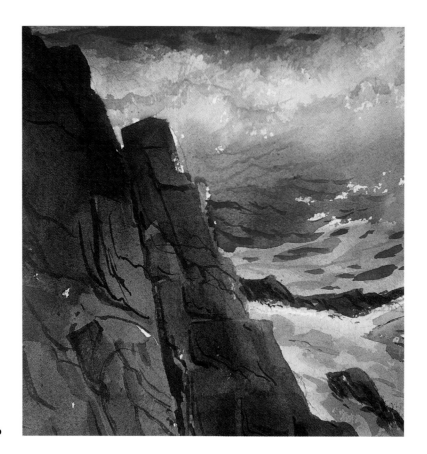

close-up

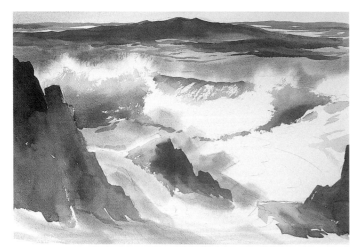

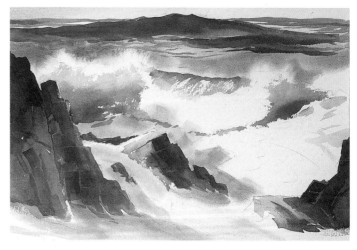

step 3: water underpainting

My main purpose now was to establish the color of the clear water, both in the background swells and the translucent area of the wave. For the background, I used ultramarine blue and viridian. I used horizontal strokes with my 1" flat making sure the upper edges of the wave were scalloped. While this was still wet, I added more blue at the top of the swells. For the clear water on the wave, I used viridian and cerulean blue. I started at the bottom and worked upward, adding more water each time I lifted the brush. When the gradation from dark to light was finished, I added more blue at the base. The paint was still wet so it blended very easily with the first strokes. I used the same color for the top of the roll. Notice I started at the top with dark color. Then, with just water in my brush, I dragged the green forward with convex strokes. Here, I used a ½" flat and with a light touch, I was able to leave textured white paper in places so I got the effect of aerated water and even the reflection of sunlight.

step 4: rock structuring

Before I went any farther I wanted to define the interior structure of the rocks. These are the strokes that determine the direction, or strata, of the rocks and indicate where the larger cracks or holes should be.

I went back to my 1" flat, mixed slightly darker versions of the underpaint, then laid down strokes that would establish the shapes and forms I wanted. Where necessary, I sharpened some outer edges as well. This gave good contrast to the soft edges of the foam and water in the painting.

close-up

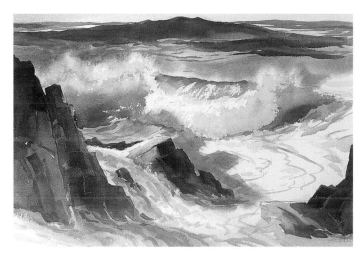

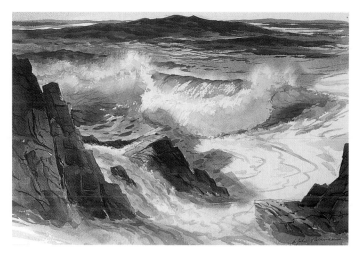

step 5: more shadows and foam definition

The paper was dry and so it was a good time to add ripples and more holes to the blanket foam. Ripples and lines should be used sparingly and they should help to give the feeling of motion. Again I used a darker version of the underpaint but with a #8 round. I first laid in strokes over the blanket foam and then some ripples in the cascading water. For the breaker foam I added warm shadows, including some burnt sienna. This was to give the effect of light bouncing from the sunlit surf foam back onto the breaker.

**step 6: final details, "Pacific Storm Waves",
17 x 22" (43 x 56cm), 300# rough**

Before I complete a painting I like to stand back, take a critical look and ask myself where I need changes before adding details. Actually, it would be a good idea to leave the painting overnight or longer, but I would rather finish it. In this case, I took a critical look and decided what was necessary to bring the painting to a good conclusion. I could see that I needed more definition in the background, a few strokes in the surf and the rocks needed detailing. Just as before, I used a darker version of the underpaint. I added darker ripples to the background swells and added a few holes in the foam as well. Using my #8 round sable, I added finer ripple lines to the wave face and underscored the foam as well. Detailing rocks is fun. I darkened a few major lines, added linear edges, defined slabs, and added cracks. I also enjoyed splattering some texture with watery, dark colors. There comes a point, however, when too much messing around can take away the freshness of a painting and it becomes overworked.

chapter 10

the forms and shapes of
foam

The area between a rising wave and either beaches or bluffs is the surf. It is the playground of action and is often covered with foam, which is the result of water mixing with air. In this chapter you will learn how to use some very special effects.

foam bursts

light foam burst
The burst is the result of a wave slamming thunderously into a rock or even another wave. The water explodes upward with tremendous force and is made white from aeration.

A burst has no definite shape and no hard edges. (In fact, it would be a good idea to practice sketching some curvy shapes and learn to avoid obvious circles, rectangles, or spires.)

In this example, the white foam burst shows up much better with a dark background and foreground. I achieved a scattered edge effect by sandpapering the outer edges after the paint had dried.

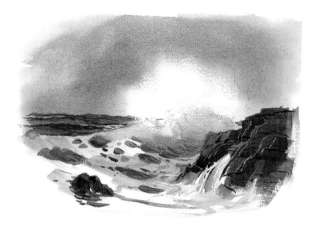

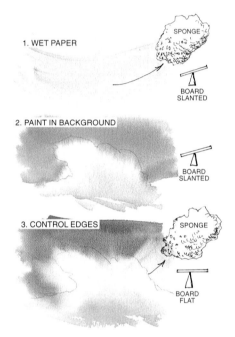

1. WET PAPER

SPONGE

BOARD SLANTED

2. PAINT IN BACKGROUND

BOARD SLANTED

3. CONTROL EDGES

SPONGE

BOARD FLAT

wiping out edges
Soft edges may be achieved using a wet-on-wet technique by wiping out with either a sponge or a tissue. Step one is to wet the paper. Step two is to apply the background color down to and around the outline of the foam. Step three is to control the edges before they dry by wiping out any color running into the foam area. The board is slanted until the time to wipe out and is then laid flat.

Timing is important in this method because of the drying time of the wet paper. Obviously, the wetter the paper, the harder it is to control the flow. Conversely, if the paper is too dry, the edges will be hard and the sponge will smear rather than lift out. In some cases, I use the hairdryer to save the edges and, as you see in the first example, I use sandpaper in some cases for a scattered edge effect. In any case, the finished foam burst must have a nebulous shape and very soft edges. Any color added at the base should gradually fade out as it moves upward because aerating dissolves color.

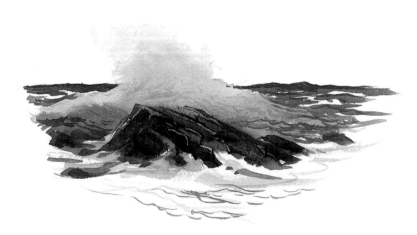

dark foam burst
There will be times when the background must be light and you may think a white burst will not show up well. You can easily remedy that by placing the burst in shadow. It then becomes a silhouette and can be very attractive. Here the edges are scattered simply by brushing the light color over dry paper.

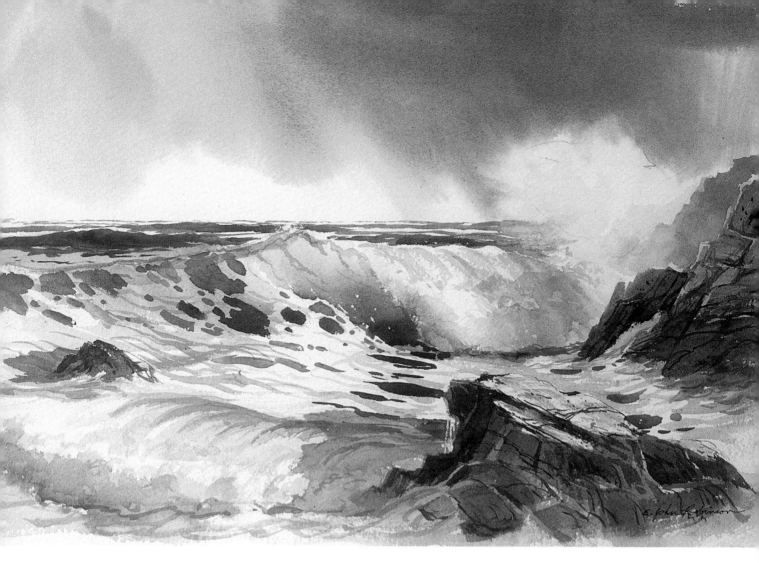

"Mendocino Surf", 17 x 22", 300# rough

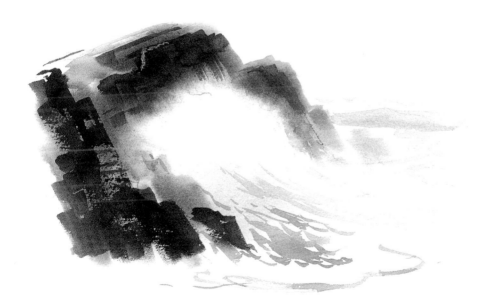

burst against rocks

Not all foam bursts will appear against a sky. Often the background will be a bluff or a large rock. In either case, the technique is the same; Paint in the color of the background with enough water to make it workable, then lift out the edges of the foam until they are dry. When the paper is completely dry the details of both the background rock and the base of the burst may be added. The hard-edged forms of the rocks are a perfect balance to the soft-edged forms of the foam bursts. Adding even sharper edges to rocks in front of the burst enhances that effect even more.

breaker foam exercise

Chapter 9 showed a number of examples of breaker foam but now let's look into ways to paint them.

Just like painting the foam burst, other examples of foam require the white paper to be saved and the surrounding areas to be painted first. After that, other colors, textures, and details may be added. Let's practice breaker foam in three easy steps.

step one: surrounding colors

With your drawing in place, mix and paint in colors for the background swells. In this case, use ultramarine blue with a touch of viridian. The paper should be dry. Load your flat brush with wet paint. Lay the strokes in horizontally, making a solid background but allowing some dry-brushing for the upper edges of the foam. If the upper edges are too hard-edged, lift off paint with a sponge or tissue. Next, paint in the small areas of the clear wave using viridian and a touch of blue. Use the same mixture for a broken line at the base of the foam.

step two: roll color and shadows

I usually determine the position of the sun, which tells me where to place the shadows. In this case, the sun is high overhead and most of the shadows will be in the lower portion of the breaker foam. Use a light mixture (watery) of ultramarine blue with a touch of mauve. With a #6 round and a circular, scrubbing motion, starting at the bottom of the white foam area. Allow a darker area of shadow on the left but add more water and use a softer touch to the upper edges on the right. This gives a much more interesting shadow than one that is the same shape, color and value all the way across the foam.

Next, with a flat brush and a watery amount of viridian, stroke in the clear water at the top of the roll. Start at the top and brush downward in a convex arc. Stop above the white foam area and wipe out if the lower edge of the stroke is too hard. The top of the breaker foam must be soft.

step three: details

With the surrounding colors and the shadow portion of the foam in place, add whatever details you like. In the background area add darker strokes for the swells. (In most cases I would probably add even more details than here on the breaker foam.) Next cast a shadow below the foam. It is the same mixture used before. Last, use the sharp tip of a knife and nick out a few sparkles on the roll. Please notice that even the sparkles follow the arcing contour of the form. Though this is a very simple breaking wave with foam, it is the basic procedure for painting any other, even more complex wave than this. Master this one and you can use variations in size, shape, color, and direction so that you never have to repeat yourself.

foam trails exercise

Foam trails are lost-and-found lines of foam floating in the surf. They are either the leftovers from blanket foam that has dissipated, or the leftovers from collapsed waves. This linear foam is thin and wider patches of it will be interspersed with holes of various sizes because this foam is also dissipating. In the painting on the right and all other examples in this book you will notice that I always run foam trails in and out of shadows. There is always an excuse for a shadow; either from rocks and bluffs in or out of picture frame or shadows cast from clouds. If all foam was treated evenly the results would be flat, and too even, so choose where you want sunlight and shadow for a more interesting composition.

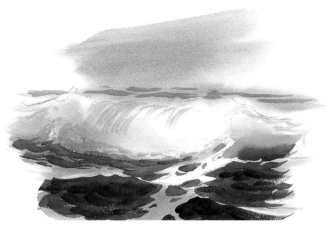

step one: casting the shadows

It may seem odd to cast shadows before painting the other features but I have found that it works very well. If the shadows are too dark it may be difficult to clearly show some things so keep the shadow color light. It can be darkened later if necessary.

After making a rough outline of the wave and swells, wet the paper. (Use either a sponge or a large brush but I find I can control the wash more easily with a sponge.) Use a mixture of ultramarine blue and mauve and brush it on with a 1" flat. Paint the shadow area in the foreground and also some of the sky and the breaker foam. Remember, you can choose where you want shadow regardless of where they may be on the scene or in a photograph.

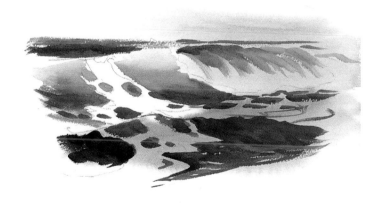

step two: color of water

When the paper is dry, using ultramarine blue and a touch of viridian, paint the foreground swell and the background. The foreground water should be painted around the outline of the foam trail and also in the holes. Never have a different color or value in the holes than in the surrounding water. Next, paint the wave face and the roll with pure viridian but darken the base of the wave and the top of the roll with blue while it is still wet. Notice the wave foam trail. The holes should be the same color as the water surrounding it — which is different from the foreground swell.

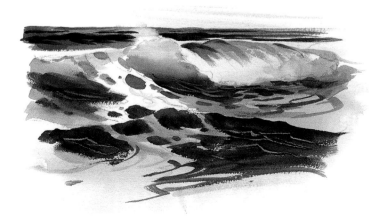

step three: details

At this point you could add any number of details but for this exercise just add a few. First, cast some more shadow on the breaker foam and at the top of the wave's foam trail. This gives the impression that the leading edge of the wave is casting a shadow over the foam. Sharpen the background swells with crisper edges then, with watered down blue, add some swirling lines to the foam trail, both in the sunlight and shadow areas. Finally, re-wet the foreground swell and scratch in some ripple lines with the sharp end of a flat brush. A sharpened stick or a knife could also be used. Just don't overdo them.

blanket foam

When the action in the surf is heavy and storm waves are crashing over each other a great amount of foam builds up. The waves are so close together there isn't time for the foam to dissipate and it builds up a blanket several inches thick. In some places it completely covers the clear water below. Where it thins out, holes appear and the clear water shows through. These holes are ideal for several reasons: They add interest to the foreground, break up flat areas, follow contours and they can be used like stepping stones to lead the eye to a center of interest.

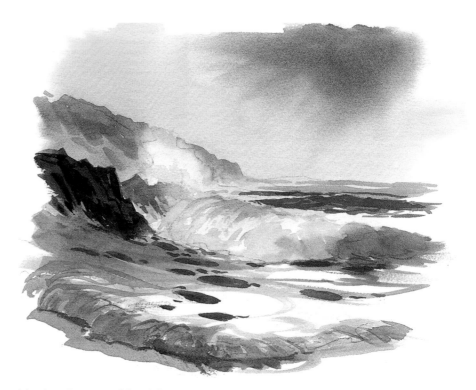

blanket foam and lead-ins
I placed some holes in such a way that they lead the eye to the breaker. Those alone would be too obvious so I added a few more in other areas. Whenever you paint these holes, it is best to keep them either in lines or in groups. Just scattering them across the surf is confusing and distracting. Notice also that I have cast a shadow from an unseen bluff so that the area of foam is not all in light. The thickness of the foam will be made evident by how much you show at the leading edge. I shadow the leading edge and then paint a darker, lost and found line directly beneath it. The thickness of the foam is established by the shadow from the base line to the lighter top.

blanket foam and contours
Depending on the way you place holes in the foam along with shadows, you can change a flat, level surf to a rolling, hilly one. You merely have to decide where you want slopes or mounds and line up the holes to follow those contours.

This painting shows the contour of the foreground sloping away from the rocks while the foam behind climbs in a different direction up the wave. There is a third hump between the other two which adds more interest and the important feeling of movement. Notice again the staggered holes that not only follow the contour but lead the eye to the center of interest.

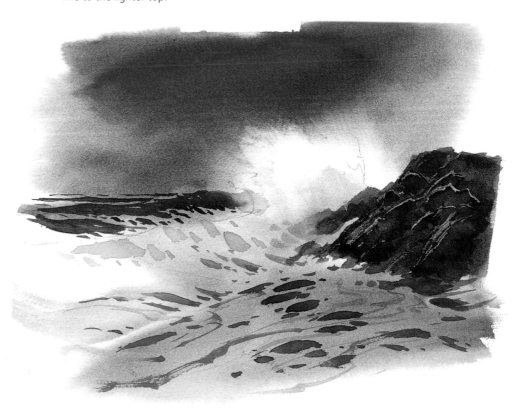

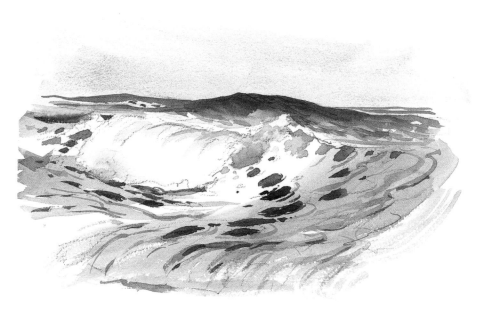

blanket foam on a wave face

Sometimes the foam is so roiled and thick that it doesn't dissipate before a new wave moves in. The result is a wave face with few holes and covered with foam. In this case it is important to distinguish the difference between the breaker foam and the wave face foam.

Breaker foam is fluffy and soft edged with a convex form and has no holes in it.

Foam on the wave face may have holes but the contour is concave. This painting is a good example of this, as well as showing foreground contours and light and shadows.

beach foam

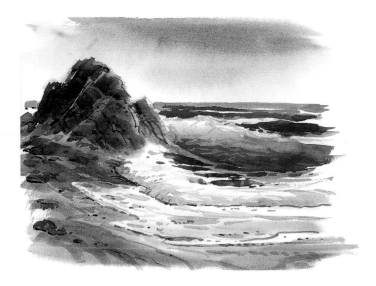

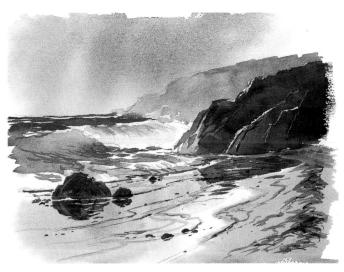

beach foam

The energy that began so far out at sea finally reaches shore and reaches up the beach or against bluffs. The energy takes on the form of swells, then rising waves, then breakers and their demise is transferred to frothy surf. Then, the blanket foam collapses to a thinner covering and extends its last push up the beach.

Beach foam is often clear water with only a little foam at the leading edge and a few streaks trailing behind. Because it is so thin the color of the sand shows through and pebbles are often evident whereas the blanket foam behind it shows the color of water below it. Beach foam covers the sand according to the tides, so may climb to different levels. Each limit though, will leave a meandering line of either some froth or bits of tiny debris. I always place a line or two beyond the existing edge to show where it has reached before. These lines may be dark or light if the foam is still there and are perfect for showing the contours of the beach.

the slick

The last surge of beach foam dissipates and runs back to meet the next layer coming in. This leaves the beach sand wet and it becomes a mirror for the sky, rocks, or other objects nearby.

This painting shows some of the forms studied in this chapter; breaker foam, a bit of blanket foam, a line or two left by beach foam and now the reflecting qualities of wet sand. The slick adds a lot of interest to a painting that has a beach and rocks. It allows the artist to extend a dark or light area where needed, it reflects the colors of the sky, which helps the entire composition to harmonize, and it can be used to lead to the center of interest.

DEMONSTRATION

T his is a scene of wave and surf action near where I live. I have studied this coastline for many years and each time I stop by I see something different. Every wave has its own personality each day its own mood. There has never been a reason to repeat a scene unless it is to make improvements.

You can see the simplicity of the composition in the line sketch; just enough to let me know where I want the individual players in this scene. The value sketch suggests where the light, middle, and dark values will be. I made the lightest light and the darkest dark adjacent to each other for the center of interest. I wanted a stormy sky for drama to back up the powerful foam burst against the rocks.

Colors for this painting were simply two blues, viridian, burnt sienna and cadmium red deep. Even with these few colors I would be able to charge colors into the rocks and clear water for variety.

LINE SKETCH

VALUE SKETCH

CERULEAN ULTRAMARINE VIRIDIAN BURNT SIENNA CADMIUM RED DEEP

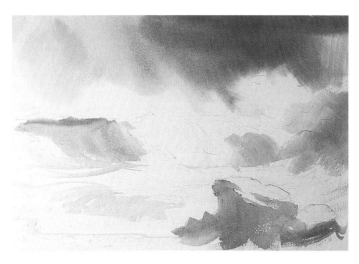

step one: sky and foreground shadows

After I sketched in the rough outlines of the major wave, the foam burst, and the rocks, I wet the paper with a sponge. I tilted the board and immediately began with the sky.

I used a 1" flat brush and first laid in a watered down burnt sienna. (Sienna is really an orange and gives a warm cast to the sky.) I quickly cleaned my brush and brushed in a mixture of cerulean blue and a touch of cadmium red deep. I allowed some of it to blend a little into the sienna. The paper was still wet at this point and I darkened some of the cloud area with some ultramarine blue. The sky was slowly moving down the paper and threatening to cover the foam area, which must remain white. I laid the board flat and, with a damp sponge, wiped upward from the foam area, stopping the flow.

I next brushed in the shadow areas in the foreground. The paper was just damp and the board flat so there was no more color running. I used the same 1" flat and made the shadow colors from ultramarine blue and a touch of cadmium red deep. Near the foam burst, I used more water to give the effect of the rock fading into the mist.

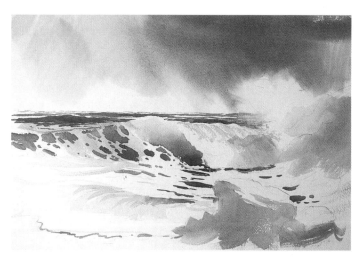

step two: background swells, color for wave and surf

Using a mixture of ultramarine blue and a touch of viridian, I cut in the background swells with a ½" flat. I held the brush upright and used horizontal strokes. Near the foam burst, I lifted some of the wet color with a tissue. Again, I wanted the vicinity around the burst to fade into the mist.

For the wave's clear water, I used viridian with some ultramarine blue. With a #8 round, I started at the bottom of the wave and worked upward. I lifted my brush at intervals, cleaned it, then worked the last strokes upward using only water. In other words, fading the color as I went until there was little color left at the top. While it was still wet, I added ultramarine blue at the base to darken it. You can see that the gradation from dark to light worked quite well.

Using the same colors I added holes in the wave face foam. Always make sure the holes of the base have the same color and value as the base clear water. The same applies to any holes up the face. They should match the color of their level. Notice I also made the holes follow the contour of the wave face. Finally, I laid in some of the same colors in the surf and foreground collapsed wave and put in a shadow line beneath it.

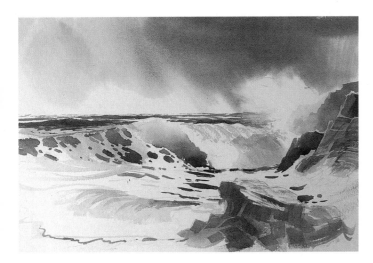

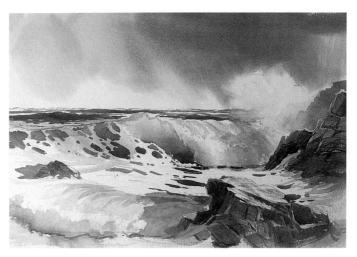

step three: rock structure

I first worked on the background rock that fades into the foam burst. I used ultramarine blue and a touch of both viridian and cadmium red deep. The red and the green neutralize to make a grey. I went over the original wash but as I neared the foam I added more water to fade this layer as well. I stopped short of covering all the former wash. The darker portions of the background rocks were burnt sienna and ultramarine blue. The lighter overlays were the same but with more water. Occasionally, I added a touch of red for variety .The foreground rock was treated much the same. Except for the top, I used very little burnt sienna. This second layer is still underpaint. Real definition would come next when this is dry.

step four: rock definition

Detailing the rocks required some thought. The second layer was applied with a ½" flat which left definite structural block-like shapes. In this stage I defined these areas with shadow lines. This gives a three dimensional effect or a thickness to each section. I used a darker version of the underpaint and applied it with a #6 round. I also darkened the lower portion of the background rock and the outer portion of the foreground rock.

Standing back from my easel I realized the composition would be better with a third rock so I added a small one to the left. The smaller rock helped to balance the composition. I also made it lighter to keep the contrast down, otherwise there would be an unwanted second center of interest. I had already laid in a cast shadow on the breaker foam. Next I defined it more clearly with some ultramarine blue and a touch of cadmium red deep. This application created variations in value and action within the shadow so it wouldn't appear flat. I added more shadow on the left of the breaker foam to show thickness and form and added a thin shadow line at the top of the translucent water. Next, using mostly ultramarine blue, I added shadows on the surf, cast by the other rocks, and shadow on the foreground collapsed wave.

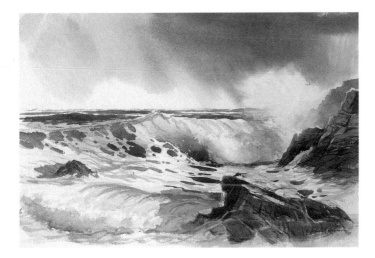

step five: final details

Then it was time for a fine point from a good round brush. It could be a brush of nearly any number as long as it came to a fine point when wet. I first painted surface ripples with shadow color, both across the wave foam and the blanket foam below. The rocks were detailed with darker lines and dots of color. It is a good idea to darken a previous line here and there to create a variation. Even a slightly different color may be used if it doesn't detract.

Back up at the translucent area of water, I added some silhouette lines, again just a bit darker than the underpaint. I then used the point of my knife to nick out some sparkle over the clear water. On the foreground rock I scratched out some white trickles, showing water dripping from the overhanging front. Stepping back I could see it was time to stop. We must all be careful not to get too carried away.

close-up

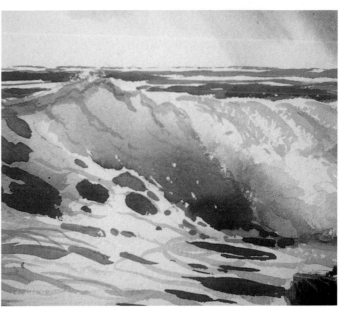

the forms and shapes of
rocks

Here's where I reveal all my secrets for painting sea-swept rocks
in all their marvellous variety, color and texture.

Painting the sea involves three natural elements: the sky, the water and the earth. Rocks, headlands, and beaches all represent the earth and play their vital part in creating harmony in a painting.

Rocks are special ingredients because their sharp edges and stationary position are a contrast to the softer edges of foam, clouds, and moving water. Too often I have seen the harmony of a painting upset because every element was all hard edged or all soft edged. Often this is because rocks were painted with soft edges or potato-like forms or the foam and clouds painted with hard edges. Nature is made up of contrasts and paintings of nature should reflect this.

Part of the problem is poor observation; we look at something but we really don't study it. For example, we see a wave burst against a rock and are inspired to paint it. However, the action was so momentary we really didn't have time to study it and this results in poor information.

Another handicap is caused by the camera. It captures the moment but the camera has only one eye and sees everything in sharp focus whether it is moving or not and whether it is far or near. With two eyes, we see hard details only when we focus on them. Otherwise everything else is slightly out of focus, especially moving objects and objects in the distance. Copying photographs therefore, removes the human outlook unless we are careful to soften moving objects and anything in the distance. I have gone so far as to reserve the hardest edges and most details for my center of interest and give less focus to everything else. After all, that is the way we see.

Another problem is being too literal: seeing something that is rare or odd and putting it down simply because it exists. I am reminded of an incident in a class I taught near Bandon, Oregon years ago. Due to poor weather we started in the studio and students were working from sketches they were supposed to have brought to class. At critique time I found that one student had painted a seascape with tall, needle-like rocks all across the foreground. They were very distracting and I gently pointed out to the class that there were too many, that they distracted from the otherwise nice breaker, and finally, that rocks didn't really "grow" that

way. The next day the weather had cleared and we all went to Bandon Beach for the experience of painting on location and there they were! Tall, needle-like rocks looming against the sky!

The students got a good laugh out of my reaction and I found it very amusing but I then gave them my little lecture on being too literal. I wanted to know if they would have painted a dead whale in the surf just because it was there, or perhaps a rusting automobile. My point is this: there will always be something odd or something in the way, but we are creative artists with the license to recreate for better harmony and composition. If you wish to paint needle-like rocks, or dead whales, or anything else you may see, that is perfectly all right, but you must remember that those objects will become the center of interest and the sea will only be a backdrop for them. Enough lecturing, let's look at the types of rocks you may wish to paint.

flat rocks
To avoid lumpy, shapeless rocks, think in terms of a group of odd sized boxes. Their forms have definite tops and sides with sharp edges. When you paint these forms, use shadows to show the sides and lines and textures for character. It is also a good idea to soften a few edges for variety but the overall impression should be hard edges.

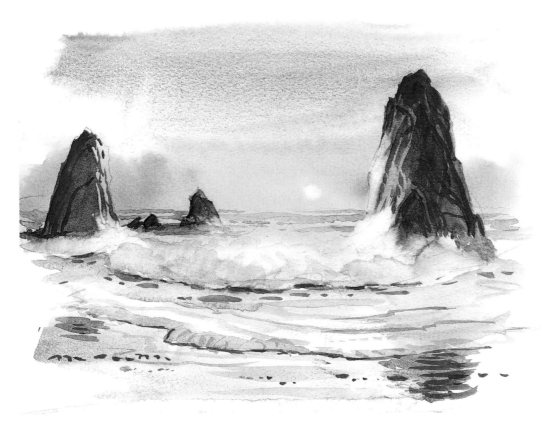

upright rocks

With my "sermon" at the beginning of this chapter in mind, let's not make upright rocks too exaggerated. Upright rocks are generally taller than they are wide. It is best to give them a slight lean to avoid a less interesting vertical and their edges should not only be sharp but made up of curving as well as straight lines. Their interior planes should follow their upright habit. To divide the interior into horizontal shapes would not be in keeping with their character. This sketch is actually the way a group of rocks look at Cannon Beach, Oregon, though I took some liberties to portray them as I have. You will note, however, that they are too unusual to play a secondary role in this scene.

They command attention because of their shapes, values, and position. The sea plays the secondary role. This is perfectly alright as long as you have decided this is what you want.

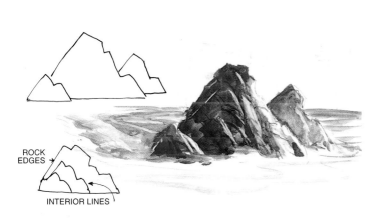

ROCK
EDGES

INTERIOR LINES

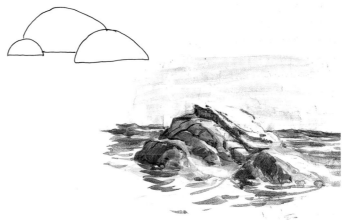

angled rocks

Angled rocks aren't box-like so may not show tops. However, they do have characteristic shapes and form. The secret is to establish hard edges with unequal sides. In other words, avoid perfect cone shapes and make one side longer than the other. Next, work on the interior shapes. In order to avoid a flat, cut out look, the rock must have depth and different layers. The interior area can be broken up with lines that suggest shapes and forms as well as cracks, pits, and holes. Make use of sunlight and shadow to bring out the interior forms.

rounded rocks

You will come across rounded rocks and some of them may come out looking more like potatoes than you wish. Go ahead and paint their rounded shapes but sharpen some edges and show a point or two and your rocks will be more rock-like. Even rounded rocks can have character, with broken off slabs, cracks and lines. As with any form, you may also alter the look with the use of shadows and reflected lights.

85

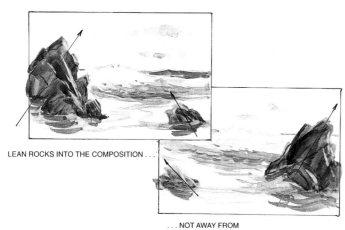

LEAN ROCKS INTO THE COMPOSITION . . .

. . . NOT AWAY FROM

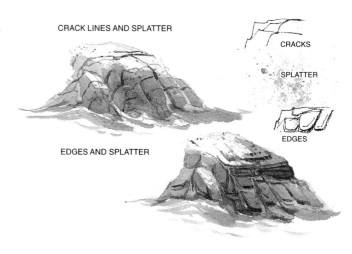

CRACK LINES AND SPLATTER

CRACKS

SPLATTER

EDGES

EDGES AND SPLATTER

leaning rocks

As I mentioned before, tall, angled rocks are more interesting if they lean slightly, avoiding a perfect vertical. However, if the tall rocks are off to the edge of the composition, it is better to lean them inward, toward a center of interest. Leaning them out to the edges could lead the eye away from the center of interest. Sometimes a rock can lean away from an oncoming wave giving the impression of the sea overwhelming the rock but then it is best to have any second or third rocks lean toward the wave, not away from it.

interior lines and textures

Rocks are rarely smooth and all have the look of eons of erosion. By adding pits, cracks and slabs, you are assuring the look of an eroded rock. I mentioned before the importance of rock edges and interior definition. The sides of a rock look too smooth if they are not broken up in some way. When painting a rock I study its characteristics and determine if it is cracked or made up of chunk-like slabs. Sometimes it is both. Here the upper rock is criss-crossed with cracks but the lower one is divided up with defined slabs. In each case the result is made up of lines. Both rocks have some brush splatter as well.

overflows

Overflows are the result of a wave completely covering a rock, usually the flatter ones. It is a collapsed wave and made up mostly of foam but it takes on the shape of the rock and only a few more upright chunks will appear above it. Where the foam or water is thin, some of the rock color will show through. Always paint the foam in sunlight and shadow and add more of the water color to the overflowing areas. Make sure the exposed rocks are different in size to avoid repetition. As shown in this example, rocks can be both flat and rounded for variety.

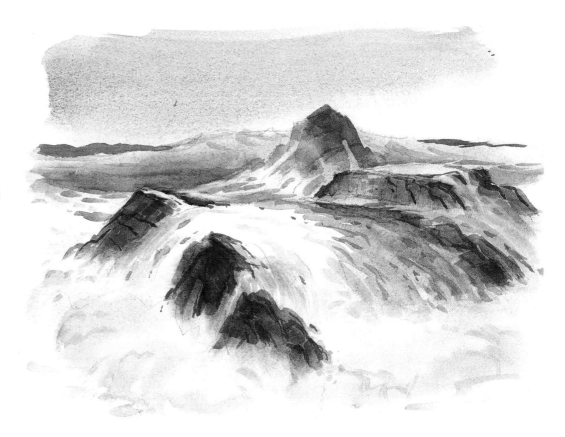

cascades

The instant after the overflow, the foam and water drop and expose more rock. Now the remaining water gushes downward between large masses of rock. The very top of the water may either be clear or foamy and the cascading water is usually white with a touch of green or blue-green.

This is a good example of an angled rock and a tilted flat one. Notice the interior cracks and lines and the use of light and shadow. Also notice the way the rock sits in the water. The bottom must fade into the foam or surface water. There should never be straight, hard lines or it will look like it is floating and be unreal. There is turbulence in this illustration because the overflow and cascades have aerated the water.

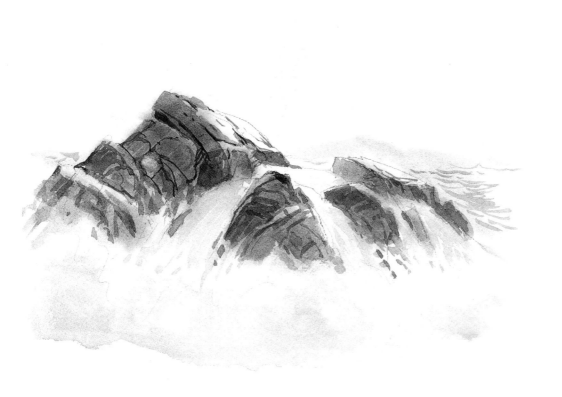

trickles

The last stage of water over the rocks is just a few trickles, water that finds its way to the surf in cracks or off vertical planes.

When you paint trickles be sure to let them flow all the way to the surf. If you stop them part way they look unreal. They sometimes flow straight and sometimes meander but they always follow the laws of gravity. Notice that the rocks still fade into the surf but there is less turbulence than in the example at the top of this page. Less action means less aeration and therefore more of the clear water will be seen.

submerged rocks

When the surf water is clear you may see rocks below the surface. I sometimes paint them as added interest or simply to break up an otherwise uninteresting area. In order to make them look truly submerged you need to follow three rules: 1. The edges of the submerged rock should not be as hard as they appear above water. 2. There should be surface lines that meander across the rock. I make the surface lines with linear foam and make sure they cross the edges of the submerged rock. It also works better if the lines flow in a different direction than the lay of the rock. 3. Paint very little rock color below the surface. I usually paint the submerged rock with a darker version of the clear water, then add a little bit of rock color, especially where the water is thinner. Notice the above the water rock is textured with both cracks and slabs.

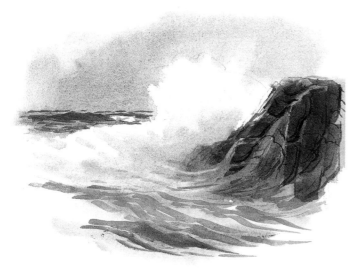

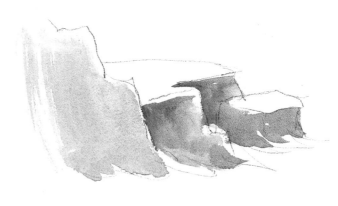

rocks fading into water

Another way to show the transparency of water is to fade a rock into a clear wave. Here, the rock color fades into the green color of the wave as it bursts against it. This can be interesting enough to be a center of interest in a composition. You can either paint the rock or the wave first, it doesn't matter, as long as you can blend the rock with the water without making it muddy. The clear water is usually a green or green-blue so use colors for the rock that are compatible, such as mauve or a combination of blue and sienna. What should really be avoided are dull brown colors for all rocks — colors such as raw sienna, burnt umber, or that very unnatural payne's gray. All the rocks in this chapter were painted with blues, greens, burnt sienna and some reds. All of them came out differently but all look like rock colors in sunlight and shadow, and different lighting conditions.

There are as many different ways to paint a rock as you can think of. The following exercise is only one way but is a simple set of steps that achieve a good result. The main thing to remember is that rocks or anything else needs to be painted in layers, starting with the base colors and working up to the surface. I have seen too many frustrated students trying to paint lines and textures first, then trying to overlay them with other colors. The results are usually muddy colors and smeared lines.

step one: shadow colors

After I have made a rough sketch of the rock, I decide where the sun is and where the shadows will be. I nearly always use a flat brush for rocks because I can get sharp edges more easily than with a round. You may choose whatever base color you wish for your rocks because that varies from place to place. In this exercise, I chose to use cerulean blue. The paper should be dry and the brush should have just enough water with the pigment to flow freely. Even then I apply it so some areas are darker than others. It is best to avoid going too dark or too light, or to paint everything the same value.

DEMONSTRATION

"Waianapanapa Surf" is from a sketch I made on the road to Hana, Maui. The drive itself is a memorable adventure but the brilliant colors of the surf and rocks are challenges. The rock formations are ancient lava flows and they often have strange, grotesque shapes. Most are nearly black but, occasionally, the material is lighter, a more earthy color. The sea is deep blue and the surf is a clean, pure, green.

I made my sketch showing the sweep of the sea rising against a curving coastline of lava rock. It is predominantly a dark painting with spot-lighting for the center of interest. I used cool colors but charged them with warm ones. Even though lava may appear black, it really does reflect other colors and looks much richer if warmed up.

Resident artists may tell you that the color of the water is different than anywhere else and that "mainlanders" don't have a clue about the right color. This is mostly true, but having painted in Hawaii many times, I did have a clue, and it wasn't something ready-mixed in a tube. In fact, the color of water varies from place to place in Hawaii, just as it does anywhere else. White sand water is much different from black sand water for example. Nevertheless, we really should not bring preconceived ideas of color to new areas no matter what. As artists we need to look for differences and try to match them. I used phthalocyanine (phthalo) green, sparingly and mixed it with cerulean to soften it. I think the results are pretty close to the water in this case.

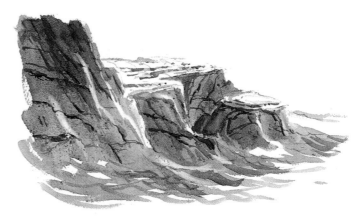

step two: charging

While the shadow paint is still wet, I like to drop in some other colors and let them flow. Here, I used touches of burnt sienna, cadmium red, and ultramarine blue. The result is an interesting pattern of colors that will be the over-all rock color, much better than a flat, brown color. It is important to mention again that values are more important than colors. One could use just about any color they wanted as long as it wasn't too far from the truth. You don't want a parrot green rock or a purple transparent wave but as long as it is believable you may use it. Just be sure your values are correct.

step three: textures

While the paint is still a bit wet, lift out some highlights. Then, use a flat brush with clear water and draw some highlights on the rock face. Immediately wipe the brush dry and go over the same lines. The brush picks up the wet paint leaving the paper showing with little color left on it.

The last layer is the application of textures. Refer to the "interior lines and textures" illustration on page 86 and use lines for thin slabs on the top of this rock and lines for cracks on the rest of it. You could also try a little brush spattering. The final result is a set of rocks with form, color and line.

LINE SKETCH VALUE SKETCH

ULTRAMARINE CERULEAN VIRIDIAN BURNT SIENNA

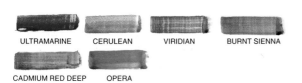

CADMIUM RED DEEP OPERA

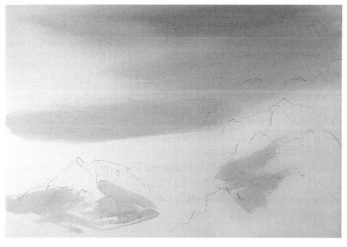

step 1: sky and sky reflections

After my initial drawing, I slanted my board and wet the paper with a sponge. I then mixed ultramarine blue with a touch of opera to warm it up. Next, I applied heavy, horizontal strokes with a 1" flat from the top of the sky area right down past the horizon line. Very quickly before the first wash could start to dry, I laid in a darker set of strokes of mostly ultramarine. The sea will reflect the sky in between the swells so should be the same colors. The dark swells of the background will be added later.

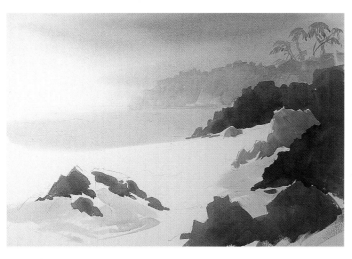

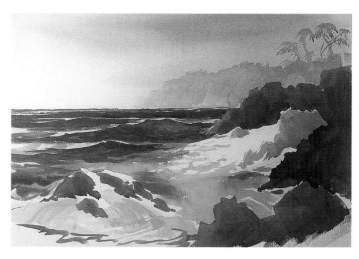

step 2: rock and headland base color

I first painted the headland with the same mixture I used for the sky, but with less water. I made sure though, that the value for the headland was slightly darker than the sky above it. I painted the palm trees with the same color but used a #8 round.

The underpaint for the rocks was different. Up close their base color is more visible than in the distance. The base color for the sunlit rock was only burnt sienna and water to thin it lighter. I then charged it with cadmium red deep. The darker rocks were underpainted with ultramarine and burnt sienna for darkness, then charged with cerulean and cadmium red deep. I applied more red to those near the sunlit rocks for reflected warmth. Forms, interior lines and textures would come later.

step 3: background sea and surf

Step three was still an underpaint but a very important one. In order to make all the colors relate and the sea reflect the sky, the colors had to be laid down before any final detailing. With a ½" flat, I applied a mixture of ultramarine blue and phthalo green. First, I laid in a medium value for the background waves, then applied a darker value of the same color near the top of each swell. (Phthalo green is very strong, so be sure to have enough blue to mellow it a bit.) For the surf area, I went to lighter values of the same colors simply by using more water. I placed a few spots and lines but was careful to leave the white foam area untouched until later.

close-up

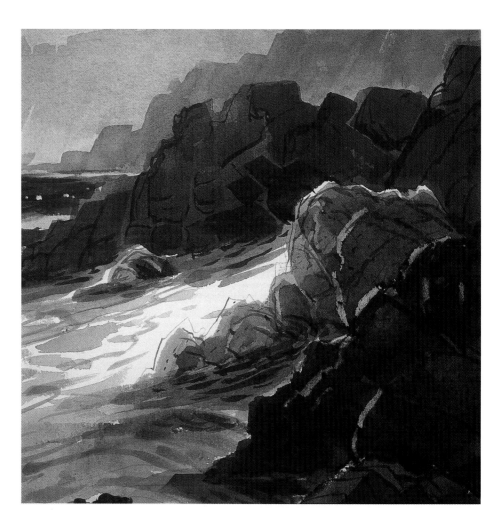

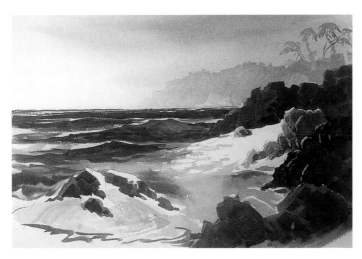

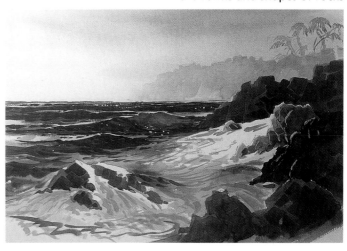

step 4: rock forms

Next came the second layer, or glaze, for the rocks and the purpose was to break up the interior planes into slabs and large cracks. For this purpose I used both 1" and ½" flats for a variety of shapes. The interior forms should not all be the same size and shape. The colors were simply a repeat of the underpaint colors, but a bit darker. Notice the sunlit rock has an overlay of sienna and the dark rocks an overlay of their base colors. I also cut in some interior rock lines with the chisel end of my flat brush before the paint dried. Doing this allowed the underpaint to show through and also guaranteed that all the interior lines would not be dark ones.

step 5: sea and surf details

I made chisel-like chops on the background sea using a ½" flat with a twisting motion. If you haven't already practiced this stroke, place the brush upright so it would make a thin, horizontal line. Then twist it upward and then downward as you move it along (see chapter 1).

I used a darker version of the same color as applied before. In the white foam area, I did the same but watered down the mixture for a more subtle hue. I also cut in some light lines to show the movement of the surf foam. The cascading water from the rocks needed some detailing so I added a bit of color, then nicked out some sparkle with the tip of my knife.

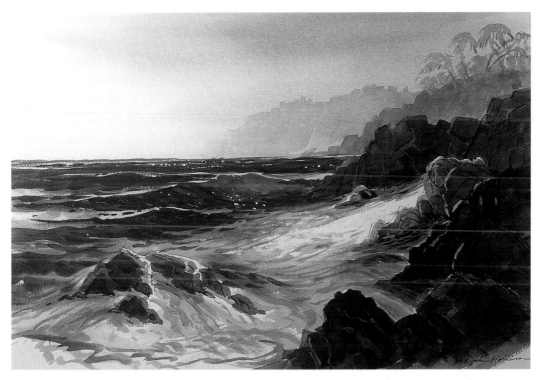

"Waianapanapa Surf, Maui", 140# cold press, 17 x 22" (43 x 56cm)

step 6: rock detailing

This stage was a good time to step back and get another perspective on the painting. I did so and was struck by the look of the palm trees in the background. They were much too large for the distance I had created for them. The solution was to create an intermediate headland under the palms, one with a bit more color or a bit darker to bring it closer. Doing so, the palms looked to be in scale with their setting. I next noticed that the foreground rocks needed correcting. They were all the same value so I darkened the central and closest one. This brought the painting to a better perspective and harmony of values.

The final detailing of the rocks was to add linear lines, cracks, and pits. I also did a bit of spattering for texture. As before, I used a slightly darker version of the underpaint for that purpose. Finally, I added a few shadow lines under the forms and cast a shadow here and there. I mixed ultramarine and a touch of cadmium red deep for the cast shadows from the rocks.

chapter 12

beaches

The flotsam and jetsam treasures of the beach; the slicks, tide pools, outlets, boats and people, can be used to break up the foreground and direct the eye to the center of interest. They also provide an outstanding opportunity for you to reflect sky color into the foreground.

When I was a child growing up along the Oregon coast, beachcombing was a favorite way to spend an afternoon because the beach held a treasure-trove of delightful objects. My sister and I used to wander through the driftwood looking for unusual shapes and figures. Of course they always seemed to resemble something else: cartoon characters or oddly shaped people or animals, and sometimes we found even more unusual things: Once we found a glass float that had drifted all the way from Japan and sometimes a float or a net from a fishing boat. Mostly though, I collected pieces of wood that were interesting just because they had beautiful forms.

I also loved to warm my back against a silvery, weathered log and watch the sea or my grandfather as he cut firewood with a large handsaw. The beach holds a special place in my memories and I enjoy including it in my seascapes from time to time. Let's take a look at how we can use the beach and its treasures for better compositions.

sand ripples

The tides bring the sea onto the beach and out again. Flood tide comes in and rises higher and higher until it reaches its peak, then recedes as a neap tide. As the water drops with the neap tide it not only leaves behind bits and pieces of flotsam, and those treasures I spoke of, but it also leaves evidence of its motion as sand ripples.

Beaches are rarely completely flat and the ripples left behind define the humps and dips as well as the scalloped curves of inlets. When painting sand ripples, I first paint in the color of the sand, let it dry, then paint the ripples using a slightly darker version of the sand color, painted to show the contours of the beach. Sometimes a shadow line may be added to some of them, giving them depth.

seaweed clumps

I know, seaweed can be smelly and fly covered, but it is still a good addition to a foreground when you want to break up an uninteresting area.

Seaweed is usually an olive green but sometimes it can be reddish, sienna, purple or green. In other words, seaweed also gives you a way to echo a color from somewhere else in the composition. It is best to show seaweed in clumps rather than scattered about.

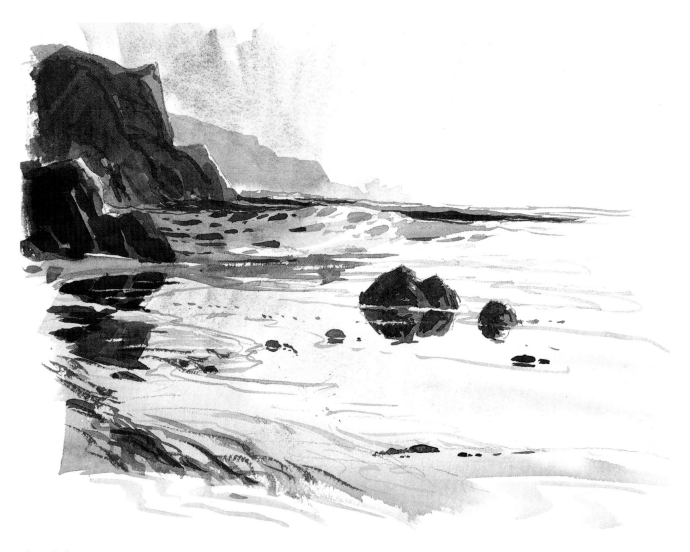

the slick

I have mentioned the slick before but have not shown how effective it can be in a shoreline painting. Quite often the view of the surf is blocked by rocks, or the surf ends abruptly against dry sand. By adding an area of wet sand, you now have an added interest and a way to bring in sky, rocks, or bluff colors. Wet sand is also nearly mirror-like, so objects reflect well in it. Here, the slick not only adds harmonious color and reflections, it also adds another element between the sand and the surf.

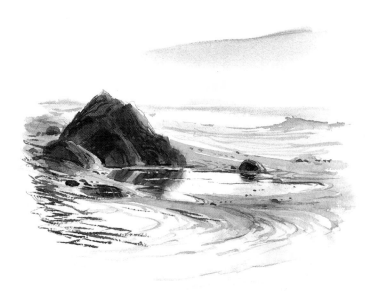

tide pool

Tide pools are pools of trapped water, either in rocks or hollows in the sand where they have been scooped out by the action of the water. Rock pools have all kinds of colors and life in them and some artists have made a career of painting them. Beach pools are less likely to contain life but are, nevertheless, a good addition to some seascapes. They may either be the center of interest or a supporting feature depending on how they are presented. In this example I have featured the pool with a dark rock reflected in it. In this case the sea is clearly background. Tide pools are also good opportunities for reflecting the sky, thus bringing those colors to the foreground for harmony.

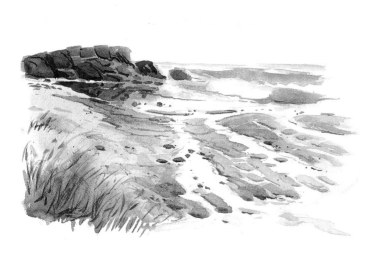

outlets

Water from creeks or springs cut their way across the sand to empty into the sea. When placed "just so" in a composition they not only break up space but can lead the eye to a center of interest. Outlets can be rushing streams but I prefer the meandering, shallow streams that reflect the sky or pebbles beneath the surface. I consider them important enough to give a quick, three-step lesson on how to paint them.

step 1: sky and reflections

After a quick sketch wet the paper with a sponge. Immediately paint in the sky color and use the same mixture in the foreground where the outlets will be. It isn't necessary to paint in the shape of the outlets. The next step will define those shapes with the edges of the sand. For now, it isn't important what colors are used either. Only the method of painting them is necessary for practice.

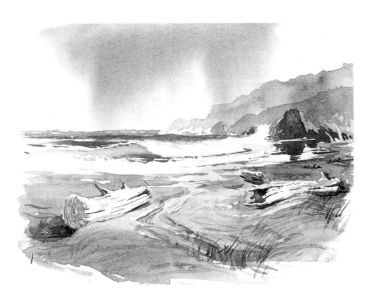

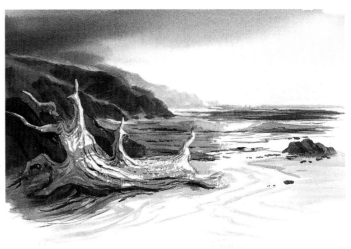

driftwood as added interest

When painting driftwood logs as added interest, be careful that they aren't too interesting or they will distract from the main center of interest. I use them to break up space and to add a more authentic look to the beach but I also use them to direct the eye. In this example, notice how I lined up three logs so that they lead to the wave crashing against a rock. They are painted with very little value change from the surrounding sand whereas the wave, rock, and the rock reflection have a strong value change and demand attention.

driftwood as a subject

Here I have shown a windfall from some long ago storm — a silvered and twisted log with its roots. I made it stand out by having a very dark background, giving plenty of contrast. The sea is in shadow and obviously plays a background role. In order to achieve this, I taped off the log and when the background paint was dry, I added color and texture to a clean, white area of paper.

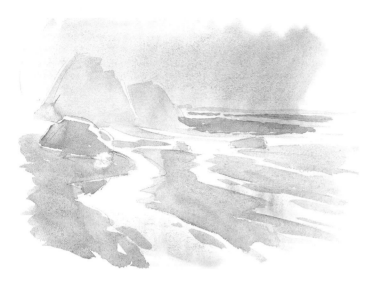

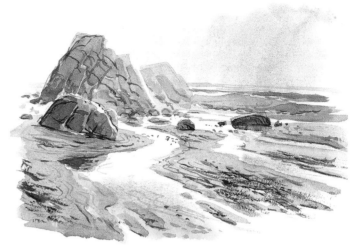

step 2: forms

Next, block in the forms of the rocks and the sea. (Notice that I used a very thin wash for the distant rocks. It was glazed over the sky color which was dry and the sky color shows through, giving a warm atmosphere.) Next, mix the color for the sand and paint around the meandering lines for the outlets. Because the sand is darker than the sky reflections it makes the outlets stand out clearly.

step 3: details

Detailing is the fun part. Some artists call it adding "salt and pepper". I have always told students it was "icing the cake" and of course, a cake cannot be iced if there is no form underneath. So, first texture the sand with a few ripples and some scattered flotsam. Edge the sand with a thin line just a bit darker than the sand in a few places. This helps to define the contours. Next, line and texture the rocks and add a few more smaller ones that reflect in the wet areas. Finally, add a few pebbles to show the water is thin. Only three steps but the result is a clearly defined set of outlet streams.

other objects

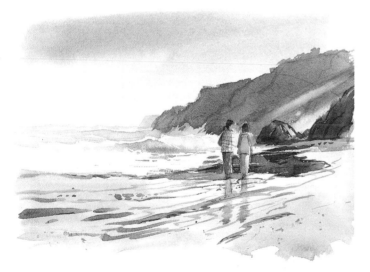

Many objects may be found on beaches but unfortunately some are not worthy of painting. I refer to garbage left by uncaring visitors — dead fish, dead cars or worse. However, we artists can leave them out and put in what we choose. People and boats are good examples of subjects we can add to beach scenes.

people

I have seen some very nice paintings of people on beaches, people at camp fires, children playing or just people strolling. Beaches are usually in a horizontal composition rather than a composition of strong movement therefore the mood is usually restful and serene. This sketch shows a couple walking beside the sea. The surf is quiet, restful rather than stormy, and I have placed them away from the center of the page. It might have been better to have had more sky or more beach but the composition works well enough.

Adding people gives us a chance to add another color as well. Notice how you are drawn to the figure. It is not only because the people represent another element in nature but the color is not repeated elsewhere. Even the reflection isn't as noticeable.

boats

Boats, like people, add another element and can attract attention if you wish to make them the subject. In this illustration I made the sea a quiet backdrop to the foreground boats. Their color, the contrast created by framing one among rocks, and the added piling all keep the attention in the foreground.

DEMONSTRATION

For "SUNDOWN AT THE BEACH" I made a linear sketch with outlets running across sand to the center of interest, the rock in front of the glowing sun. My values must be strong at the center of interest so I intended to reserve the darkest dark for the strongest contrast to the light area of the sun. Most of the painting would be a middle value but with lighter values in the sky and their reflections in the slick.

Cadmium yellow medium was my chosen color for the sunlight, viridian is for the sea, burnt sienna and cerulean blue for the rocks. The remaining colors, such as opera and ultramarine blue, were used to charge the others.

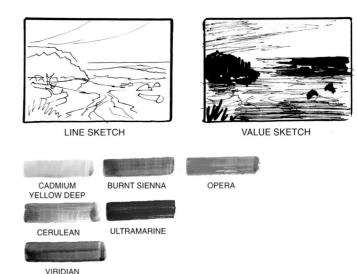

LINE SKETCH VALUE SKETCH

CADMIUM YELLOW DEEP BURNT SIENNA OPERA

CERULEAN ULTRAMARINE

VIRIDIAN

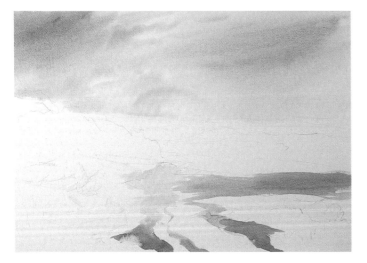

step 1: sky and wet-sand reflections

After my initial drawing, I took a few moments to tape off the foreground driftwood. With my board slanted, I then wet down the paper in the sky area and in the slick and outlet areas below. I used my large #12 round sable and applied cadmium yellow medium for the glow area. I repeated some of that in the foreground. With the paper still wet, I stroked in cerulean blue and ultramarine, then added a bit of opera to warm it up. These colors were also repeated in the foreground. You will notice that my brushstrokes are on a slight slant. This is because the composition is horizontal and the slanted lines keep the painting from being monotonous.

You will also notice that the outlet water is darker than the sky. That is because it is in the foreground and reflects more of the sky above. The sky above is nearly always darker than it is at the horizon.

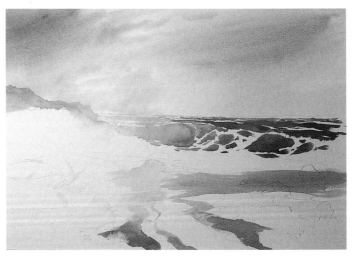

step 2: underpaint for the sea

With my #8 round I cut in the waves below the sun with the yellow medium. As I painted outward, I gradually made the yellow become bluer with ultramarine. I then dropped in some opera and viridian for variety. While in the vicinity I thought I would also paint the background rock. I started with cadmium yellow medium under the sun area then added opera as I painted it toward the left. Finally, I added ultramarine to darken the rock further.

Waves and rocks will take on the color of the sun when it is directly behind them. This means the viewer is looking at the sun and the objects are blurred by the brightness and color.

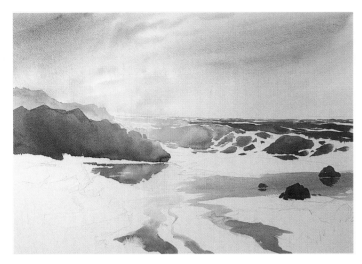

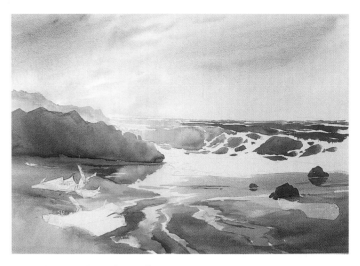

step 3: underpaint for the rocks

Using ½" flat, I began with the rocks just beneath the sun using cadmium yellow as before. I then added opera to the yellow and washed to the left. As I continued to wash color away from the sun I added ultramarine blue to the opera, but no more yellow. I then added some blue to the base of the rocks. The rock's reflection is a repeat of the colors used above. Notice I lifted a couple of horizontal lines; I held the flat brush upright and simply drew the thin edge horizontally. Last, I added three more smaller rocks on the right. Two reflect into the slick and one sits on sand, which does not reflect.

step 4: beach underpaint

As I have said before, the color of beaches will vary from place to place. Sometimes it is best for the color harmony of a painting if you choose a beach color that is more in keeping with the tone of the painting than what the sand color actually is. In this case, I chose burnt sienna but I kept the purest sienna for beneath the sun. The rest was mixed with ultramarine, some viridian, and some opera to give some warmth in places. The taped-off driftwood was now more visible but I intended to leave it until I did more painting around it.

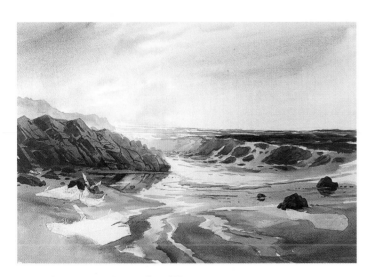

step 5: rock and sea detailing

I actually painted two steps on the rocks: I first used my ½" flat to define the broader shapes and shadow areas with a darker version of the underpaint. Then, after that work was dry, I cut in the lines and cracks with the point of a #8 round. Again, I used a darker version of the first mixture. Next, I reflected some of the more visible lines and textures below the rock but not exactly, nor as dark. I did not want a mirror image. Finally, I added a group of smaller rocks under the main mass and behind the left side piece of driftwood.

To detail the sea, I laid in an ultramarine wash as a shadow over the white foam of the right side background and the foam patterns on the wave. I then added foam lines and some subtle detailing on the transparent wave. When everything was dry, I pulled off the tape, exposing the shapes of the driftwood.

step 6: detailing sand and driftwood, "Sundown at the beach", 17 x 22", 140# cold press

The white forms of the driftwood came next. They could not remain pure white but I wanted a clean area to work in so the colors would be unmuddied by overlaying. I especially wanted clean, white, edges on some of them. I mostly used burnt sienna as a thin wash, then added ultramarine and opera for variation of cool and warm coloring. After the initial washes dried, I detailed the pieces with lines and textures, using the point of a #8 round. As always, the lines were a darker version of the underpaint. The last step was to texture the sand and add some grass here and there. I painted in sand ripples the way I showed earlier in this chapter. I didn't want too many which would be too distracting. I only wanted enough to give the appearance of a typical beach. Under the sun area, I didn't want any sand ripples at all. The glow of the sun obscured the detail, even in the foreground. The final effect is a view from a beach and looking toward a setting sun.

harbors and coastlines

The sights and sounds of a working harbor are unforgettable, and to render them evocatively you must instill that atmosphere into your painting. Harbors also challenge your skill at painting reflections. We covered reflections before, but here are some more pointers.

wooden piers
There are as many different kinds of wooden piers as there are boats. Most of them, however, are basically wooden-planked decks supported by vertical logs. The logs may have all kinds of bracing as support and there may be rusty old bolts protruding here and there. A single plank or piling can be so individual and interesting that it would make a good subject all by itself. Most piers have either a railing or a heavy rope strung from post to post and nearly all seem to be cluttered with boxes, traps or fishing gear, especially if a boat is moored alongside. This is a very simple wooden pier; not too interesting, but basic in structure.

As a child growing up on the Oregon coast, it was necessary to move quite often because my father went where jobs were available. Many of the towns were small fishing or logging villages and the memories of those colorful places are very dear to my heart. My father either logged or found work as a longshoreman, but my uncles were fisherman, following the trade of our English ancestors.

Often I would wait at dockside for their return from the sea. They had to cross the "bar", a narrow and sometimes treacherous inlet to the harbor. There were times when I watched with some fear as their boat lifted and dropped, rocked from side to side or seemed perilously close to the rock jetty. This fear was generated by stories of other family members who had not made it. Fortunately, I never saw a disaster of any kind and as the boats came into the harbor they seemed to glide noiselessly to dock as if there was nothing to it.

The sights and sounds of a working harbor are unforgettable, and if you are to paint them as a subject you must instill that atmosphere into your memory banks. It is more than just picture taking when you paint; you are painting feelings as well. You need to see the wheeling and screeching gulls in the sky, hear the shouts and laughter of the men, the chugging of diesel engines, the grinding and scraping of boats nudging the pilings. Then, there are always the smells of oily water, tar, hemp ropes, and the peculiar odors of waxes and waterproof tarps. These are the ingredients to include in a painting and they are as important as learning how to draw or mix colors.

Harbor water is a study in itself: no longer the action of waves against rocks and the bounding energy of the surf, harbor water is serene, calm and very reflective. It is a mirror for sky, bluffs, buildings, boats, and people. You have seen the principles of reflecting water in chapter 7; now let's put that knowledge to work.

piers and piling

Piers and docks can be made up of logs and timbers, or piles of rocks. Modern docks are often just platforms resting on pontoons, but I prefer the more colorful, and still used, old ones. Pilings are usually logs that have been driven deep into the harbor by a piledriver. They support docks, are used for mooring boats, and when they are placed further out can be used for channel markers. In any case, they are valuable elements in your composition. When placed right, they provide a vertical line in an otherwise horizontal painting, or they may simply be used to break up an uninteresting space.

rock piers

Rock piers can be very colorful. I start by laying in a base wash, letting it dry, then overlay it with rock forms, and finally cut in lines for shapes and shadows.

The procedure is exactly the same as for painting a large rock but in this case it is a grouping of smaller rocks.

Avoid painting too many the same size and shape and don't use too many colors. Just a few colors with some variation is fine — and it looks authentic to use a mossy green for those lower rocks that would be covered with a high tide.

piling

Here are the three kinds of piling: The single type, the clustered, and the conical in the background. Notice how each of them breaks up space in the composition or gives perspective. I should point out that most pilings are cut on a slant. If they were cut square, water would collect and begin to rot the center. More modern piling will often be capped with a copper or plastic cone. The seagulls do not like them one bit.

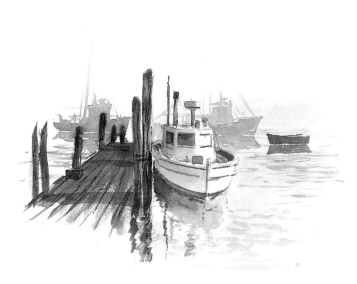

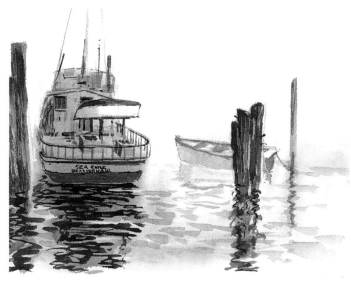

boats in still water

Truly still water may give a mirror image but I prefer to have just a little ripple or two and avoid that. Mirror images are distracting and confusing, so I ripple the water as well as make the reflection a bit lighter and with less detail. It should be noted that a reflection doesn't necessarily reflect the colors of the objects. In some cases, the color of the water will show, taking on the shape of the object. The green reflection shown here is a good example of this. The water is actually green in appearance but is reflecting the sky — except under the boat.

boats in rippled water

Ripples break up mirror-like reflections. The reflected edges meander about and even appear detached. There may also be an interchange of reflection and non-reflection as described in chapter 7. The more the water is agitated, the more broken up the reflections will be. For the most part, harbor water is fairly smooth and the ripples have rounded, curving edges. There is nothing better to show contrast than the clean lines of a boat above the jagged, choppy water below.

boats on dry dock

Sometimes called "on the ways", a boat out of water is in for repairs. They seem almost embarrassed as they sit exposed, propped up by old barrels, timbers and whatever is handy, having their bottoms scraped. Nevertheless, boats in dry dock make a delightful subject and are an integral part of harbor life. I like to show some water in the background, a reminder that this is still a part of seascapes and harbors.

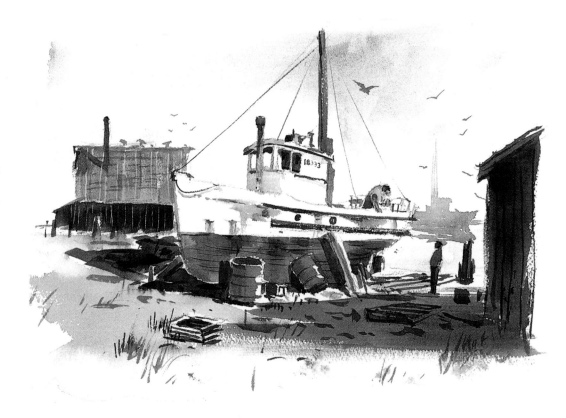

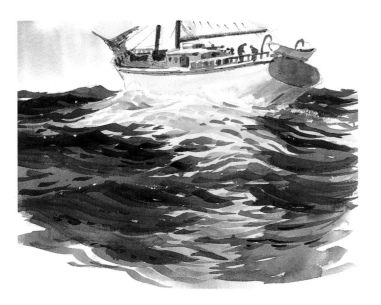

boats at sea

Open sea is the ultimate in choppy water. Here the boats cut through swells, which are really huge chops, and the swells are covered with smaller chops. This sketch shows a sail boat reflected in swells. The boat itself will create some of the action: The prow cutting through the water churns up some foam, the forward movement leaves a foamy wake and ripples are formed by its passing as well.

low tide

At low tide, smaller boats that have been tied up will rest high and dry on the berm or on launching ramps. It is a good opportunity to show harbor and land together. In this illustration, small boats rest on the ground with the larger boats riding anchor or tied to piling. This sets a mood of peace and quiet. The harbor is truly a haven of rest.

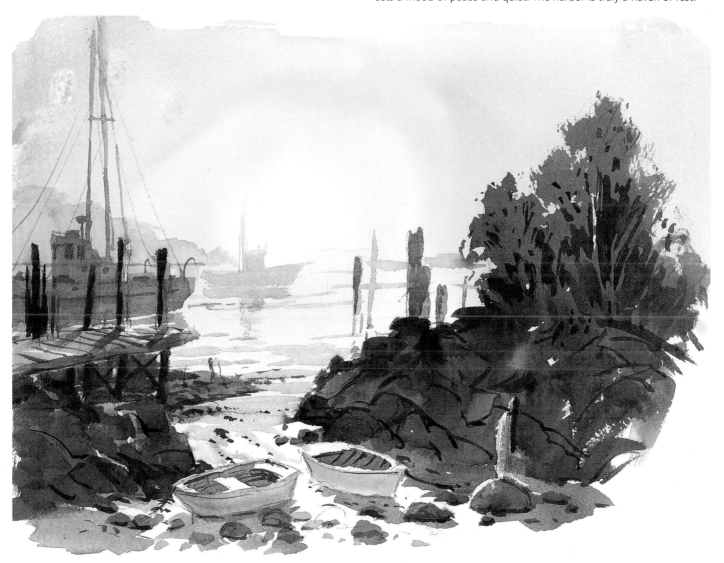

fishing shacks

Another vital part of harbor scenes are fishing shacks. Often built on piers or cantilevered out over the water on piling, they add a great deal of color and can make a wonderful subject. Of course there are modern buildings, even boutiques and tee-shirt shops now, but I prefer the old relics with character. Here is just such a shack, but also a wooden dock and a stone pier. You can have fun with this subject by adding all kinds of signs, people, activities, and color.

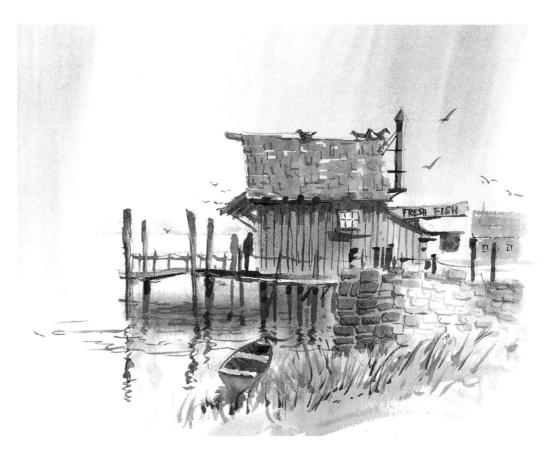

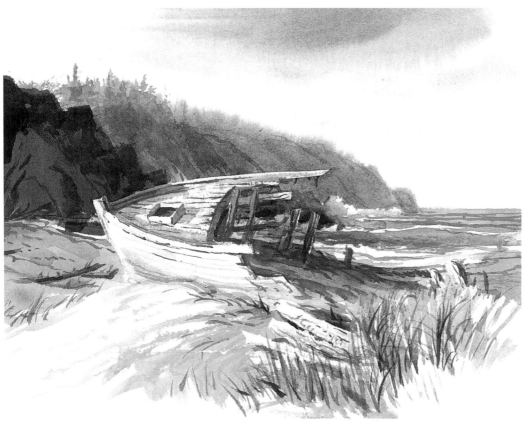

shipwrecks

I was quite young when I first saw the wreck of the "Peter Iredale", a great steamer from the early 1900s. She had gone aground off the mouth of the Columbia River in 1906. It was a stormy day but I bundled up and walked around her. Most everything was long ago buried in the sand but the bow and the bowsprit were intact and a number of rusting ribs projected above the sand. There were still a few weather timbers, rusted bolts and pieces of iron as well. This old relic is another grim reminder of the power of the sea and man's limitations against nature. It was a subject I was to repeat many times and though I made a new composition each time, I could not help but portray the same mood.

Here is the wreck of a much smaller boat, a wooden fishing trawler, but the theme is still there; the mood of tragedy and loss. The sea appears placid but the wreck is a reminder of its awesome power.

lighthouses

Some artists make a career out of painting lighthouses. Like so many other things associated with harbors and coastlines, lighthouses are disappearing all too fast, so we should be pleased someone is giving them immortality.

When treated as a focal point lighthouses are so interesting that the sea is only a backdrop. Here, I taped off the structure first and painted the background. That left a clean, white surface to paint the shadow and details.

Notice the position of the lighthouse. It is in one of the four optimum places for a well balanced composition as referred to in chapter 6.

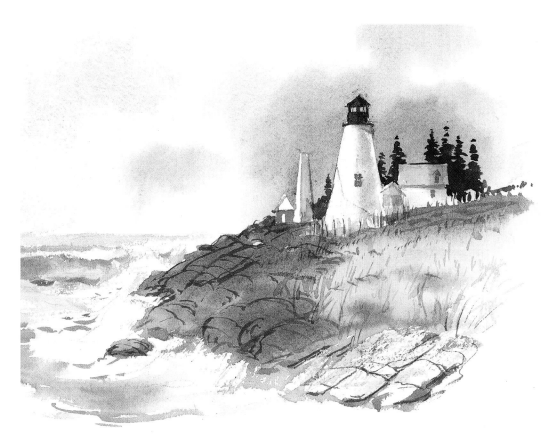

islands

Many coastlines are dotted with islands, remnants of the eroded land and the action of crashing waves. In the Pacific northwest, as well as other places around the world, many islands are tree covered. They can be treated in a quite dramatic way with weather-beaten trees above stormy seas. They lend themselves to a theme of endurance against the relentlessness of the sea. However, even though they are an interesting subject, I generally give them a secondary role with the sea as the main attraction.

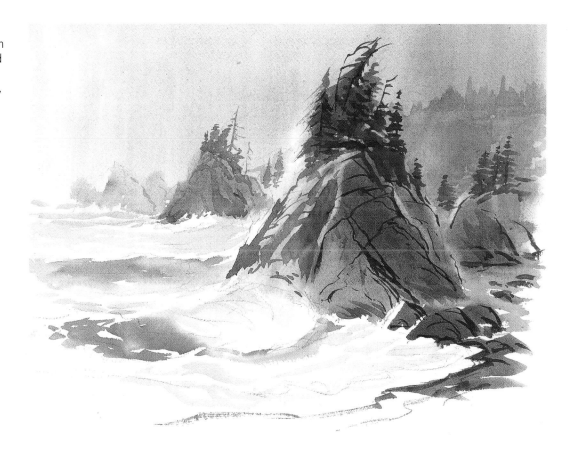

DEMONSTRATION

For "Noyo Harbor", I worked from a small watercolor I had done on the scene. It needed some corrections so I made several sketches until I arrived at this one: a simplified setting, it is nearly a vignette because there is so much light area around a contained grouping of objects. In the value sketch, I arranged the dark areas to frame the boat and buildings, then used middle values to push the buildings back. This made the cabin of the boat stand out strongly and made it the center of interest.

The colors are mostly hooker's green for the trees and the water, augmented by all of the other colors in the adjacent palette. The buildings were mostly burnt sienna and raw sienna, also influenced by the other colors. Overall this was to be a green painting with both warm and cool variations.

LINE SKETCH

VALUE SKETCH

HOOKER'S GREEN CERULEAN BURNT SIENNA RAW SIENNA

CADMIUM RED
DEEP MAUVE

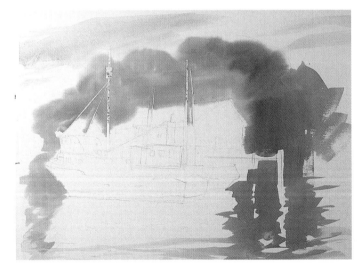

step 1: background trees and reflection
After my initial drawing, I took time to tape off several masts. As usual, I laid the tape over the area, then cut away what I didn't want with a sharp blade. I then wet down the paper, slanted my board, and quickly laid in my colors with a 1" flat. I first used hooker's green with raw sienna, then came back over it with some cerulean blue. I used quick strokes but painted around the buildings. I wasn't too concerned about some color bleeding over those structures because they would become background, but I was careful to stay away from the boat because I wanted it to remain pure white for later work. I also laid in a couple of cerulean strokes for the sky. Notice the water reflects the background.

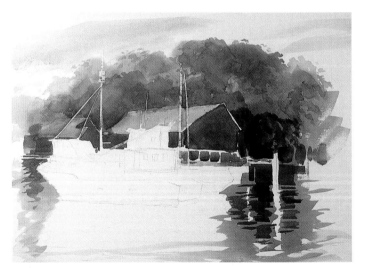

step 2: background buildings and trees
I laid a second wash over the background trees with hooker's green and burnt sienna and reflected them in the water as well. Notice I left the boat and its reflection untouched. The buildings received a base wash of burnt sienna charged with cadmium red deep and cerulean. I avoided being precise because nothing but the boat would have sharper lines and attention to finer details.

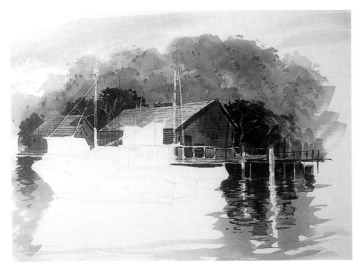

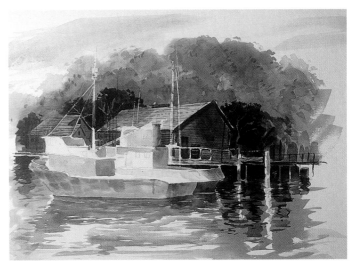

step 3: background detailing

I added some very dark tree forms to frame the buildings. Not only would this set off the boat as the center of interest, it also defined the shapes of the buildings. You can now see why I was not concerned when the first wash ran into the building space. The very strong dark colors were made from mauve and hooker's green. This can be mixed to be cool in tone with more green, or made warm in tone by adding more mauve. Before this section dried, I scratched in a few tree trunks with the chisel end of my flat brush then added a few leaves near the edges. I detailed the building with the point of a #8 round, cutting in shingles, boards and windows. I also darkened a section under the pier and reflected it.

step 4: boat color and shadows

This particular boat was already a cerulean color so I used it in the first wash of the hull. I later went over it with slightly darker blue to show the weathered and warped panels. For the superstructure, I painted in only the shadows as an underpaint using mauve and cerulean with a lot of water. I then charged some of it with a bit of sienna. Finally, I reflected the boat with the same colors but weakened a bit with more water.

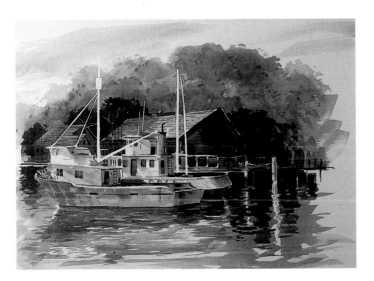

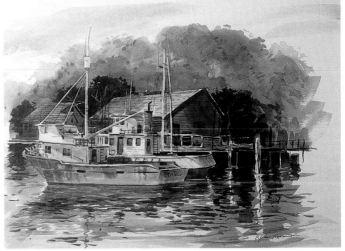

step 5: detailing the boat

I detailed the windows with a flat brush first, then lined them with a pointed brush. I also added more shadows, some other poles and masts and some rigging and antenna. The hull still needed attention so I laid in some darker plates with a wash of more blue, then under scored them with shadow lines. All of this was repeated in the reflecting water, but with less detail. Then I could pull off the tape and expose the masts and spars.

final details: "Noyo Harbor", 15 x 20" (38 x 51cm), watercolor board, rough

In this last step I carefully painted a shadow side to the masts and spars using the mixture of cerulean and opera. Then I added more rigging with dark lines. An artist has to be careful about rigging. We may know how to paint but a fisherman could easily criticize our paintings if the anatomy of the boat is wrong. I am not an expert on fishing boats so I rely rather heavily on photos to get the rigging correct. I also can give a smarty answer to criticism that says the boat was being refitted and therefore missing some vital pieces of equipment. Or perhaps a handyman had rigged the boat and messed it up? I also added more dark green color to the reflections. I felt it needed more depth than I had given it. I used my 1/2" flat for the chops and squiggles achieved with hooker's green and mauve.

photo references

I could spend all day going through a mountain of photographs and they still would not give me the inspiration to paint, but an outdoor sketch, along with my memories of being there, gives me everything I need to make a painting full of mood. So, while the photographs on these pages show you many of the specific conditions described in the previous chapters, it is not my intention to promote the habit of working from photographs. I always advocate taking your sketching kit outdoors.

Moody scene

Sun's path

Warm atmosphere

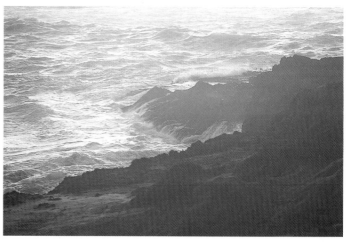

Golden light

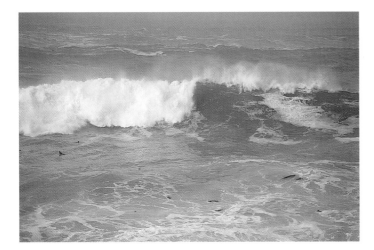

Breaker

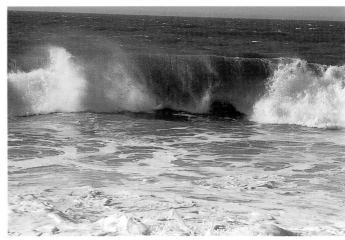

Breaker roll

Linear foam patterns

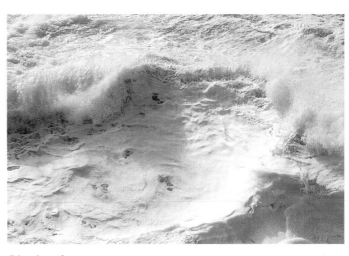

Blanket foam

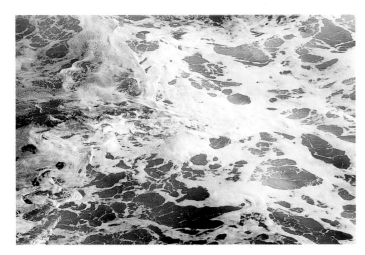

Blanket foam patterns

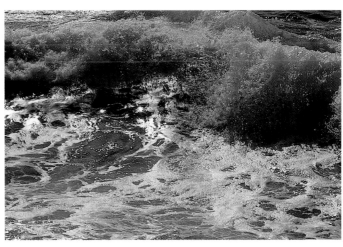

Sun glare

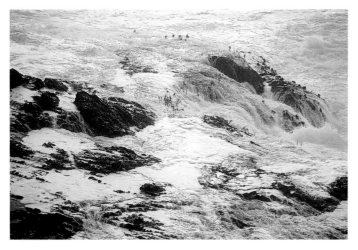

Overflows

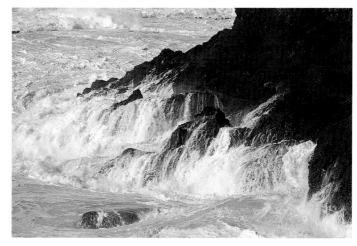

Cascading water

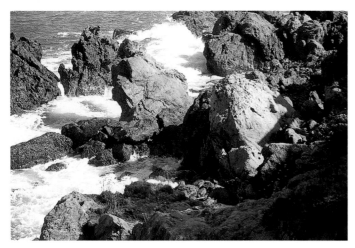

Rocks

Scud

Sand and seaweed

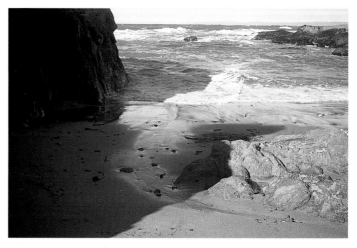

Beach outlet

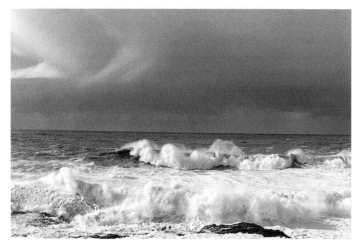

Storm sky

Cumulus clouds

Seagulls

Tranquil harbor

Harbor light

Drydock

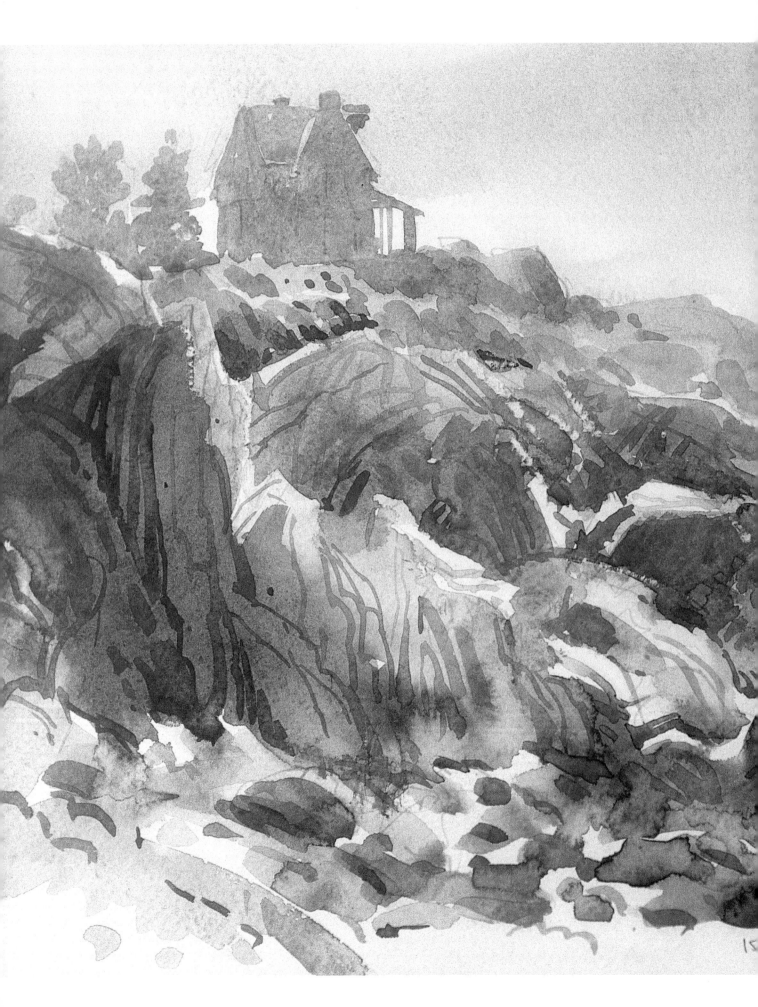

15

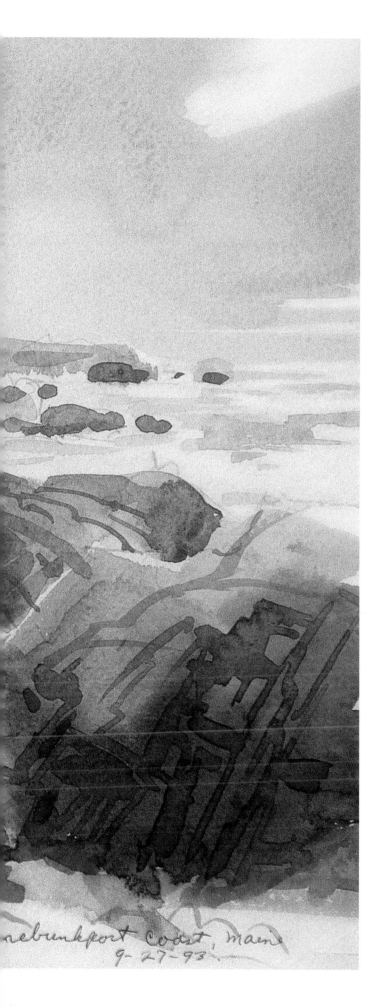

section 4

gallery

"Kennebunkport Coast, Maine", 9 x 11½" (23 x 29cm)

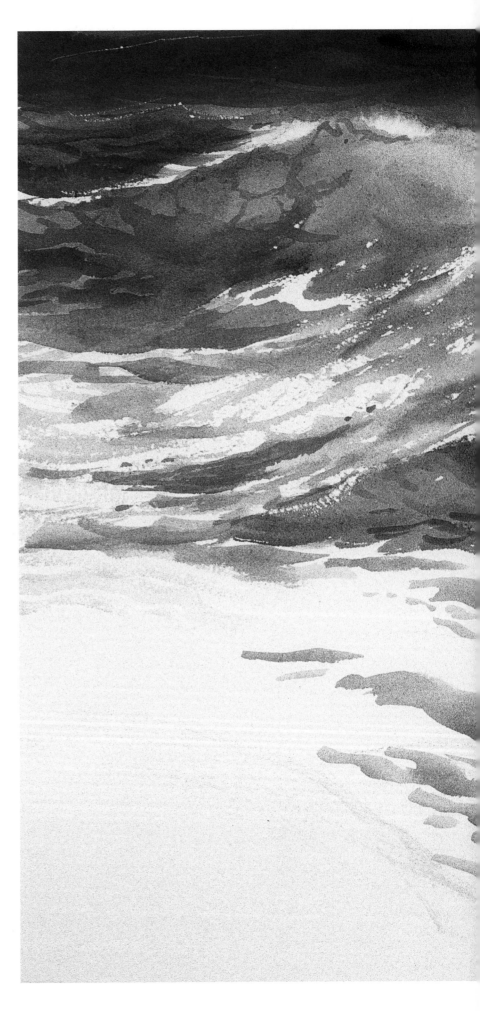

"Breaker Study",
14 x 18" (36 x 46cm)

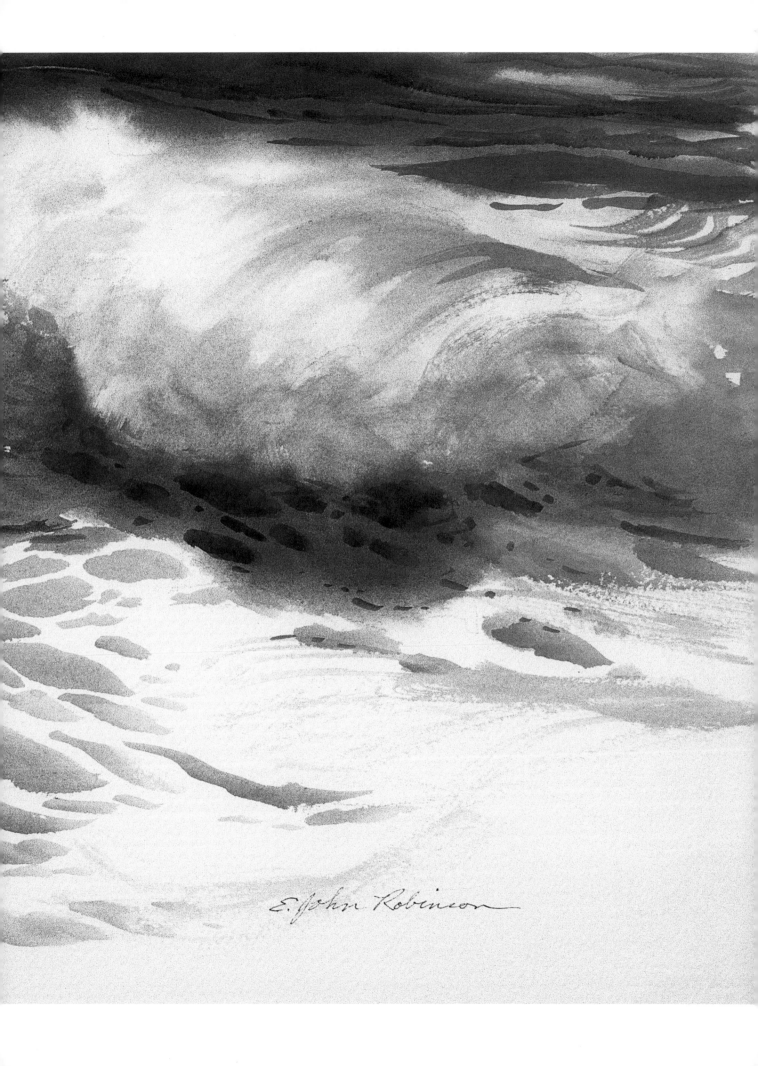

E. John Robinson

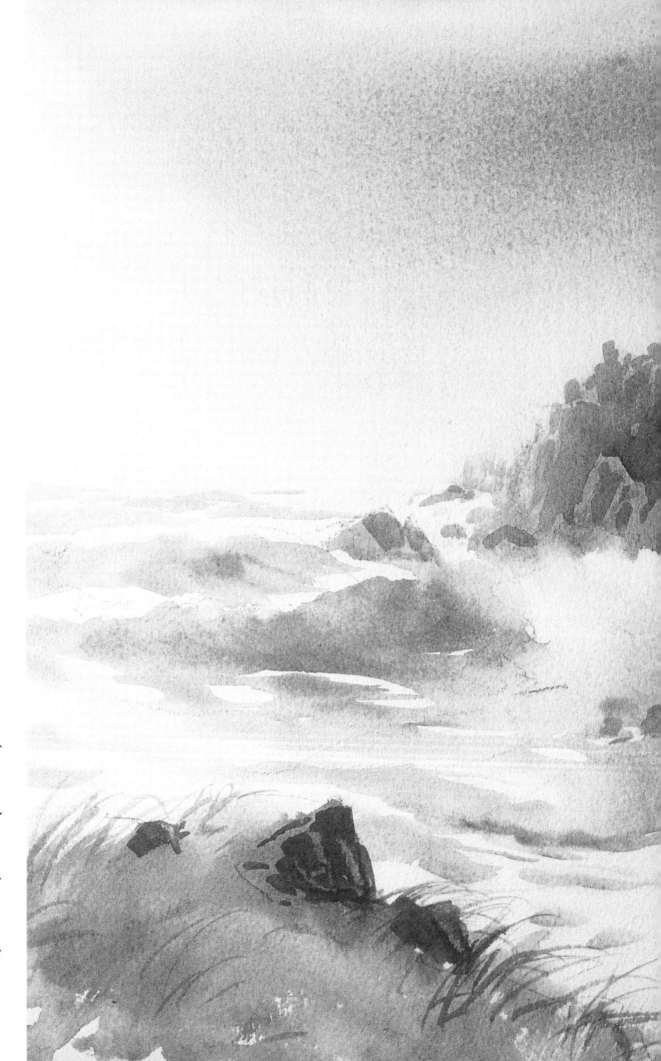

"Land's End, Cornwall", 15 x 22" (38 x 56cm)

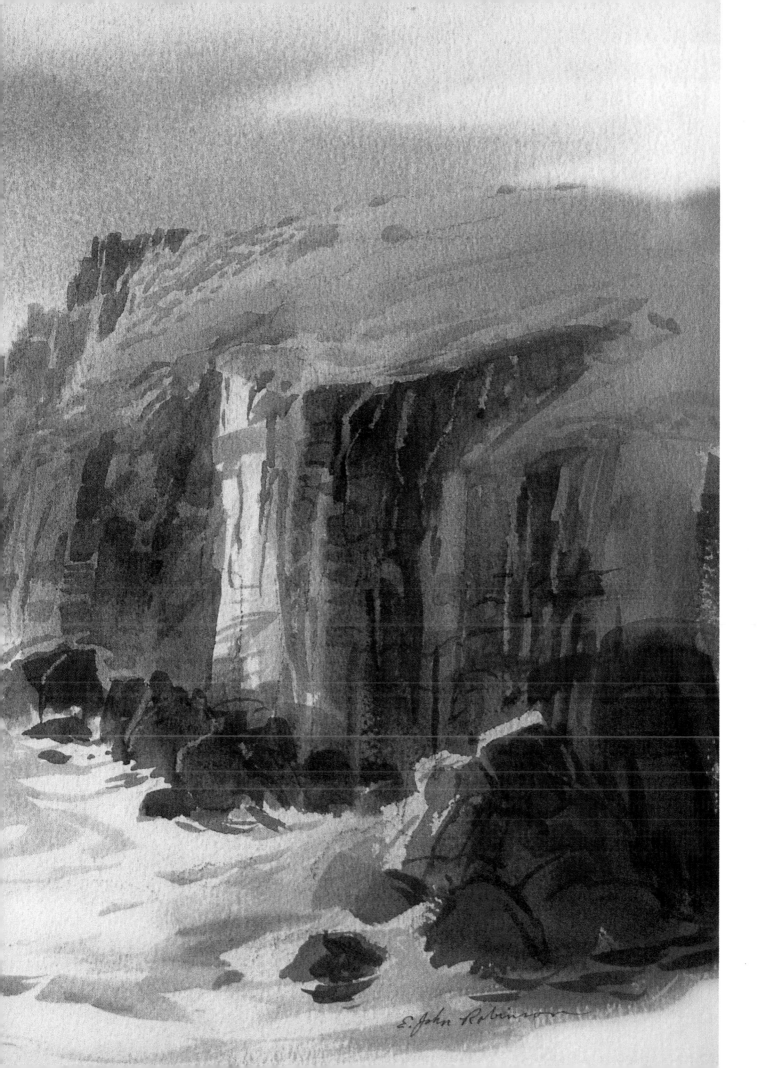

E. John Robinson

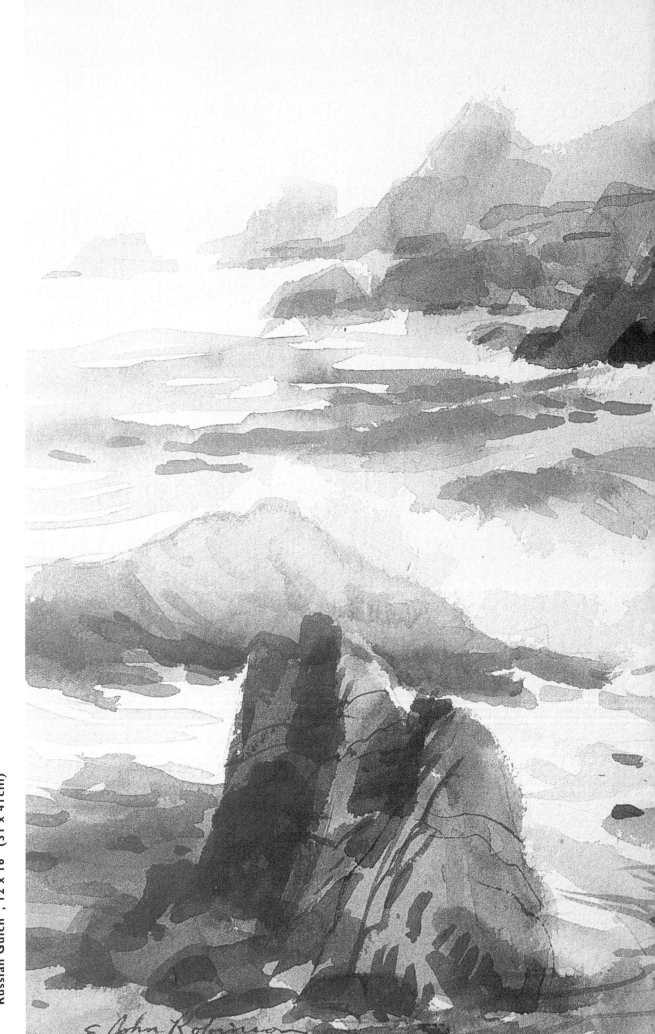

"Russian Gulch", 12 x 16" (31 x 41cm)

E. John Robinson

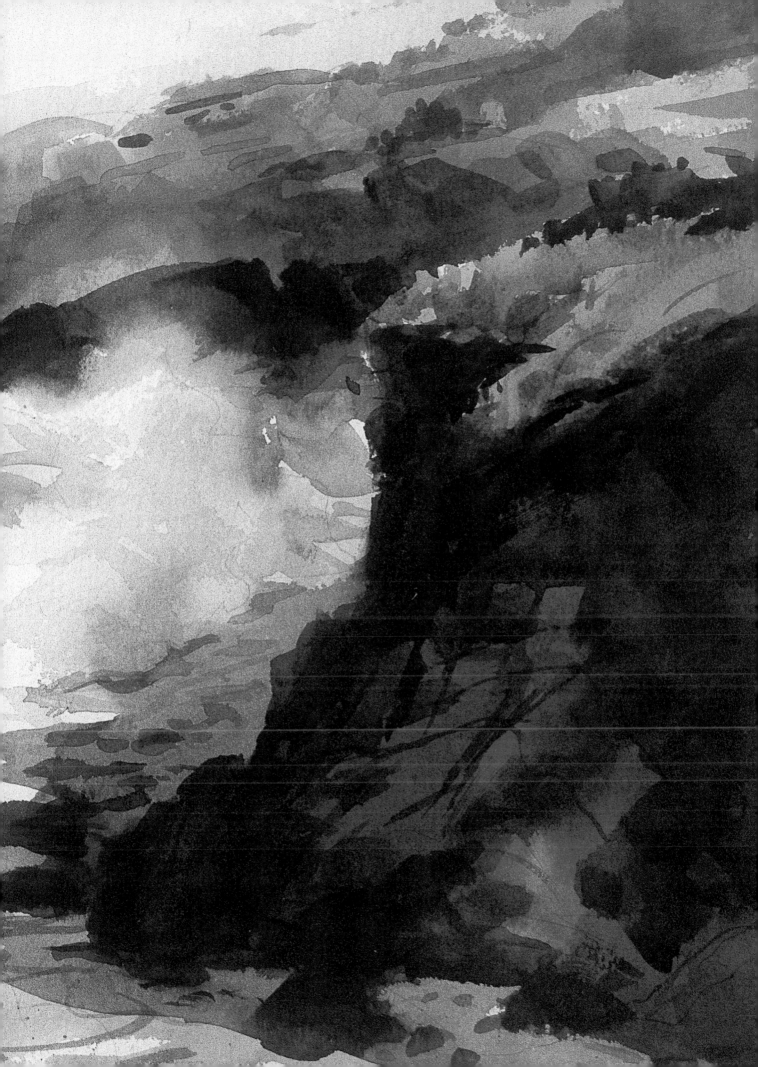

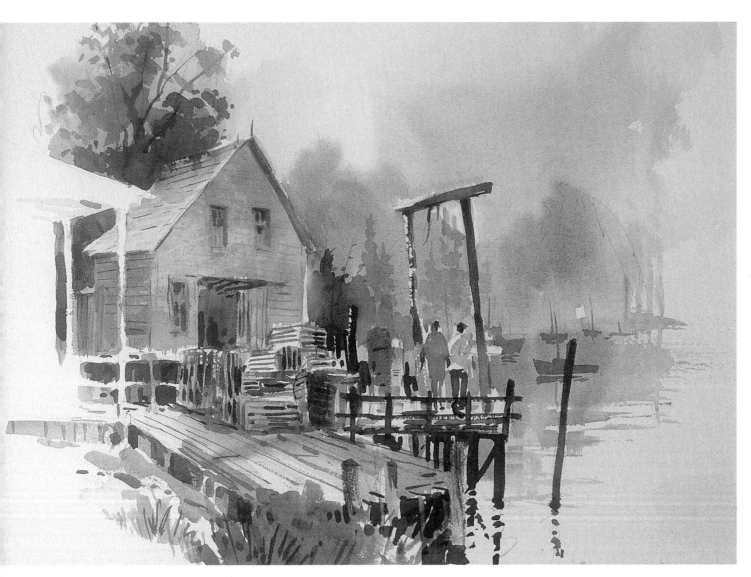

"Dock Talk", 15 x 22" (38 x 56cm)

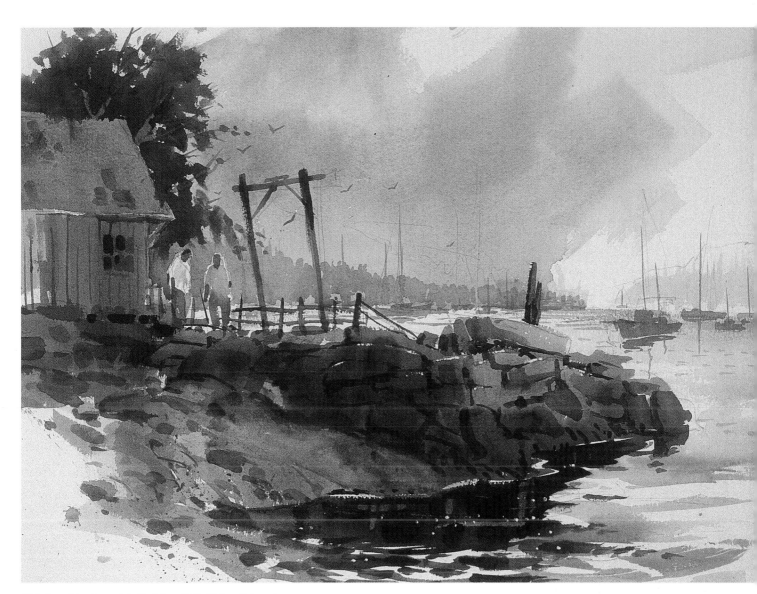

"Maine Harborside", 15 x 20" (38 x 51cm)

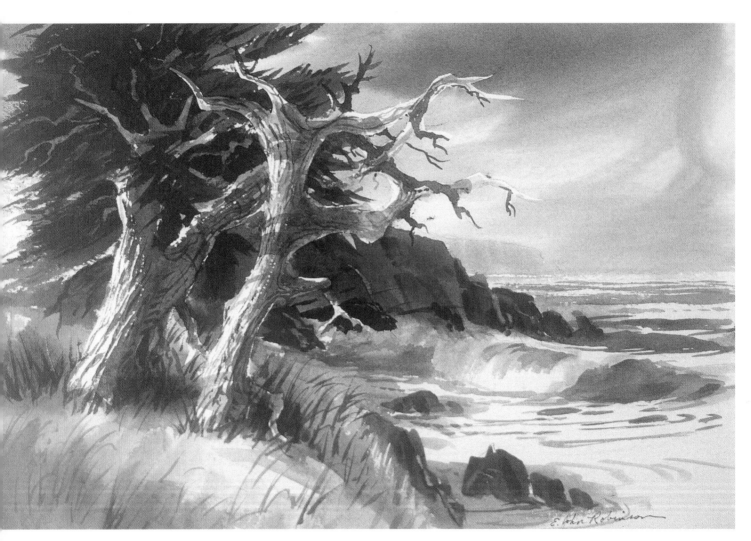

"From the Bluffs", 12 x 16" (31 x 41cm)

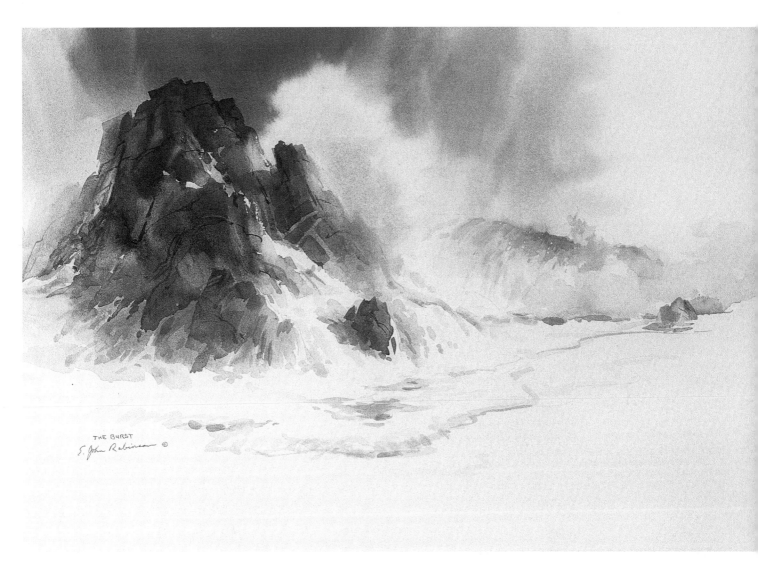

"The Burst"

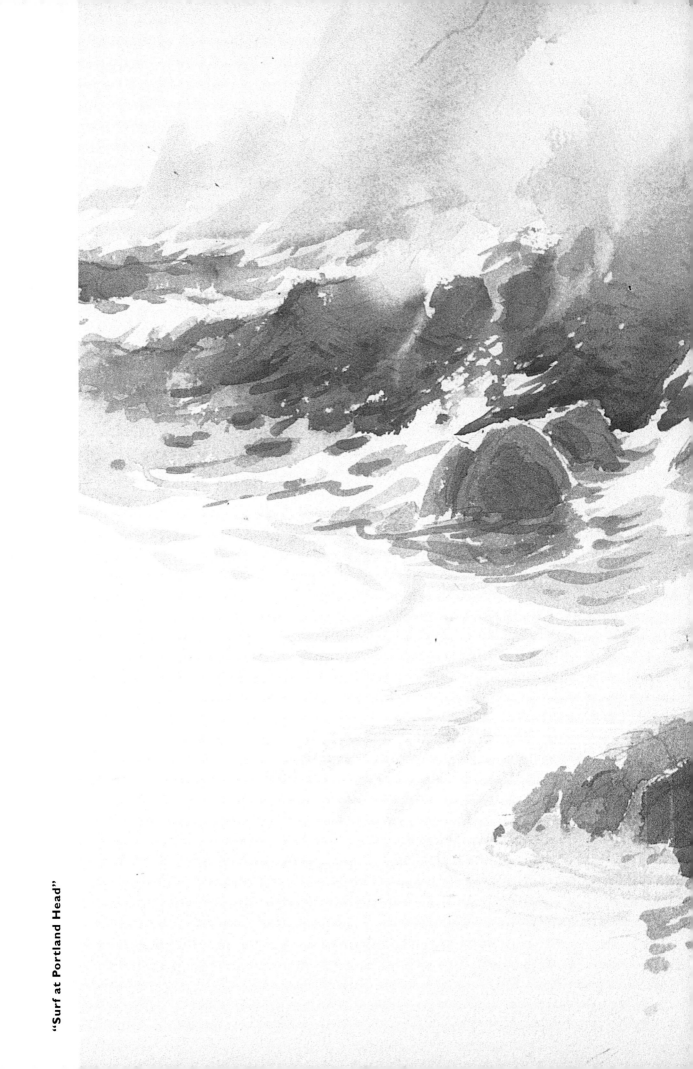

"Surf at Portland Head"

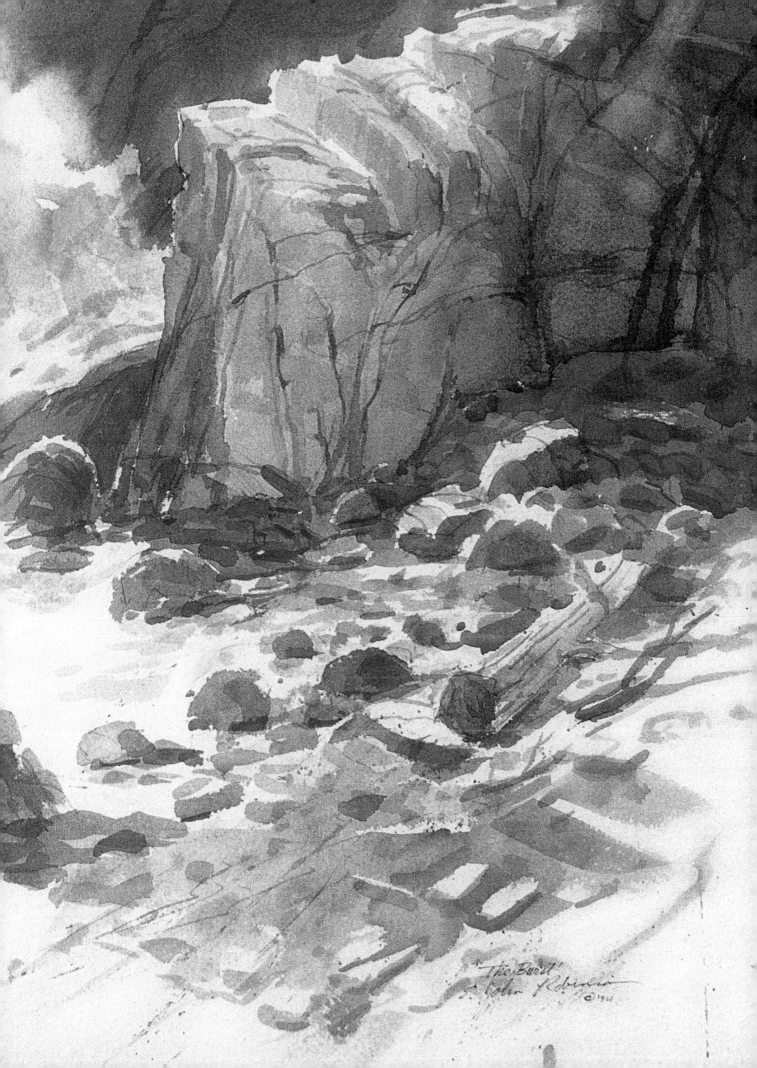

"The Burst"
John Robinson
©'94

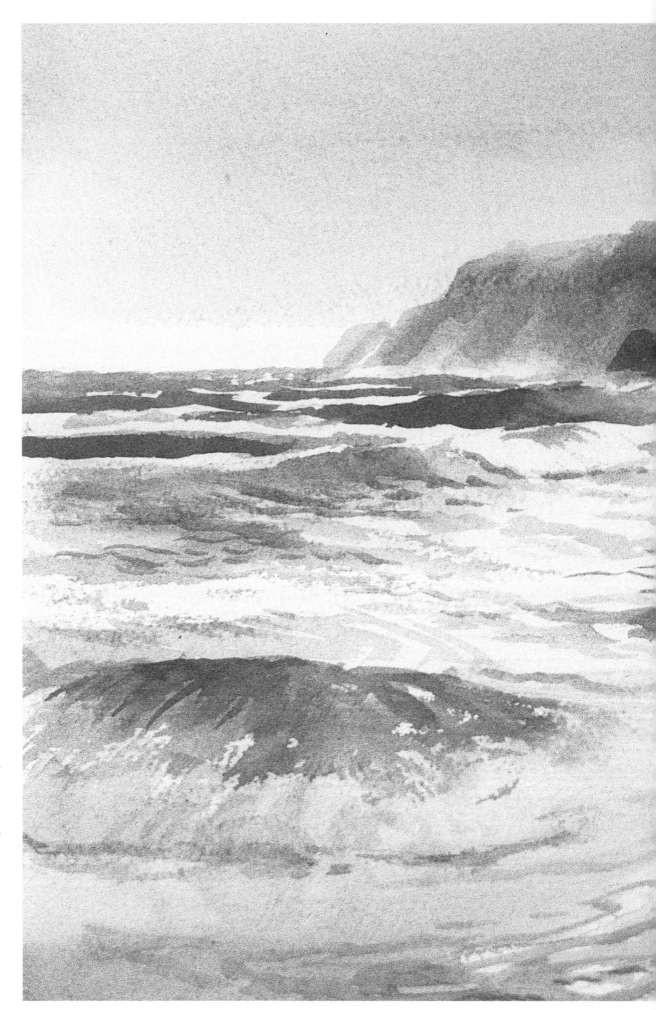

"Pirate's Cove", 12 x 16" (31 x 41 cm)

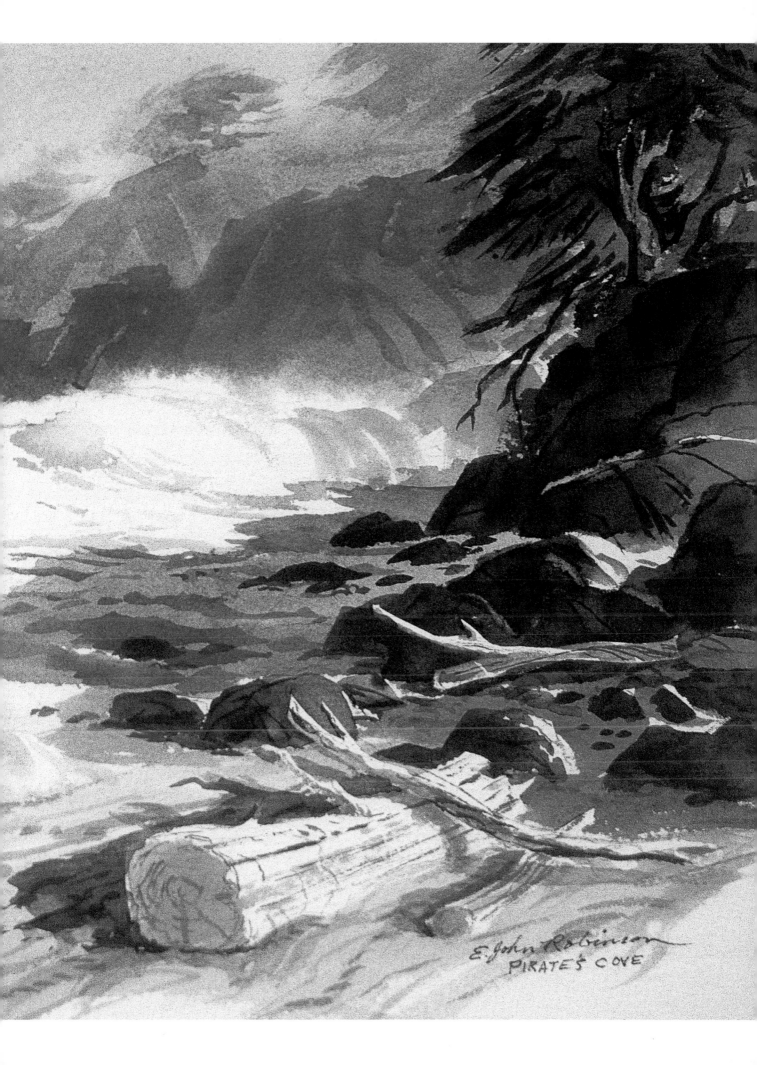

E. John Robinson
PIRATE'S COVE

the three stages of expression

There are three stages or levels of creative development:

1. Copying

We all started by copying others. We watched what others were doing and tried to make our attempts look like theirs. Most people began learning in this manner well before they went to school and most people, for one reason or another, never advance beyond this approach

2. Advanced copying

For the few people who do go beyond stage one, the next stage requires some skills. They still copy but rely more on photos or even go outside and copy what they see from nature. The more they practice, the more skilled they become, and some extremely fine art has been created in this way. However, most do not go beyond this stage.

3. Expression

In the third level of creative development the artist goes beyond just making an image and expresses a mood or a message. Stages one and two are still there to a certain extent but now the personal touch is more evident. There has always been a personal touch in that everyone in each stage chose their favorite subject, favorite colors, and ways of expression that are unlike others, but now the artist uses the subject as a means to express feelings. It could be a seascape, a landscape, a still life or an abstraction, but now it conveys to a viewer what the artist felt when they first came upon this moment. Now the artist can express joy or sadness, happiness or anger, a feeling of motion or peaceful rest. No matter whether the message is considered good or bad, it is a message to be felt rather than just viewed.

This book has given a few ways to go beyond the first two levels and you must know there are many more. Discovering them will be much easier now that you are aware of another level and as you develop your skills to express yourself, more ways will become apparent.

Painting is one of the most exciting things a human can do on this earth and you are fortunate indeed, to have such a gift. Remember though, it takes time and effort to develop the technical skills. It can be frustrating at times but you will advance. Simply try to improve today over what you did yesterday and look forward to tomorrow to improve over today. Never mind what others are doing, these are your skills and your expressions. All it takes is awareness, dedication and the pleasure of much, much, painting.

E John Robinson

"In the third level of creative development the artist goes beyond just making an image and expresses a mood or a message."

"Spring Surf", 14 x 18" (36 x 46cm)